ESSAYS IN ART AND CULTURE

Image on the Edge
The Margins of Medieval Art

Michael Camille

Harvard University Press
Cambridge, Massachusetts 1992

First published in the United States of America in 1992
by Harvard University Press, Cambridge, Massachusetts
Published in Great Britain in 1992 by Reaktion Books, London
Copyright © Michael Camille 1992
Printed in Great Britain
10 9 8 7 6 5 4 3 2 1

This book is printed on 130gsm Fineblade Smooth,
an acid-free stock made from 100 per cent chemical woodpulp,
and its materials have been chosen for strength
and durability.

Library of Congress Card Number 91-077846

ISBN 0-674-44361-6

Contents

Acknowledgments 7

Preface 9

1 Making Margins 11

2 In the Margins of the Monastery 56

3 In the Margins of the Cathedral 77

4 In the Margins of the Court 99

5 In the Margins of the City 129

6 The End of the Edge 153

References 161

Bibliography 164

List of Illustrations 172

Acknowledgments

In addition to all the staff of those manuscript libraries and museums in Europe and the United States in which I have spent days on end on the edge, I would like to thank those friends, colleagues and students who have discussed the periphery with me: Lilian Randall, Lucy Sandler, Robert Nelson, Linda Seidel, Eugene Vance, Stephen G. Nichols, R. Howard Bloch, Malcolm Jones, Jonathan Alexander, Ross G. Arthur, Nurith Kenaan-Kedar, Jerry Dodds, Paula Gerson, Sarah Hanrahan, Ben Withers and Rita McCarthy. A special thanks to Mitchell Merback for help with compiling the Bibliography.

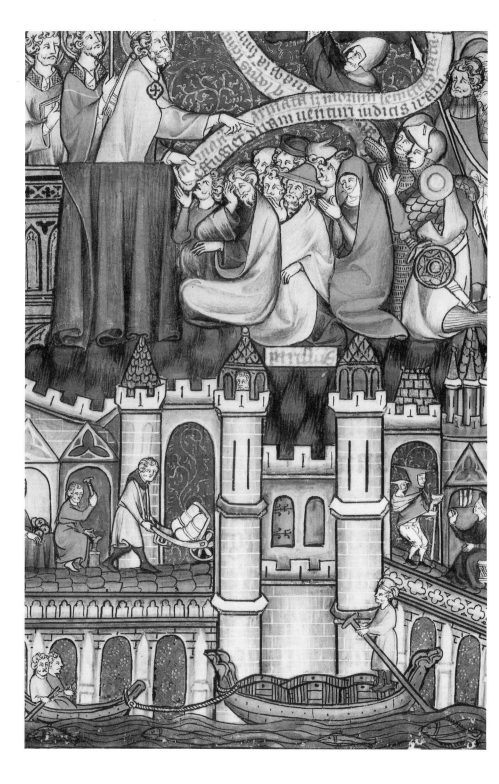

Preface

I could begin, like St Bernard, by asking what do they all mean, those lascivious apes, autophagic dragons, pot-bellied heads, harp-playing asses, arse-kissing priests and somersaulting jongleurs that protrude at the edges of medieval buildings, sculptures and illuminated manuscripts? But I am more interested in how they pretend to avoid meaning, how they seem to celebrate the flux of 'becoming' rather than 'being', something I am able to suggest only in the completed sentences and sections of these essays. Nevertheless, my heteroclite combination of methodologies, aping those of literary criticism, psychoanalysis, semiotics and anthropology, as well as art history, is an attempt to make my method as monstrous (which means deviating from the natural order) as its subject. As was noted by Arnold Van Gennep, one of the first anthropologists of the edge, 'the attributes of liminality are necessarily ambiguous since [they] elude or slip through the network of classifications that normally locate states and positions in cultural space'.

My opening chapter examines the cultural space of the margins and explores how it came to be constructed and colonized with such creaturely combinations during the thirteenth century. Images in the margins of Gothic manuscripts have been studied before, most notably by Lilian Randall. But rather than looking at the meaning of specific motifs, which are often reproduced as isolated details, I shall focus on their function as part of the whole page, text, object or space in which they are anchored.

The subsequent chapters focus on the margins of specific sites of power in medieval society – monastery, cathedral, court and city. These spaces, although controlled by specific groups – monks, priests, lords and burghers – served more than a single audience. They were arenas of confrontation, places where individuals often crossed social boundaries. At a monastery or cathedral, for example, the fringes are where we find ejected forms, taboos sculpted in stone that seem to intensify the very desires they delimit. In courtly society,

1 Beggars on the bridges of medieval Paris (detail of illus. 69)

where the same bodily impulses were to some extent legitimated by a class ethos of pseudo-sacred chivalry and idealized in new genres, such as Romance, the marginal was rather a mode of entertainment or a means of subjugating the lower orders.

My chapter on the medieval city focuses on the visual representation of the subjugated rabble of urban marginals – beggars and prostitutes. It also raises the crucial question of whether or not medieval artists, who increasingly worked in an urban context and portrayed themselves in the margins of their own images, were ever able to do more than 'play' at subversion. Do the margins represent the beginnings of autonomous artistic selfconsciousness, as many have claimed? Finally, I will glance at the demise of the Gothic tradition of marginal image-making, which coincided with the rise of illusionistic space in fifteenth-century manuscript painting.

While an examination of marginal art is timely, considering current critical debates over centre and periphery, 'high' versus 'low' culture and the position of the 'other' or minority discourse in elitist disciplines such as art history, we must be careful not to think of the medieval margins in Postmodern terms. During the Middle Ages the term marginal denoted, above all, the written page. The efflorescence of marginal art in the thirteenth century has to be linked to changing reading patterns, rising literacy and the increasing use of scribal records as forms of social control. Things written or drawn in the margins add an extra dimension, a supplement, that is able to gloss, parody, modernize and problematize the text's authority while never totally undermining it. The centre is, I shall argue, dependent upon the margins for its continued existence. For this reason I hope my book will stimulate many annotations, additions, queries and even, perhaps, one or two doodles of disagreement from its readers, eager to make images on the edge.

1 Making Margins

> The men of the Middle Ages participated in two lives: the official and the carnival life. Two aspects of the world, the serious and the laughing aspect, co-existed in their consciousness. This co-existence was strikingly reflected in thirteenth and fourteenth-century illuminated manuscripts . . . Here we find on the same page strictly pious illustrations . . . as well as free designs not connected with the story. The free designs represent chimeras (fantastic forms combining human, animal and vegetable elements), comic devils, jugglers performing acrobatic tricks, masquerade figures, and parodical scenes – that is, purely grotesque carnivalesque themes . . . However, in medieval art a strict dividing line is drawn between the pious and the grotesque; they exist side by side but never merge.[1]

Opening her Book of Hours at Terce, the third canonical Hour of the day, which was at about 9 o'clock in the morning, a woman – who was possibly called Marguerite and who lived in the second quarter of the fourteenth century – would have seen herself on the 'dividing line' in the margin of the left-hand page (illus. 14). Holding open a tiny book – this book – she kneels before the Adoration of the Magi that takes place under the triple arches of a Gothic shrine built into the letter 'D' of God's Word, *Deus*. Looking down to the *bas-de-page*, she would have seen how three monkeys ape the gestures of the wise men above. Top left, a spiky-winged ape-angel grasps the tail of the 'D', as if he is about to pull the string that will unravel it all. Another simian plays a more supportive role, holding aloft, Atlas-like, the platform on which she kneels. On the sinister, or left side, and also mocking the gift-bearing Magi, struts a marvellous monster, known as a sciapod because of his one enormous foot, who proffers a golden crown.

The opening words, *Deus in audiutor* (O Lord hear my prayer), remind us that the owner of this book would have

read it out loud. But would her prayers not have been inter-rupted by the visual noise of bells clanging from the Fool's Cap of a glaring gryllus at the top right, or the din of the pipe and tabor at the lower limit? These pages of Marguerite's Hours, rather than revealing her participation in what the Russian scholar Mikhail Bakhtin described as two distinct aspects of medieval life – one sacred and the other profane – situate her neither outside nor inside, but in-between, on the edge.

The butterfly juxtaposed with a cooking-pot in the right margin of the opposite page might remind modern observers of the Surrealists' pleasure in the 'fortuitous meeting of a sewing machine and an umbrella on an operating table'. But whereas modern artists such as Magritte or Ernst juxtaposed banal fragments of the real world as ominous fetishes, the exquisite incongruity of medieval marginal art refuses us the illusion of a dream. These combinations are as conscious and as instrumental as the little monsters that bleep and zig-zag across today's computer screens in similar games of scopic concentration. Other words that, like 'surreal', are inappro-priate for describing these creatures include the Romantic term 'fantastic' (as used in Jurgis Baltrusaitis's book *Le Gothique fantastique*, 1960), and – most important of all – the negatively loaded term 'grotesque', which was invented in the sixteenth century to describe newly discovered Antique wall paintings.[2] Marguerite might have described her mar-ginal creatures with the Latin terms *fabula* or *curiositates*, but this laywoman would more likely have used a variant of the term *babuini* (the source of our word baboon), which is recorded in a document of 1344 describing carvings by a French artist at Avignon, and which might best be translated as 'monkey-business'.[3] Chaucer used the word in English when describing a building decorated with 'subtil compas-inges, pinnacles and babewyns', making a double reference to simian similarity – babewyn, or baboon-like, and compas-singe, which joins the word for geometrical design with *singe* or monkey.[4]

That the term babewyn came to stand for all such composite creatures, and not just apes, is significant. Isidore of Seville, the authority on etymology throughout the Middle Ages, traced the derivation of *simius*, or ape, from *similitudo*, noting that 'the monkey wants to mimic everything he sees done'.[5]

A beast that was kept as an entertaining toy by jongleurs and as a pet by the nobility, the ape came to signify the dubious status of representation itself, *le singe* being an anagram for *le signe* – the sign. The prevalence of apes in marginal art similarly (sic) draws attention to the danger of mimesis or illusion in God's created scheme of things.

Marguerite might also have called the things in the margins *fatrasies*, from *fatras*, meaning trash or rubbish, which was a genre of humorous poetry particular to the Franco-Flemish region where her Book of Hours was produced. Although they follow a strictly syllabic form, these poems describe things that might have sprung from its very pages:

> *D'un pet de suiron*
> *Uns pez se fist pendre*
> *Por l'i miex deffendre*
> *Derier un luiton;*
> *La s'en esmervilla on*
> *Que tantost vint l'ame prendre*
> *La teste d'un porion . . .*

From the foot of a mite a fart hung himself, the better to hide behind a goblin; whereupon all were astounded, for there, to carry off his soul, came the head of a pumpkin.[6]

The *fatrasie*, which consist of communications that are impossible despite the comprehensibility of each linguistic unit, are not unlike that which we see in the margins. These poems are, however, perfectly self-contained, and they were enjoyed by court society as an amusement, whereas the systematic incoherence of marginal art is placed within, perhaps even against, another discourse – the Word of God. Yet, what we today may perceive as contradictory cultural codes might not have been seen as so separated during the Middle Ages. In a typical non-illustrated manuscript (Paris, Bibliothèque Nationale, fr. 19152) we can find moral tales, saints' lives, fables, courtly poems and two bawdy fabliaux bound together. The concoction of hybrids, mingling different registers and genres, seems to have been both a verbal and a visual fashion for élite audiences. Monkey-business, such as that to be seen in Marguerite's Hours, can be found in the borders of contemporary stained-glass windows at York Minster,

documented in liturgical albs made for Westminster Abbey and embroidered on the cushions made for the private chapel of Isabella of Hainault, the Flemish consort of Edward III.[7] But this still does not answer the question of what it was that such elevated patrons wanted in this garbage-world, this apish, reeling and drunken discourse that filled the margins of their otherwise scrupulously organized lives.

THE WORLD AT THE EDGES OF THE WORD

People's fears were exorcised by dumping them on those who inhabited the edges of the known world, who were lesser in some sense; whether troglodites or pygmies . . . the outskirts are felt to be infected zones, where all kinds of monstrosities are possible, and where a different man is born, an aberrant from the prototype who inhabits the center of things.[8]

During the Middle Ages the edges of the known world were at the same time the limits of representation. On the World Map painted on a page of an English Psalter of *c.* 1260 (illus. 2), the further one moves away from the centre-point of Jerusalem, the more deformed and alien things become. From outside time and space, in the apex of the page, God controls all, while two coiled dragons suggest the space of the 'underworld' at the bottom. Skirting Africa in the lower-right quadrant of this tiny one-and-a-half-inch cosmos, the artist has managed to depict fourteen of the monstrous races whose types derive from Pliny and who were thought to exist 'at the round earth's imagined corners'.[9] Here we see minute blemyae and cynocephali (men with eyes in their chests and dog-headed persons), giants, pygmies and many others. There is a sciapod too, like the one who must have come a long way to play a mock-magus in the left margin of Marguerite's Hours. In this sense, illuminators were often not inventing monsters but depicting creatures they might well have assumed existed at the limits of God's creation.

With God at the centre of the medieval panopticon, 'all-seeing' and everywhere at once, most models of the cosmos, society and even literary style, were circular and centripetal. The safe symbolic spaces of hearth, village or city were starkly contrasted with the dangerous territories outside, of forest,

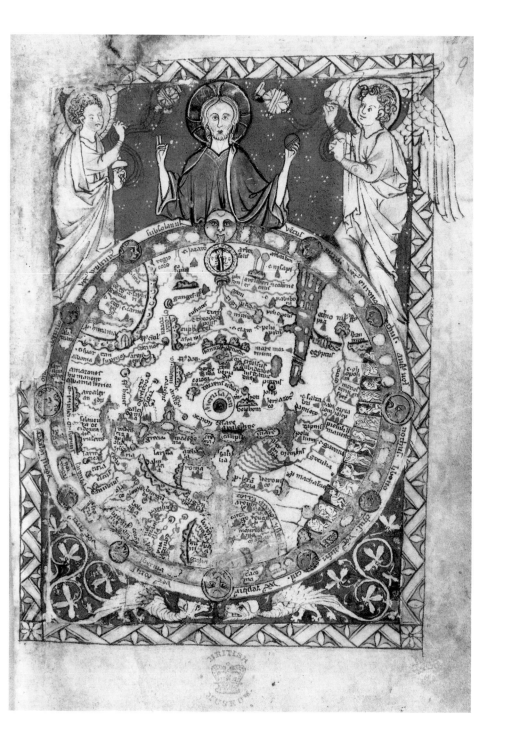

desert and marsh. Every country child would remember the boundary brooks and trees where he was dunked and bumped on Rogation Day in a village ritual sometimes called Beating the Bounds, which marked upon his own body the spatial limits of his world. The realms of the unknown were not distant continents traversed by travellers and pilgrims; they began just over the hill.

Yet people were also highly sensitive to disorder and displacement precisely because they were so concerned with the hierarchy that defined their position in the universe. Such schemas included, in addition to the three orders of society – those who prayed, fought and laboured – the free and unfree, religious people and lay, city-dwellers and country-dwellers, and, of course, women and men. Although it lacked our predominant dichotomy of public versus private, the medieval organization of space was no less territorial. In the fields, strips marked off each peasant's holding, while in towns and cities every street and enclave, each market and waterway, came under the control of particular ecclesiastical or secular lords. The thirteenth century was precisely the period of arable expansion that reclaimed much marginal land for enclosure to increase seignorial revenues.[10] This control and codification of space represented by the labelled territories of the centrifugal circular World Map created, of necessity, a space for ejecting the undesirable – the banished, outlawed, leprous, scabrous outcasts of society.[11]

If these edges were dangerous, they were also powerful places. In folklore, betwixt and between are important zones of transformation. The edge of the water was where wisdom revealed itself; spirits were banished to the spaceless places 'between the froth and the water' or 'betwixt the bark and the tree'. Similarly, temporal junctures between winter and summer, or between night and day, were dangerous moments of intersection with the Otherworld. In charms and riddles, things that were neither this nor that bore, in their defiance of classification, strong magic. Openings, entrances and doorways, both of buildings and the human body (in one Middle English medical text there is mention of a medicine corroding 'the margynes of the skynne'), were especially important liminal zones that had to be protected.

Most of the visual art that has come down to us from the early Middle Ages was made for God. All else was the Devil's.

3 'Chi-Rho' monogram. *The Book of Kells*. Trinity College, Dublin

In a letter written to the Archbishop of Canterbury in 745, St Boniface complained of

> those ornaments shaped like worms, teeming *on the borders* of ecclesiastical vestments; they announce Antichrist and are introduced by his guile and through his ministers in the monasteries to induce lechery, depravity, shameful deeds and disgust for study and prayer.[12]

In the near-contemporary Book of Kells made by the monks of Iona, not only were serpents allowed into the borders but the Word of God itself became 'a habitation of dragons'. In the famous *Chi-Rho* monogram page, the three Greek letters

17

that spell out the name 'Christ' form visual riddles and magical knots, their edges inhabited by cats, mice and otters in a cosmological image of God's created universe as Word (illus. 3). Under the top-left arm of the great X two moths meet, their wings fluttering and transparent against the metallic swirls of Celtic interlace. Basil described the moth's transition from a chrysalis as a symbol of the metamorphosis of the soul through the Logos incarnate. For the monastic makers and audience of Kells, the world of nature was something to be integrated into spiritual meditation and to be set up in opposition to it.[13] By contrast, the butterflies that flutter in the borders of Marguerite's fourteenth-century Book of Hours are emblems of flitting fancy, of insubstantial emptiness. No longer locked, as on the Kells page, into a Christological conundrum these insects are verminous whimsies outside the confines of the text. Whereas the Word and the world are sacrally interwoven in the Book of Kells, here they confront one another as centre and periphery – the site of reading and the edge of distraction. In the early Middle Ages, then, images existed not at the edges, but within the sacred Word itself.

Of course, the periphery of the written page had existed in earlier periods and had even been the site of pictures, as in Byzantine and Anglo-Saxon Psalters of the tenth century, where the side margins were the locus of often complex text illustrations. But this extra-textual space only developed into a site of artistic elaboration as the idea of the text as written document superseded the idea of the text as a cue for speech. The way monks read was called *meditatio*, in which every word was masticated and digested for memorization by being uttered out loud.[14] Page layout, even word separation, mattered little in this system since the Word was always performed. Letters could become ductile channels of pure fantasy, striking signals of beginnings and endings, since they did not need to be readable in our sense of the term. This focus of artistic play within the text itself continued well into the twelfth century.

An early example of an artist pushing representation outside the boundaries of the letter occurs in the great Bury Bible painted for the monks of Bury St Edmunds *c.* 1130 by a professional artist, Master Hugo. It appears in the book's very first letter, the 'F' for *Frater Ambrosius*, which is the opening,

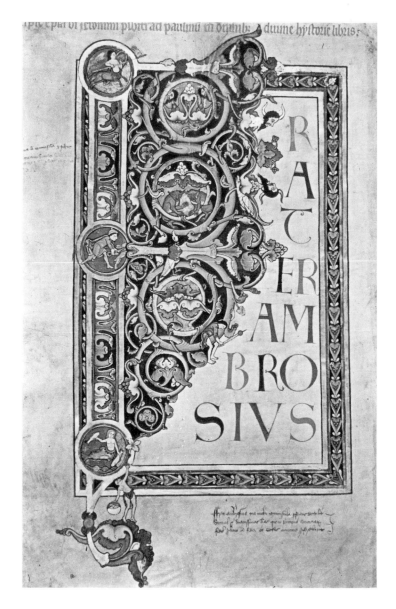

4 Rustic enigmas at the edge of the Logos. *The Bury Bible*. Corpus Christi College, Cambridge

not of the holy text itself, but of Jerome's preface, which perhaps accounts for the licence given the artist (illus. 4). The left edge of the swirling organic letter contains a centaur, a man with a wooden leg attempting to shave a hare with scissors (a popular riddle) and a fish-tailed siren. The centaur and siren are the remnants of a Classical decorative vocabulary used in the inhabited scrolls of Antique art and later demonized in Christian iconography. The riddle of the hare,

not recorded until centuries later, is an amazing instance of the irruption of oral folk-culture into the monastery. Serlo of Wilton and other Anglo-Norman clerics of the period were known to have collected vernacular proverbs, or what they termed *enigmata rusticana*, for use in Latin translation exercises.[15] Shaving the hare is an *adynaton* – a representation of an impossible task. Is this a pictorial gloss on the difficulty of reading itself, of pinning down the meaning of the biblical text? As in so many manuscripts, it is that which is found at the bottom of the page that is most significant. Outside the lower frame, a half-naked man with a basket stands on a blossom, stretching up to pluck a flower. The offshoots of the Word have begun to form free-floating and uncircumscribed pockets of independent life.

With the increase in both devotional and bureaucratic literacy and the rise of new methods of textual organization and analysis in the later twelfth century, the page layout or *ordinatio* of the text supplanted monastic *meditatio*.[16] Now it was the physical materiality of writing as a system of visual signs that was stressed. This shift, from speaking words to seeing words, is fundamental to the development of marginal imagery, because once the letter had to be recognizable as part of a scanned system of visual units, possibilities for its deformation and play became limited. No longer forming the letter, representations either enter its frame to form what is known as the historiated or pictured initial common in Gothic manuscripts, or they are exiled into the unruled empty space of the margins – the traditional site of the gloss.

ANNOTATION AND THE ORIGINS OF MARGINAL ART

The word gloss means tongue (*lingua*) because in a way it speaks (*loquitur*) the meaning of the word under it.[17]

As Hugh of St Victor describes it, the eleventh- and twelfth-century gloss was often interlinear. Squeezed between the lines of text it 'spoke' the same words, only in a different language, as in the famous Anglo-Saxon gloss in the Lindisfarne Gospels. The marginal gloss, by contrast, interacts with and reinterprets a text that has come to be seen as fixed and finalized. In Langland's fourteenth-century poem *Piers Plowman*, we read the phrase 'Marchauntes in the margins'.[18] This

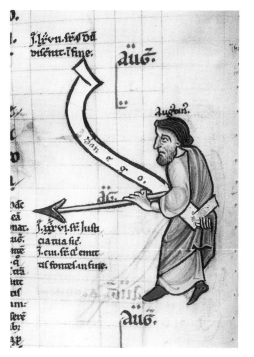

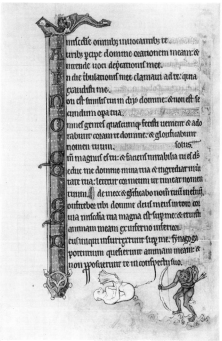

5 St Augustine
disagrees. Peter
Lombard's gloss
on the Psalms.
Trinity College,
Cambridge

6 Text versus
image. *The Rutland
Psalter*. British
Library, London

refers both to the merchants' physical place in the written
document described in this part of the poem, as well as to
the adjunct position of this 'new' class in relation to the tra-
ditional tripartite model of society. The word margin – from
the Latin *margoinis*, meaning edge, border, frontier – only
became current with the wider availability of writing. Once
the manuscript page becomes a matrix of visual signs and is
no longer one of flowing linear speech, the stage is set not
only for supplementation and annotation but also for dis-
agreement and juxtaposition – what the scholastics called *dis-
putatio*.

The *Glossa Ordinaria*, the great gloss to the Bible perfected
in the Schools of Paris, and Peter Lombard's gloss on the
Psalms are important late twelfth-century examples of this
new approach to reading.[19] In manuscripts of Peter Lom-
bard's gloss, figures and actions are sometimes painted on
the bare vellum of the page's lateral edges not specifically
to illustrate, but to comment upon the adjacent text. In a
manuscript given to Christchurch, Canterbury, in the late
twelfth century, Augustine is pictured pointing his barb at the
patristic commentary where he is quoted, while also holding a

scroll that reads *non ego*, as if to say 'I didn't say that' (illus. 5). The gloss here literally 'speaks' in Hugh of St Victor's terms not with, but against the text.

It is not until the Rutland Psalter, made in England half a century later (*c.* 1260), that a fully developed sequence of marginal images appears in a Gothic manuscript. On one page the letter 'p' of the Latin word *conspectu* (meaning to see or penetrate visually) enters the anus of a prostrate fish-man by joining up with the arrow shot by an exotic archer (illus. 6). Whereas in the Peter Lombard gloss, images sometimes argued with words in the text, here the word fights back. Such antagonism or 'difference' between text and image is due to important changes in manuscript production. Whereas in the previous century the text-writer and artist of a book were often one and the same, increasingly the two activities were practised by different individuals and groups. The illuminator usually followed the scribe, a procedure that framed his labour as secondary to, but also gave him a chance of undermining, the always already written Word. It is the artist of this page of the Rutland Psalter who has continued the tail of the letter into his figure's anus, perhaps suggesting to the scribe what he can do with his pen. While often undermining the text, drawing attention to its 'openness', marginal images never step outside (or inside) certain boundaries. Play has to have a playground, and just as the scribe follows the grid of ruled lines, there were rules governing the playing-fields of the marginal images that keep them firmly in their place.

By the end of the thirteenth century no text was spared the irreverent explosion of marginal mayhem. As well as the traditional tools of liturgy – Bibles, Missals and Pontificals, and books owned by individuals for use in private devotion, mostly Psalters and the increasingly fashionable Books of Hours – secular compilations, such as Romances, and legal works, such as the Decretals, were filled with visual annotations. The recently translated Latin manuscripts of Aristotle's *Physics* produced for scholars at Oxford with a myriad of glosses and interlinear additions are among the earliest examples with independent marginal figures, here poking fun at 'the philosopher'. This text was indeed controversial: it was banned and publicly burned in Paris and Oxford twice during the thirteenth century.[20] In a magnificent Harley

manuscript that depicts the book-burning on its first folio, the beginning of Book IV on the Heavens juxtaposes knowledge and its opposite. A seated sage inside the letter looks up to the stars from his desk, while an undulating groundline above brings us back to earth with a bump, for over it a gawping, leprous idiot is being trundled in a wheelbarrow (illus. 7). Is this the madness that, some believed, could result from too much knowledge? Here the edge already displays the signs of derangement.

The increasing selfconsciousness of the marginal artist is

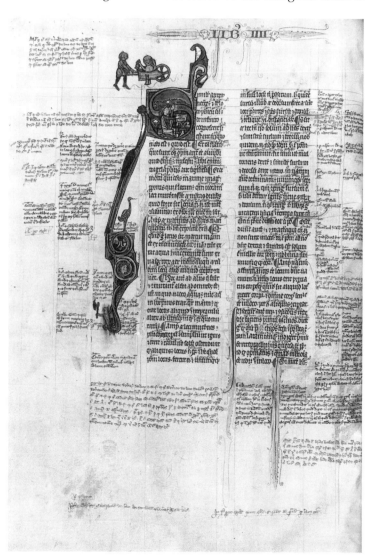

7 Folly crosses the philosophical text. Aristotle's *Physics*. British Library, London

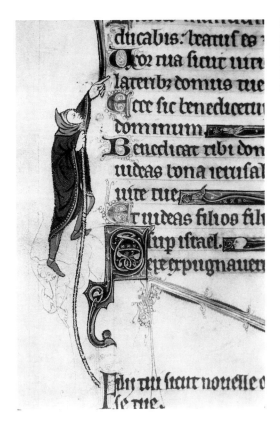

8 Man pulling into place the missing fourth verse of Psalm 127. Book of Hours. Walters Art Gallery, Baltimore

most evident in an English Book of Hours, *c.* 1300, now in Baltimore, where the scribe has forgotten certain passages; these *corrigenda*, or additions to the text, are hauled up, pointed out and pushed into proper position by tiny textual construction workers (illus. 8). Open to miscopying, misreading, corruption and appropriation, the text becomes an imperfect physical mark – just another image in the fallen world. In the eighth century the monastic scribe-illuminator had been a revered figure; sometimes his writing hand was venerated as a relic because it relayed the Word of God. Fourteenth-century scribes and illuminators were, by contrast, mostly professionals paid by the page, their work mocked by monkeys in the margins of a Missal made at Amiens (illus. 9). Whereas the early Gospel Books retained the myths of their being made on the instruction of angels, Gothic manuscripts often document their own material origin. This one bears a colophon informing us that it was ordered by Abbot Johannes de Marcello of the Church of St

9 Monkeys mock writing. Missal illuminated by Petrus de Raimbeaucourt, 1323. Koninklijke Bibliotheek, The Hague

mulus tuus clemen
tie tue longinqua
miseratio · sana
uulnera · eorumq;
remitte peccata :
ut nullis a te ini
quitatibus sepa
rata tibi domino
semper ualeant
adherere. Per.

Deus sub ai
us oculis omne
cor trepidat om

nesq; consciencie
contremiscunt.
propiciare omni
um gemitibus ·
et cunctorum
medere uulneribz;
ut sicut nemo
nrm liber est a cul
pa. ita nemo sit
alienus aucnia.

Per xpm :

Domine ds
noster qui
offensione nra

Jean at Amiens, that it was written *'per manum'* Garnieri di Moriolo and illuminated by Petrus de Raimbeaucourt, a layman, in 1323. Petrus the *pictor* was probably playing a game with the *scriptor* here, since this *bas-de-page* image of a monkey displaying its rear to the tonsured scribe was presumably inspired by an unfortunate word division seven lines above. This line ends by breaking the word *culpa* (sin) in a crucial place, thus it reads *Liber est a cul* – the book is to the bum!

Although medieval Christianity was a religion of the Word, by the time this liturgical book was made there was a widespread distrust of the surface of the letter and its overproduction: 'For in the multitude of many words there are also divers vanities' (Ecclesiastes 5:7). Perhaps this anxiety over the proliferation and profanation of the written Word, or rather words that were now available to vast new audiences of lay as well as religious readers, made it all the more crucial that they be fixed in the centre and their shaky status be counterposed with something even less stable, more base and, in semiotic terms, even more illusory – the image on the edge.

MODEL AND ANTI-MODEL

> *Solomon* The four evangelists support the world.
> *Marcolf* Four underpinnings support the toilet and he who sits above them will not fall.[21]

The medieval image-world was, like medieval life itself, rigidly structured and hierarchical. For this reason, resisting, ridiculing, overturning and inverting it was not only possible, it was limitless. Every model had its opposite, inverse anti-model.[22] The early fourteenth-century English artist of the Ormesby Psalter painted the traditional subject of the Devil's triple temptation of Christ in the Desert (Matthew 4:1–11) inside the initial to Psalm 52, *Dixit insipiens in corde suo non est deus* – 'the fool said in his heart there is no God' (illus. 15). In the *bas-de-page* he painted a parallel *disputatio* from a rarely pictured story, the 'Dialogue of King Solomon and Marcolf'. This debate between the wise biblical king and the wily peasant was enjoyed in oral and written form throughout the Middle Ages. The scene on the lower left, which shows Solomon and his huntsman pointing from a building, is recounted thus in the Middle English version:

Tho commaunded Salomon his seruantes 'have thys man out of my syghte: and if he come hythre any more, set my howndes upon hym . . .' [Marcolf] bethoughte hym in his mynde how he myghte beste gete hym agen into the kinges courte wythout hurte or devouryng of the howndes. He went and bought a quyck hare and put it undre hys clothis and gede agen to the courte. And when the kynges seruantes had syghte of hym, they set upon hym alle the howndes and forthwyth he cast hys hare from hym, and the howndes aftre, and left Marcolf, and thus came he agen to the king.[23]

Marcolf's unusual arrival – riding a goat, a common sign of lewdness, and holding a hare – illustrates a part of the tale not recorded in this text, whereby he fulfils a riddle he had earlier told the King: Marcolf had said how he would come before him neither walking nor riding (his one shoe is off the ground), neither dressed nor naked (he wears but a hood) and bringing something that was a gift and no gift (the proverbial running hare that will immediately escape). This image is a literal depiction of something that is and, at the same time, is not – the betwixt and between beloved of riddle-riddled popular culture. Marcolf is a trickster-type known in folklore all over the world.[24] In his 'double nature' he appears at crossroads, in disguise and always as a force of disruption; an arch-inverter who, in the *Dialogue*, turns all Solomon's turgid truths into turds:

> *Solomon* Give the wise an opportunity, and wisdom will be added unto him.
> *Marcolf* Let the belly be stuffed, and shit will be added unto you.

Such coprophagic retorts have their pictorial parallel in the right margin of this Psalter page, where the inverted fart of a trumpet blasts into the rear of a startled anal animal. This might refer to the end of the Marcolf story, which literally involves him tricking the King into looking into his dirty and filthy 'end' as he squats backwards inside an oven, a scene, in fact, illustrated in another English Psalter of the period.[25]

But does not this marginal scene of Solomon fooled undermine rather than reinforce the 'central' initial image here, in which Christ triumphs over the fool/Devil? Tempting the

reader to invert the standard interpretation, this juxtaposition suggests that it is Christ, not the Devil, who is 'the fool'. It is Christ in the Temptation image who outwits the fiend in accepting humility and refusing the 'high' offers of all the kingdoms of the world. In this biblical dialogue it is the Devil who always makes the first statement and Christ who counters it with 'for it is written', just as Marcolf always has a proverbial, if perverse, retort to Solomon's words of wisdom. This double inversion by which Christ is reinscribed as the fool at the bottom of the page is also visually suggested by having Marcolf's gestures match those of Christ seated on the throne above. Nor is Marcolf painted as the gross and dirty brute he normally appears, nor even as the court 'fool' in his bifurcating cap and bauble, as he is sometimes depicted for this Psalm.[26] But what of the atheistic fool's pronouncement that 'there is no God', which would make Christ deny his own existence? Perhaps it is significant that this negative phrase does not appear until we turn over to the next folio. On this page Marcolf is the wise fool, of I. Corinthians 3:18.

All this is even more surprising given that this book was used in the Psalm readings of the liturgical offices and was, according to an inscription, 'The Psalter of brother Robert of Ormesby, monk of Norwich, who assigned it to the choir of the [Cathedral] Church of Holy Trinity, Norwich, to lie forever at the stall of the incumbent Sub-prior'.[27] To understand how the fool's anti-language and bodily perversity functioned in a liturgical context it is not sufficient simply to label these margins as negative *exempla*, of the kind preachers used to wake up their sleepy audiences. While certain marginal themes can be related to the didactic tradition of the sermon *exemplum*, it is not always clear that the margins depict the deadly distractions of the flesh that were meant to be transcended through the spirit of the letter, as has been strongly argued in the past.[28]

For example, the same spatial juxtapositions of sacred and secular that occur in the Ormesby Psalter are to be found in English polyphonic music of the same period. Religious motets sometimes even combine Latin top parts with vernacular tenor lines, as in a fourteenth-century three-part motet in a manuscript at Durham Cathedral that combines the sacred narrative of the Massacre of the Innocents, beginning *Herodis in pretorio* in the top line, with a prostitute's call ('*Hey*

10 Signs of the Passion. Book of Hours. Pierpont Morgan Library, New York

11 Bird-headed Christ. Book of Hours. Walters Art Gallery, Baltimore

Hure Lure') in the bottom part. This 'profane' utterance literally appears in the space of the *bas-de-page*.[29] The Ormesby Psalter has been called part of a 'Giottoesque episode' in English medieval art because of its three-dimensional style;[30] like the Durham motet it might as well be called a polyphonic episode, in its brilliant elision of different visual voices.

We should not see medieval culture exclusively in terms of binary oppositions – sacred/profane, for example, or spiritual/worldly – for the Ormesby Psalter suggests to us that people then enjoyed ambiguity. Travesty, profanation and sacrilege are essential to the continuity of the sacred in society.[31] Notions of play and games have been seen as crucial to the religious sensibilities of those involved in the English mystery plays of the fourteenth century.[32] In these plays the jokes made by Christ's tormentors as they hammer the nails into his hands and feet remind us that games can be deadly serious. In one of the few calmer margins of Marguerite's Hours, the *Arma Christi* – the various implements used in the Crucifixion – are laid out alongside the text of the Passion according to John (illus. 10). There is not one *singe* to be seen here, for these are true *signa* to be contemplated by the devout reader.

In one of the margins of the Baltimore Hours, the Cruci-
fixion is scandalously debased by distortion (illus. 11). In the
bottom margin is an odd agglomeration with crossed feet and
loincloth that, in its schematic shape, is closely comparable
to the crucified type in the right margin of Marguerite's
Hours. The head, however, is stretched into that of a hideous
beaked bird. What did the female patron of this book – who
is depicted on some of its pages[33] – make of this ostrich-
Christ? Was it the artist having his own joke, perhaps playing
on Verse seven of the Psalm five lines above – 'thou hast
painted [*impinguasti*] my head *in oleo*' – which can mean 'with
oil' in Latin, or 'with a goose' in French?

Just as we come across courtly personnel like fools, manic
musicians and lovers in the margins of sacred texts, it is per-
haps not surprising to find a naughty nun – a jibe against lax
monastic celibacy – in the margins of a vernacular Lancelot
Romance (illus. 12). Suckling a monkey, the nun parodies the
traditional type of the *Virgo lactans*. She is the antinomy of
the Virgin, although, as a nun, she is supposed to be a virgin –
to be *like* Mary. The ape is always a *singe*, a sign dissimulating
something else. Whereas the Virgin gave birth to Christ, this
supposed virgin has given birth to a monstrous sign that, in
its distortion of the human, points to her all-too-human sin.
Such images work to reinstate the very models they oppose.
For behind them, or often literally above them, is the shadow
of the model they invert, either on the very same page, as in

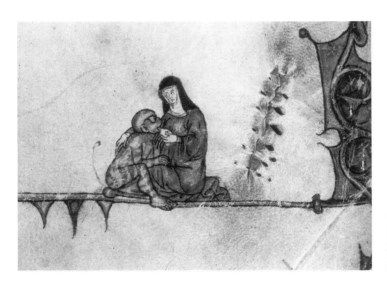

12 Nun suckling a
monkey. *Lancelot
Romance*. John
Rylands Library,
Manchester

the Ormesby Psalter, or as here, by reference to the widely known iconographic conventions they subvert.

SIGNIFICANCE AND THE SNAIL

> The ornamentation of a manuscript must have been regarded as a work having no connection whatever with the character of the book itself. Its details amused or aroused the admiration of the beholder, who in his amusement or admiration took no thought whether the text was sacred or profane. A tradition of ornament had in the course of generations been established, and no-one, not even probably a person of exemplary piety, sustained any shock to his feelings when he performed his devotions from a prayerbook whose margins were made the playground for the antics of monkeys or bears and impossible monsters, or afforded room for caricatures reflecting upon the ministers of religion.[34]

This pronouncement by a Keeper of Manuscripts in the British Museum on the non-meaning of marginal art is the clearest expression of a nineteenth-century attitude, a fear of the proliferation of perversities, that blinded generations of scholars, from M. R. James to Margaret Rickert, to the significance of marginal visual play.[35] When manuscripts were catalogued and described the marginal elements were deemed inessential and often not included. The way disturbing marginalia has been effaced more recently is through the analytic codification of art historians, who rather than ignore them have attempted to formally classify them. This was the approach of Jurgis Baltrusaitis, who constructed diagrams and plans mapping monstrosities into different formal groups with various sources in ancient and earlier Indo-European art.[36] This codification not only plucked these forms from their context, it relegated marginal art to the menial position of 'pure decoration'.

The notion, however, that marginal art is full of 'meaning' also has a long history. In the middle of the last century the Comte de Bastard, bibliophile and publisher of the first facsimiles of illuminated manuscripts, wrote an article in which he interpreted the common marginal image of the snail, an example of which he had encountered in the margins

of a French Book of Hours.[37] Because he found it adjacent to a picture of the Raising of Lazarus, he thought the creature emerging from its shell was a symbol of the Resurrection. This was soon discounted as over-zealous symbol-seeking by Champfleury, the famous nineteenth-century Realist critic, who, fitting Gothic marginal art into his history of caricature, preferred to see the snail being vilified in the margins as an agricultural pest.[38]

There have been many interpretations of the ubiquitous knight and snail motif since. According to one Flemish historian of caricature, the snail in its safe shell was a 'satire on the powerful who in their fortified castles laughed at the threat of the poor whom they exploited'.[39] But this does not explain why snails were the object of chivalric attention. More recently, and more persuasively, Lilian Randall argued that in 29 different manuscripts made between 1290 and 1320 the knight fighting the snail was associated with a particular ethnic group in medieval society – the cowardly Lombards, who not only bore the stigma of being turncoats but who, along with the Jews, were Europe's bankers.[40] The snail has been

14 Marguerite's monkey-business. Book of Hours. British Library, London

13 Knight and snail, woman and ram. Psalter. Kongelige Bibliotek, Copenhagen

uum meum intende dñe ad adiu
uandum me festina)

Gloria pri. hymnus
eni cxatox spñ mentes
memeto salutis

aria mater gñ ac
lona tibi domine qui
dix leuaui culos meos
qui hicis in celis ps.
ecce sicut oculi seruox
in manibz dñorum suorum
sicut oculi ancille in manibz
domine sue ita oculi nri ad do
minum deum nrm donec misereat
isceat nri dñe miserere nri
nri quia multum repleta sum
despectione)
quia multu repleta est aña no
st obpbrui habundantis et despectio
supbis. psalmus
isi quia dñs crat in nob
dicat nunc ist nisi quia

idebunt michi ꝶ timebunt ꝶ super eum
ridebunt ꝶ dicent: ecce homo qui non
posuit deum adiutorem suum.
et sperauit in multitudine diuiciarum
suarum: ꝶ preualuit in uanitate sua.
go autem sicut oliua fructifera in domo
dei sperauit in misericordia dei in eter
num ꝶ in seculum seculi.
onfitebor tibi in seculum quia fecisti: ꝶ
expectabo nomen tuum quoniam bonum est
in conspectu sanctorum tuorum.
octius mundane uanitatis desti
tor omnipotens deus fac nos quesumus in domo
tua sicut oliuam flo
rere fructiferam: ut in
misericordia tua sperantes ab
omni tali maledicto saluem
xit insipiens in corde

resurrected again in the broader context of folklore studies as a shifting sign for various groups in society. In some places it is an object of terror for knights, in others it is attacked by peasants, tailors and other 'low' groups. The snail emerging from its shell was associated with the social climber; its shape and size linked it to the genitals of women and hermaphrodites.[41]

A marginal image of a knight dropping his sword at the sight of a snail perched on the tendrils of a minute Flemish Psalter (illus. 13) suggests in this instance an erotic encounter being juxtaposed with the drooping drone of the testicular bagpipe above and a woman's 'basket' being attacked by a ram on the right page. But the same motif cannot have the same playful association with genitalia when found at the edges of a royal charter bearing the seal of Edward III of England.[42] Nor is it a saucy snail that slithers across the choir screen or *jube* that once separated the nave from the choir at Chartres Cathedral (illus. 16). Here, in the corner of an animal panel in low relief, a knight drops his armour and flees from the gigantic gastropod in the top-right corner. Also carved on the west front of the cathedrals of Paris and Amiens, the subject here suggests the vice of cowardice seen as a sin against God. The appearance of such animal *exempla* within

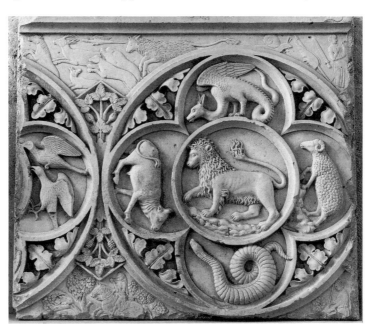

16 Knight flees snail in upper margin. Chartres Cathedral

35

the sacred precincts of the Cathedral itself, alongside more standard bestiary symbols, such as the lion, indicates how common proverbial expressions like 'to flee a snail' (*fuit pour ly lymaiche*) were also visualized as part of the Cathedral's 'Bible in stone'.

But it is important to remember that proverbs, which play an important role in medieval communication as well as in art, are not really 'texts'. Because of their oral matrix as 'sayings', they suggest speech without a speaker, an utterance of universal application that can function with various metaphoric or parabolic associations.[43] The all-purpose utterance of proverbial expression is protean, as opposed to the fixity of written meaning. Just as the proverb has no single divine authority, but is spoken in response to specific situations, marginal imagery likewise lacks the iconographic stability of a religious narrative or icon. The knight and snail motif is drawn in the pattern-book (*c.* 1230) of Villard d'Honnecourt ready to be placed into a variety of contexts, where it will work in different ways and mean different things.[44] The medieval artist's ability was measured not in terms of invention, as today, but in the capacity to combine traditional motifs in new and challenging ways.

PRICKS, PRAYERS AND PUNS

Many of the features Sigmund Freud lists in *Jokes and their Relation to the Unconscious* (1905) as part of 'joke-work' might seem at first quite applicable to images in the margins: their 'peculiar brevity', 'condensation', 'multiple use of the same material', 'double meaning' and 'allusion', for example.[45] Meyer Schapiro, writing under the influence of psychoanalytical theory in the 1930s, saw marginal images as the liberation of unconscious impulses repressed by religion, while, more recently, one scholar has described them as 'like the doodles in student notebooks today . . . the signs of daydreams'.[46] Since conscious and unconscious are exactly the kind of polarized terms – like secular versus sacred – that I have been trying to avoid in this study, how are we to understand the resonance of Gothic marginal monsters as any more than 'free associations', or the return of the repressed?

Many Gothic marginal motifs are not, in fact, scribbled doodles but conventional image types inherited from Graeco-

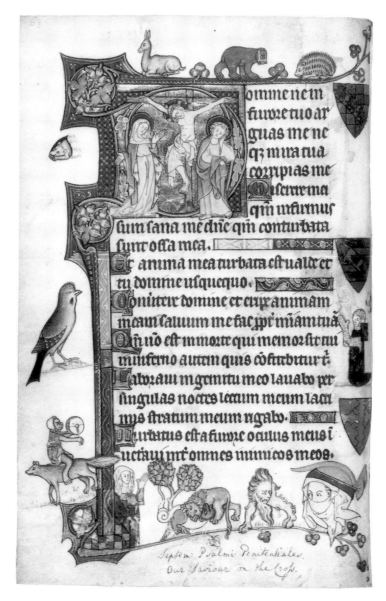

Roman tradition. This is the case with the gryllus – the enigmatic face set upon two legs noted by Pliny that appears in Hellenistic gems and which, perhaps, had an amuletic significance. For medieval people the gryllus came to represent the baser bodily instincts, or 'how the soul of desiring man had become a prisoner of the beast'.[47] In the Seven Penitential Psalms page of the Grey-Fitzpayn Hours, the gryllus is an embodiment of the gaze. His glaring look is returned by

the even bolder stare of a mysteriously coy female head at the bottom right (illus. 17). Does this not echo the words of the text one line above: *Turbatus est a furore oculus meus*, 'My eye is disturbed in anger'? It is important to remember that during the Middle Ages looks could literally kill – the eyes being powerful weapons that emitted rays and which were susceptible to demonic imprints from outside. The perverse looks within this book lead the reader's eye away from the proper focus of desire – Christ crucified in the letter above. Looking towards the life-saving cross are St John and the Virgin within the 'D' and, outside in the margins, the couple for whom this Book was produced, probably as a marriage gift sometime before 1308.[48] Joan Fitzpayn forms part of the angular corner of the lower bar border, her body quartered like one of the family's heraldic shields in the opposite margin, her arms rigid in prayer compared to the curvilinear 'low life' all around her. Richard Fitzpayn is 'higher' in the marginal matrix, and even closer in form to the heraldic signs that legitimate his marriage, title and lands. As well as these political affiliations, the marginal imagery here might well have had specific associations for the couple as they look at the monstrous man and woman glaring so *angrily* at one other. The shaggy gryllus is close to the wildman, a common type in marginal art and exemplary of the rude physical passions, although here he is repelled by the lady's look.

When we look at such pages today, we are apt to see them as charming and view the animal 'vignettes', as they are often, erroneously, called, as humorous, even childlike. Nothing could be further from their purpose. At the top, and juxtaposed with the Crucifixion, a little squirrel squeezes into its burrow. For French-speaking aristocratic readers such as Joan and her husband, small furry animals tended to be euphemisms for the sexual organs. In the fabliau 'De l'Escuirel', a young girl asks 'What's that?' on seeing the male member for the first time. Told that it is a squirrel, she immediately wants to hold it in her hands. In this naming game desire is encoded in innocent signs that are the girl's undoing.[49] The innocent sign in the manuscript page is placed alongside Christ's crucifixion, which acts as a visual pun as a hole in the vellum page while, on another level, as a perverse parallel to Christ's adjacent wound. A popular joke of the age asked which was the 'dirtiest' word in the

Psalter – the answer was *conculcavit*, which combines the word for cunt (*con*), ass (*cul*) and prick (*vit*).[50] Artists were especially attuned to see such sexual syllabic play in the already written text before them. On this page the word *conturbata* perhaps inspired the odd, drooping but phallic turban worn by the female in the lower margin. What we are now in the habit of seeing as unconscious 'sexual' associations are, in fact, quite conscious, although these forms are less conventional parts of the illuminator's repertory than the monkey riding backwards on a fox, a common sign of infamy, in the left margin.[51] The gryllus is, in a sense, a body backwards, since its head is where the other seat of appetite, the belly, should be. We need to remember that medieval people did not think of 'sexuality' in our modern sense of the term. Rather than being 'a central feature of human life', human sexuality was but a further ineradicable trace of fleshly, fallen

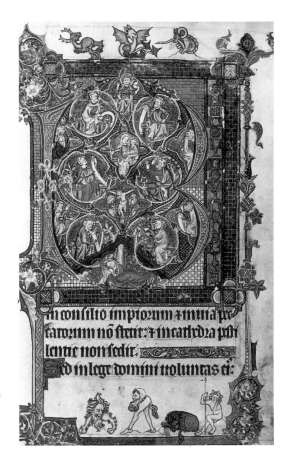

18 The 1st Psalm and 'dirty looks'. *Bardolf-Vaux Psalter*. Lambeth Palace, London

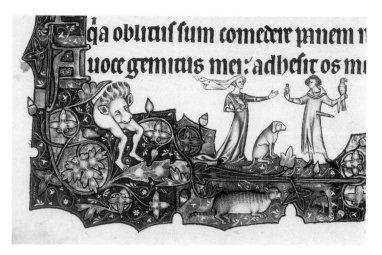

19 A bawdy
betrothal and a
'dirty look'. *The
Ormesby Psalter*.
Bodleian Library,
Oxford

human nature, one of many sins of the flesh that were, for
the soul seeking salvation, expendable.[52] It was because sex
was marginalized in medieval experience that it so often
became an image on the edge.

Exactly the same gryllus design was used by the same
artists at the opening of Psalm I, *Beatus Vir* (illus. 18), in a
Psalter made for another aristocratic family. Here, the same
monster stomps off at the far left while looking back, not at
a woman, but at another arse-head. On the right are a sleep-
ing lion and a seated, naked king. These four figures refer
more directly to the Latin text above: 'Blessed is the man that
walketh not in the council of the *ungodly*, nor *standeth* in the
way of sinners, nor *sitteth* in the seat of the scornful.' This
presupposes that the artists were able to read Latin. Even if
they did not, the strutting pair of monsters might be the
'English' misreading of *In lege domini* as 'legs'. In the medieval
love of etymological thinking, words really were things, and
if two words sounded alike it meant that what they desig-
nated must also be similar. Such textual allusions are not strict
or hermetic, and, I would argue, they are not part of the
official iconography of the book. When the family ordered
this Psalter, they probably asked for a large historiated Beatus
initial and perhaps even stipulated the Tree of Jesse – a popu-
lar image of patriarchal lineage for the nobility. The rest was
extra, and left the illuminators room to extemporize.

In the *bas-de-page* of the Ormesby Psalter's 101st Psalm, the
scandalized look of the gryllus is almost voyeuristic (illus.
19). Here he stares at a 'bawdy bethrothal', in which another

squirrel-grasping lady accepts a ring from a young man – an anti-illustration of 'my heart is smitten' in the Psalm above. In this marginal masterpiece the margins include their own meta-marginal parody further out on the edge. Here, beneath the courtly couple, a fat cat stalks a mouse, reversing the gender positions above, so that the mouse in its hole is beneath the knight whose sword sticks out of his own hole like a phallus.[53] The complex criticism of their encoded eroticism is further annotated by the gryllus here who, watching from the wings, as it were, is an incarnation of scopic obsession – having a head between his legs instead of a prick. His look is an ejaculation.

Exactly the opposite of spontaneous unconscious associations, these examples suggest how medieval artists created marginal images from a 'reading', or rather an intentional misreading, of the text. This conscious word-play, which has not been noted enough, is a very common means of marginal generation. This is the case with what must be the very earliest marginal images, which Carl Nordenfalk discovered in the Registers of c. 1200 of Pope Innocent III. Here, fox-monks and goat-musicians are suggested by certain phrases of the Latin text of the Registers.[54] Similarly, pages of the early Rutland Psalter that scholars have thought of as pure fantasy can also be seen as the artist's poetic licence with the text. A man clutches the stem of the bar-border in pain (folio 14r) as a serpent, terminating the flourishes opposite, bites his foot. The text above is verse 15 of Psalm 9 – 'the heathen have sunk in the pit which they made. In the net which they hid has their own foot been caught'. In the bird-Christ of the Baltimore Hours (illus. 11), and in many other examples, the literacy of the artist is evident.

Even the most doodle-like line-endings and pen-flourishes by one of the artists of the Baltimore Hours might at first look like an example of what Victor Turner calls 'liminoid flow', an action of physiological intensity, a kind of automatic writing in which one plays 'a game . . . by using the rules to generate unprecedented performances' (illus. 20). Victor Turner actually defines one of the fields where 'flow' can take place along with gambling, chess and liturgical action as 'miniature painting'.[55] However, these ghostly blue and red monstricules seem to respond to words in the Latin text, as here the face-footed bird holds a sword below words that

uoniam deus magnus dominus rex
magnus sup omnes deos. quoniam
non repellit dominus plebem suam qa
in manu eius sunt omnes fines tre et

20 A flourisher's doodle. Book of Hours. Walters Art Gallery, Baltimore

describe smiting with the hand. Even this subsidiary pen-flourisher in the scheme is conscious of the text, and is doing more than decorating it. Ironically, the medieval illuminator hardly ever read the text of a work he was formally illustrating – in the case of Bibles or Romances – where he followed earlier copies or models; but on the edge he was free to read the words for himself and make what he wanted of them. In this respect, marginal images are *conscious* usurpations, perhaps even political statements about diffusing the power of the text through its unravelling (the word 'text' is derived from *textus*, meaning weaving or interlacing), rather than repressed mean-ings that suddenly flash back onto the surface of things.

Another important aspect of the way marginal motifs work is not by reference to the text, but by reference to one another – the reflexivity of imagery not just across single pages but in chains of linked motifs and signs that echo throughout a whole manuscript or book. In many manuscripts one can detect thematic links running through sections and gather-ings where specific artists are at work. What is surprising, when one considers that manuscripts were painted while still unbound and out of order, is how often the margins work across whole openings. One of the artists of the Rutland Psal-

42

ter, for example, who seems obsessed with naked men exposing their buttocks to the phallic thrust of arrows and letters, often uses the verso-recto spread. Below Psalm 67 a young male figure bends over to expose his buttocks to the lance of an equestrian monkey on the left page (illus. 21). This might be a play on the word *iuvencularum* on the line above (*iuvenis*, young man, combined with *cul*), but most mysterious of all is the bending figure's striking resemblance to Christ.

One of the earliest, as well as the most haunting, marginal masterpieces, the Rutland Psalter cannot be described as having a 'programme'. There are important illuminated manuscripts that have fully coherent narrative or typological sequences of pictures in their margins, such as the Belleville Breviary or the Tickhill Psalter, as well as Chronicles, like those of the English artist Matthew Paris, with carefully integrated marginal drawings.[56] In saying that marginal image-making is conscious I am not suggesting that it was pre-planned, as were most miniatures. These were produced from instructions written elsewhere, as with the Belleville Breviary, from scribal indications written in the margins or from sketched models, which were often also placed on the page's edges and subsequently erased.[57] It was one area where artists could 'do their own thing', which was, of course, always already somebody else's. Freud describes as a part of 'joke-work' the importance of the appearance of spontaneity, the illusion that the joke has occurred 'involuntarily' – the 'sudden release of intellectual tension' that depended upon its not being premeditated.[58]

Perhaps Freud's most useful point about the psychology of the joke, as regards our subject, is that, compared to the dream, the joke is always socially recuperative. Unless it is shared and we 'get it', it fails. The question is whether people 'got' anything from the strange and, what seem to us, anally compulsive images in the Rutland Psalter? Theorists of the joke, such as Mary Douglas, also stress its socially binding aspect, which makes it 'frivolous in that it produces no real alternative, only an exhilarating sense of freedom from form in general'.[59] This lack of an alternative, the joke's inscription within the *status quo*, is important. It prevents medieval joke-making from becoming subversive. Howard Bloch, writing on the genre of medieval dirty stories, or fabliaux, has argued for their 'essentially conservative impetus', which is 'at once

21, 22 *overleaf*: An anal opening. *The Rutland Psalter*. British Library, London

43

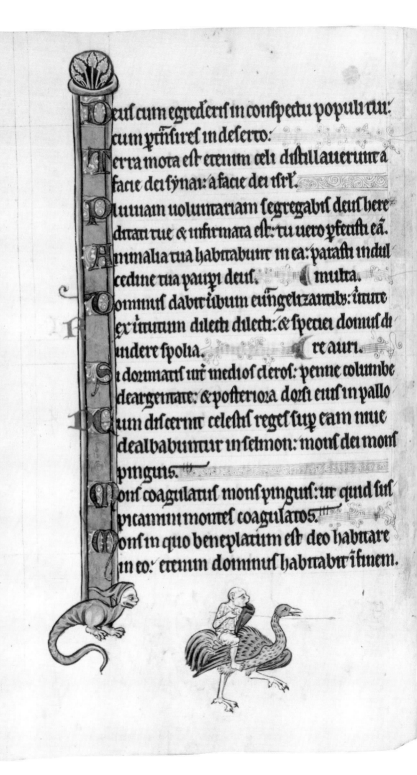

Deus cum egrederis in conspectu populi tui: cum ptïsires in deserto:

Terra mota est etenim celi distillauerunt a facie dei synai: a facie dei isrł.

Pluuiam uoluntariam segregabis deus hereditati tue & infirmata est: tu uero pfecisti eam.

Animalia tua habitabunt in ea: parasti in dulcedine tua pauipi deus. Multa.

Dominus dabit uerbum euangelizantibus: uirtute ex irutum dilecti dilecti: & speciei domus diuidere spolia. re auri.

Si dormiatis inter medios cleros: penne columbe deargentate: & posteriora dorsi eius in pallore auri.

Dum discernit celestis reges sup eam niue dealbabuntur in selmon: mons dei mons pinguis.

Mons coagulatus mons pinguis: ut quid suspicamini montes coagulatos.

Mons in quo beneplacitum est deo habitare in eo: etenim dominus habitabit in sinem.

urrus dei decem milibz multi plex milia leta
tium: dominus in eis in sina in sancto.
scendisti in altum cepisti captiuitatem: acce
pisti dona in hominibz. deum.
tenim non credentes: inhabitare dominu
enedictus dominus die cotidie: ipsum ti
faciet nobis deus salutarium nrorum.
eus nr deus saluos faciendi: & dñs dñs ex
tus mortis.
erumptame deus confringet capita inimi
corum suorum: uticem capilli pambula
tium in delictis suis.
ixit dominus ex basan connitam: conuer
tam in pfundium maris.
t intinguatur pes tuus in sanguine: ling
canum tuorum ex inimicis abysso.
iderunt ingressus tuos deus: ingressus
dei mei regis mei qui est in sancto.
reuenerunt principes coniuncti psallentibz:
in medio iuuencula rum tympanistriarum.

against the law and on the side of the law'.[60] The same can be said of the grylli and other gambolling Gothic creatures, whose bodies seem so spontaneous and free-floating but are tethered to texts which they can 'play' upon but never replace.

NATURALISM AND NOMINALISM

Birds and beasts are better understood through pictures than words (*paintes ke dites*).[61]

The words of the thirteenth-century poet Richard de Fournival introduce us to an aspect of marginal image-making not yet touched upon – its so-called naturalism. At the very same time, marginal art presents us with things that refuse labels: works such as the Grey-Fitzpayn Hours depict grylli rubbing shoulders with specific species of bird and animal (illus. 17). It has been argued that the margins are, in fact, the place where we should seek the beginnings of 'naturalism' or even 'realism' in Western art. An ornithologist has dedicated a whole book to describing the 'accuracy' of depictions of birds in a number of Gothic manuscripts.[62] How can the margins be at the same time conventional and realistic, so natural and yet so monstrous? The assumption often made about marginal animals is that they show a 'love of nature' in the modern, Romantic sense. However, animals and birds were lower than man in the medieval order of things and were there for him to exploit for meat, sport or vellum-making. This, above all, is why they share the margins with the bestial babewyn and the brutish peasant.

The most common type of illustrated book depicting animals was the Bestiary, but in them each beast is framed in a visual stereotype that is as strict as the theological interpretation presented in the text. A more scrupulously observed and 'natural' depiction of the animal world can be linked to Aristotle's works on animal biology, which were being rediscovered and read in the universities. Freedom from convention in the depiction of animals can be seen in a fourteenth-century Parisian manuscript of Albert the Great's work, *De Animalibus*, that depends on Aristotle (illus. 23). It also underlines the division between human and animal depiction, for in this page, in which reproduction is discussed, horses, fish and birds are all copulating in wild aban-

23 Coitus of creatures. Albert the Great's *De Animalibus*. Bibliothèque Nationale, Paris

47

don in the outer margins, while in the letter of the text a man and woman, cut off at the waist, embrace. At the lower right, the serpent splits in two because serpents were thought to reproduce through spontaneous generation. Compared to the animals the two figures are static shades. This was because humans were too bound up with taboos to be viewed with anything approaching visual veracity. On this page Albert remarks that man is the only animal to perform coitus in silence (unlike beasts, with their excited grunts and whinnies), partly out of his consciousness of shame at the act.

The tradition of minute, marginal animal life is best seen in early fourteenth-century English manuscripts, though, as I shall argue in a later chapter, there are political and social reasons for the choice of particular beasts, especially for the landowning and hunting aristocracy. But it was not only the English who were 'nature lovers'. Otto Pächt has published an unusual Italian manuscript, parts of which are now in the British Library, which was made for a Genoese family in the mid-fourteenth century and which has scintillatingly naturalistic margins depicting insects and other small creatures.[63] One page combines two carefully observed species – a camel and a giraffe – alongside a bright red toy-like elephant and a heraldic lion. In between the lines, serpents coil in corrupt self-generation. At the top is evidence of man: a city and a gruesome scene of cannibals having a feast. Here the margins represent the wilderness outside the Italian city state (illus. 27). The artist, like his English contemporaries, was not adverse to combining radically different styles and models, some natural, some totally fabulous, in the same space. Only later, in the fifteenth century, did the space of the margins really become the site of 'nature studies', as people began to define themselves more distinctly against the natural world. Medieval people felt themselves too close to the beasts, like those cannibals that munch on genitalia in this fourteenth-century Genoese manuscript, to see the margins as anything other than the site of their wallowing, fallen co-existence.

THE PREGNANT PAGE

Since marginal art is about the anxiety of nomination and the problem of signifying nothing in order to give birth to meaning at the centre, I want to return full circle to the place where

I began – to the little prayer-book that I called Marguerite's
Hours – where so much proliferates and so little is named.
This manuscript is now actually divided in two. The first half,
containing the Hours of the Virgin, the Use of St Omer and
the Office of the Dead, is in the British Library, London (illus.
14). The second half, with the Hours of the Holy Spirit, other
prayers and vernacular texts is in the Pierpont Morgan Lib-
rary, New York (illus. 24–26, 28). The British Library part once
belonged to that nineteenth-century idealizer of the Middle

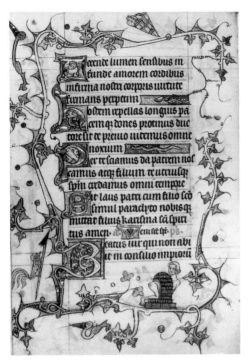

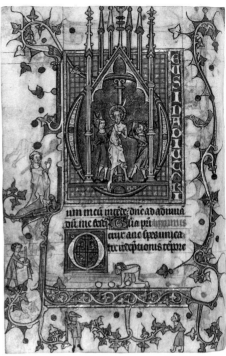

Ages, John Ruskin;[64] one wonders what that Victorian moralist thought of its irrepressible irreverence?

The manuscript is illustrated throughout in a rapid, linear, almost 'cartoon-like' style. Even on non-illustrated text pages there are curvaceous pen-flourishes forming a spidery code that seems a sort of mock-writing (illus. 25). Every element springs into disordered life: line-endings lurch, rabbits run out from behind pen squiggles, hands emerge from holes in the vellum to play catch across the page. In an example of abject mechanical magic on folio 92r, cooking-pots boil and pour water of their own accord, while other household objects dance as they do in the story of the Sorcerer's Apprentice (illus. 28). Alongside the solemn text of the Office of the Dead, skeletons grin and cavort in playful putrefaction. If the narrative of Christ's birth and death told in the sequence of enormous historiated initials throughout the book depicts how the Word was made Flesh, this is reversed in the anti-incarnations of the edge, which are worldly, fragmentary and fleshly.

These images would not have shocked the Franco–Flemish lady who used this book, precisely because they articulated

25 Bum in the oven. Book of Hours. Pierpont Morgan Library, New York

26 Flagellation of Christ and egg/turd-bowling. Book of Hours. Pierpont Morgan Library, New York

27 Creatures and cannibals. Treatise on the Vices. British Library, London

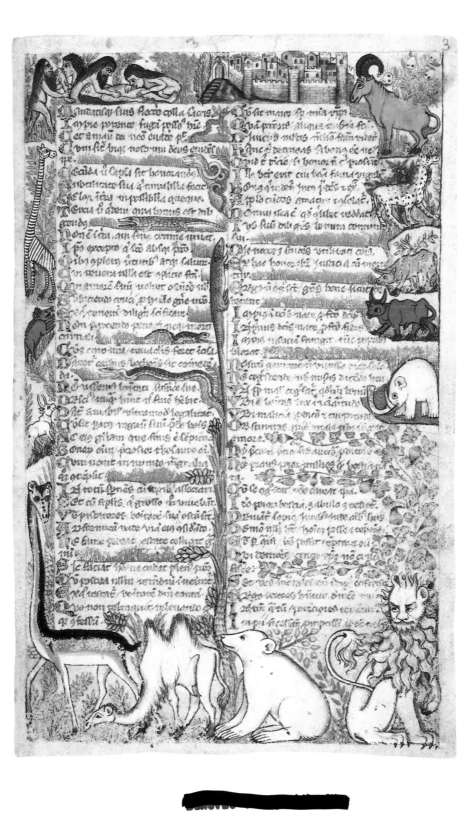

misericordiam tuam; et uistifi
cationes tuas doce me.
Seruus tuus sum ego da
michi intellectum; ut
sciam testimonia tua.
Respice in me et miserere
mei secundum iudiciū
diligentium nomē tuū.
Gressus meos dirige seċū
dum eloquium tuum;
et non dominetur mei omnis
iniusticia.
Redime me a calumpnijs
hominum; ut custodiā
mandata tua.
Faciem tuam illumina
super seruum tuum; et

doce me iustificationes tuas
Vide humilitatem mea; et
eripe me; quia legem tu
am non sū oblitus.
Iudica iudicium meum et
redime me; propter eloqui
um tuum uiuifica me.
Longe a peccatoribus salus;
quia iustificationes tuas
non exquisierunt.
Misericordie tue multe do
mine; secundum iudicium
tuum uiuifica me.
Multi qui persecuntur me et
tribulant me; a testimonijs
tuis non declinaui.
Vidi preuaricantes et
propinquet deprecatio
mea in conspectu tuo do
mine; iuxta eloquium tuum
da michi intellectum.
Intret postulatio mea in cō
spectu tuo secundum elo
quium tuum eripe me.
Eructabunt labia mea
hympnum cum docueris
me iustificationes tuas;

her world. Most people today consider that man is at the centre of an ethnocentric world system, both politically and aesthetically.[65] In contrast, the people of the Middle Ages saw themselves at the edge, the last ageing dregs of a falling-off of humanity, the dissipated end of a Golden Age eagerly awaiting the Last Judgement. Everything was worse not better, everything was mere *imago*, or would be until that great sorting-out at the end of time. This is the space in which Margaret saw herself – mostly alone, but with her husband in Morgan folio 71*v*. The fact that this book was made largely for her use is significant. Women were associated with the dangers of excess, with speaking too much and too loosely, and with the artifices of representation – their fashionable clothes and cosmetics. According to mysogynistic medical discourse, their bodies overflowed their boundaries and they could infect others with their venomous menstrual looks. During conception, in Aristotle's opinion, man provided the animating spirit, while woman gave only the material form of the foetus.

Perched between grace and garrulousness, in a world infested with material monstricules and simian signs, Margaret is pictured as pregnant on some pages (illus. 26). This is not unusual, since women of her years were pregnant most of the time. Margaret, who appears specially highlighted in an illustrated French poem in this book, was the patron saint of childbirth, and a prayer on folio 126 specifically calls on this saint's protection of all those who are 'enceinte'. I wish I could believe that this book was made for Marguerite de Beaujeu, wife of Charles de Montmorency, as some writers have suggested. Seven years after her marriage in 1330 she died in childbirth, aged twenty-six. But there is no heraldic or other evidence to place it firmly in her sickly hands.[66] The Margaret pictured in this book was, I believe, not a member of the aristocracy but a wealthy bourgeois from a thriving Franco–Flemish centre, such as St Omer. Even though we cannot locate its patron, we can see this book as 'engendered' in more general ways.

Having children was the major job of all classes of women in the Middle Ages, and the margins of this book are full of references to fecundity and birth. A youthful gryllus plays bowls with the eggs he has just laid below the patron's swelling figure, as she kneels outside the scene of the Flagellation

(illus. 26). There is an exceptionally explicit image in the very top margin of one folio, of a naked man on top of a naked woman, his anus threatened by the gold beak of a red bird (illus. 24). Although the man's head is aimed at her *con*, oral sex is rarely pictured in medieval art or even mentioned in the fabliaux. This man is actually diving back into the womb in an 'anti-illustration' of Psalm 87:5 just below – 'this man and that man were born in you. The habitation of all delights is within you'. The phallic bird is perhaps an aberrant vernacular reading of the first words on this page, *'vitas dei'* – speaking these prayers aloud makes the first syllable a 'prick'. Birds are associated with sodomy in the fabliau in which a seducer promises a young girl that by copulating – with him entering her from behind – they will 'make a bird'. In another *bas-de-page* 'illustrating' Psalm 1, the *impiorum*, or ungodly, of the text is the trickster Marcolf exposing his bum in the oven, as he does at the end of the popular tale (illus. 26). His anus is indistinguishable from the many fascinating rectums paraded by monkeys throughout the book. The heads in the basket above allude to those of the souls of illegitimate infants carried to Hell on Hellequin's back in another popular legend.[67] Every tendril is spiky and sharp, the cock and spear and another beaked bird alongside evoking more dangerous penetrations of the ductile body.

Margaret herself is so often depicted that she appears to change shape, costume and size, sometimes swelling up larger, sometimes elongated and emptied (illus. 14 and 26). Pregnancy has been called 'an image of natural grotesqueness'. St Jerome referred to a woman with child as a 'revolting spectacle'.[68] In sexual intercourse, pregnancy and menstruation, women broke out of their boundaries. Theirs became the Bakhtinian body that is 'never finished, never completed; it is continually built, created and builds and creates another body'.[69] The pages of this book are pregnant in the sense that they teem with gynaecological promise even within the detritus of fallen, decomposing life.

The inscription of a woman's body within the margins of this fourteenth-century illuminated manuscript never ceases to take my breath away. In post-medieval image-making, the rules laid down by the academy, self-censorship and audience taste delimit the collusion of the refined and the instinctual, the mind and the body. Moreover, different styles became

associated with a hierarchy of genres. These barriers between high and low culture have, until the advent of Postmodernism, simply not allowed the confrontation of such radically discrete image types as we find counterposed in this book. The Thirties' animated cartoon character Betty Boop and the works of Constantin Brancusi cannot coexist within the same frame (even though formally the two are quite similar). The soul of the cartoon character under capitalism is relegated to a Purgatory of the popular, whereas even the most shocking of babewyns and grylli – who are, I would argue, Betty's ancestors – could play within and against the most elevated and transcendent forms. Formalist dichotomies that separate the look of 'art' from 'popular imagery' did not exist during the Middle Ages. All forms were equal. Only their position gave them authority. This was what worried the early medieval author of the *Libri Carolini*, who asked how was one to distinguish between the Virgin and the ass in representations of the Flight into Egypt, since both are made of the same colours?[70] Similarly, it is perhaps the greatest irony in Marguerite's Book of Hours that the illuminator's quirky pen-lines and curves circumscribing the revered visages of Christ and the saints are indistinguishable from – indeed, they are the same as – the squiggles that suggest a monkey's bum.

2 In the Margins of the Monastery

A boundary separates two zones of social space-time which are *normal, time-bound, clear-cut, central, secular,* but the spatial and temporal markers which actually serve as boundaries are themselves *abnormal, timeless, ambiguous, at the edge, sacred.*[71]

According to the twelfth-century monastic writer Peter of Celle, 'the cloister lies on the border of angelic purity and earthly contamination'.[72] From the eremitic austerity of the early Desert Fathers to the written Rule of St Benedict, living the enclosed life meant 'being a stranger [*alienum*] to the deeds of the world' in a zone of sacred liminality, likened to both death and being in the womb. After a millennium of distrust of images in the round, the revival of monumental sculpture in the massive Classically inspired forms that we usually call Romanesque took place in monastic communities throughout Europe in the eleventh and twelfth centuries. But whereas in the ancient world triumphal arches and amphitheatres articulated the centrality of imperial rule, for medieval people they became gates and passageways between psychological, rather than political, states. Romanesque art is one of entrances, doorways, westworks, narthexes, porches, capitals and cornices. As well as articulating boundaries and limits for those existing within, those persons outside the Church were also addressed by these powerful images, notably pilgrims who had similarly renounced the world for a short period of wandering as they travelled towards the *stabilitas* of the sacred centre.[73]

GOD'S ACROBATS: ST BERNARD AND THE JONGLEUR

One of the insights of Christianity, and not the least one, is to have gathered in a single move perversion and beauty as the lining and the cloth of one and the same economy'.[74]

The cloister of the Benedictine Abbey of La Daurade in the centre of the *cité* of Toulouse, with its thriving mercantile

and secular culture, was a place where ritual purity came up against worldly corruption, where inside and outside were strongly counterposed. The monastic buildings were destroyed in the early nineteenth century, but the Abbey's remarkable series of single and double capitals, from two phases of work undertaken during the opening years of the twelfth century, still survive in the Toulouse museum. Scholars have related them stylistically to the cloister of Moissac, and reconstructed the Passion narrative of the whole programme in a way that invites a systematic 'reading' in terms of monastic spirituality.[75]

The capital on which I want to focus depicts the Transfiguration in Matthew 17, the moment when Christ reveals his divinity before the prostrate disciples. The carver has stretched the narrative around three of the faces, forcing the monastic viewer to move around it, just as he perambulates around the cloister walk itself (illus. 29). The first face bears the diagonal inscription *Transfigurationis*, like an introductory rubric announcing the subject-matter that unfolds as we move from left to right (the usual direction of reading). The next face shows Christ standing in the centre of the field, once more gesturing to the right towards the prophet Moses, who curves around the corner. On the third face is the second prophet from the Transfiguration scene, Elijah, while the rest of the field is taken up by a city, which acts as a 'full stop' or closure device. The fourth face represents a different New Testament scene – that of Doubting Thomas placing his finger in Christ's wound (illus. 30).

What makes this capital unusual is that on the strip-like impost along all four sides is a series of marginal representations depicting ludic activities: men wrestling, playing musical instruments, board games and somersaulting, their movements starkly contrasting with the planar, angular forms of the larger figures below. They represent the world of secular pleasures outside the monastery. These very pastimes – theatrics, dancing and lude song – were frowned upon by monastic writers in this period, who referred to these performers on the margins of medieval society as *histriones* and *gesticulatores*. Monks were warned not to become *gyrovagi* (literally gyrators), but to remain fixed and upright in their commitment to God, in contrast to the worldly exhibitionists, who are most often called by their vernacular name

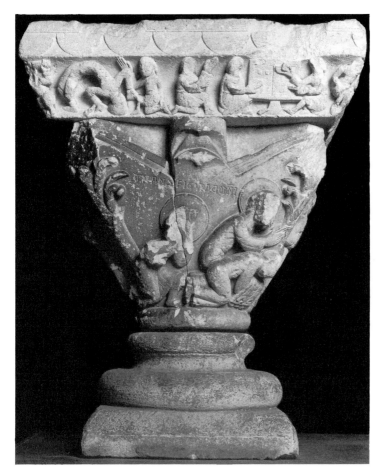

29 Stone capital with Trans-figuration on face and games on the impost. Musée des Augustins, Toulouse

jongleurs.[76] Documents record a jongleur named Pelardit living in twelfth-century Toulouse who was so admired that a street was named after him. In 'official' Romanesque representation such figures are always placed 'outside' the sacred, as in an archivolt of the Church at Civray where a tumbler and musician are flanked by two noble-looking spectators who, in the eyes of the clergy, were just as damnable for watching (illus. 31). The Cistercian Bernard of Clairvaux refers to gesticulating bodies like those on the Toulouse capital in one of his letters, but literally turns the idea upside-down to make a parallel between the contorted body of the acrobat and that of the monk:

> I say it is a good sort of playing in which we become an object of reproach to the rich and of ridicule to the proud.

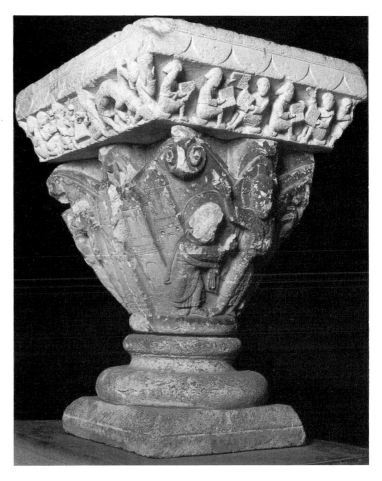

30 The fourth face of the same capital. Incredulity of St Thomas on face, men with books on impost. Musée des Augustins, Toulouse

In fact what else do seculars think we are doing but playing when what they desire most on earth, we fly from; and what they fly from we desire? Like acrobats and jugglers (*ioculatorum et saltatorum*) who with their heads down and feet up, stand or walk on their hands, and thus draw all eyes to themselves. But this is not a game for children or the theatre where lust is excited by the effeminate and indecent contortions of the actors, it is a joyous game, decent, grave and admirable (*iucundus, honestus, gravis*) delighting the gaze of heavenly onlookers.[77]

The theatrical or performative metaphor was a powerful one in the dynamic rituals of the monk's life. Peter of Celle described the discipline of the cloister as a 'spectacle for God, the angels and men'. But it was a spectacle of static gestures,

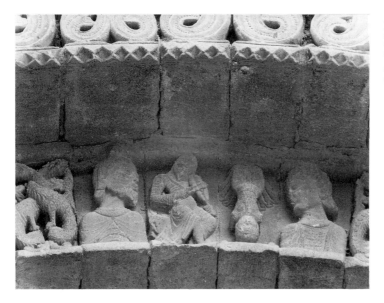

the cyclical repetition of the liturgy, whose hieratic position and sacred *ordo* was totally at odds with the quick movements and mimicry of the jongleur. The carver of the Toulouse capital is playing on the juxtaposition of the sacred drama with its worldly counterpart above, reversing our expectations of the sacred being 'higher' than the secular. This forces us to compare and link the two gestural systems. Christ's Transfiguration is confronted by another transfiguration in which the body is distorted rather than deified, the flesh revelled in rather than transcended.

The fourth face of the capital, with its scene of Christ appearing to St Thomas, adds, through its meta-marginal addition, another dimension to the way the monks would have read this capital (illus. 30). As a scene of doubt dispelled by witnessing and touching the very flesh of the Saviour, the subject was especially popular in monastic contexts. It appeared for a second time at La Daurade in a simpler composition and, further south, on the pilgrimage route to Santiago, in the famous cloister of S Domingo de Silos. But once again, what happens at the edge alters our perception of this subject. At the very moment when truth is tested and Thomas puts his hands into the flesh of Christ, we look up to the impost to see not a continuation of the gambling, chattering and dancing, but a group of men reading. Have they found the truth in the Word, just as below them the doubts of Thomas

are dispelled by the proof of Christ's presence? Is the carver playing here on the association of flesh in the form of parchment and the humanity of Christ's passion? The gesture of the raised right arm is echoed in the top-right figure, as if to underline the revelation of the Word made flesh in Christ and the Word made flesh in the pages of the Scriptures. If the previous three faces of the impost had shown the worldly pleasures of a different fleshly set of concerns, why does the focus change here to depict the revelation through reading?

On the far left sits a solitary figure engaged in private *meditatio*; to the right sit two groups whose members, reading aloud to each other, seem to be in *disputatio*. Illegible characters can be made out on the open pages. Are the gesticulations of the figures meant to ring as negatively as those of the gamblers on the other face? Peter of Celle stresses that monastic *lectio* should avoid being vain and garrulous – '*vana et garrula*' – but should rather be focused inward upon the soul.[78] The little figures, moreover, are not tonsured; some seem distinctly non-monastic in their dress. Why are laymen shown reading in the monastic cloister? These books are being used in a way alien to monastic *meditatio* and closer to the intellectual argument of the schools and the secular courts, where, along with singing and dancing, reading was a pleasurable diversion. For the monk the book was pre-eminently a tool for inward contemplation, not a toy to be played with, as is the case here. The similarity between the gesticulating gamblers and the same type of animated figure poring over his text on the Toulouse capital, makes implicit this analogy between certain kinds of play and certain kinds of reading, as opposed to those that should animate the rhythms of the claustral life. Just as the monk might find an important marginal gloss in his reading or *meditatio*, here is a text and gloss in stone.

READING THE RIDICULOUS

What is the point of ridiculous monstrosities in the cloister where there are brethren reading – I mean those extraordinary deformed beauties and beautiful deformities? What are those lascivious apes doing, those fierce lions, monstrous centaurs, half-men and spotted pards, what is the

meaning of fighting soldiers and horn-blowing hunters? You can see several bodies attached to one head, or, the other way round, many heads joined to one body. Here a serpent's tail is to be seen on a four-footed beast, there a fish with an animal's head. There is a creature starting out as a horse, whilst the rear half of a goat brings up the rear; here a horned beast generates the rear of a horse. Indeed there are so many things, and everywhere such an extraordinary variety of hybrid forms, that it is more diverting to read in the marble than in the texts before you, '*ut magis legere libeat in marmoribus quam in codicibus*', and to spend the whole day gazing at such singularities in preference to meditating on God's laws.[79]

One of the best-known statements about art in the Middle Ages, this scintillating passage by St Bernard is contained in his letter of 1135 to another Cistercian, Abbot William of St Thierry. Here again is the notion of 'reading' images, but vociferously condemned as the eruption of the worldy within the supposedly otherworldly zone of the cloister. It has often been noted that in this passage St Bernard delights in what he seeks to denounce, rhetorically amplifying and aping the combinative antithetical forms of the sculptor in his own rhetoric. His point about distraction from the text is surprising, considering that early twelfth-century manuscripts, some of them Cistercian, often incorporate the same deformed forms into initials (illus. 32) and a number of early Bestiary manuscripts have a Cistercian provenance.[80] But it is the metaphor of 'reading' in images rather than in books that is most striking, since it suggests investing marginal imagery with the time and space of meaning. To understand the power of this metaphor we have to realize what reading meant in the life of the monk.

Reading meant speaking words aloud. Remember how Peter the Venerable complained when suffering from tonsilitis, that not only was he unable to preach, he was also unable to read! A second important point is that the same texts were read over and over again. Rote repetition also aided the monastic reader in memorizing whole passages of text. This also led to a multi-layered approach to interpretation in which one object, as St Bernard stresses in his Commentary on the Song of Songs, can point to a multitude of metaphoric signifi-

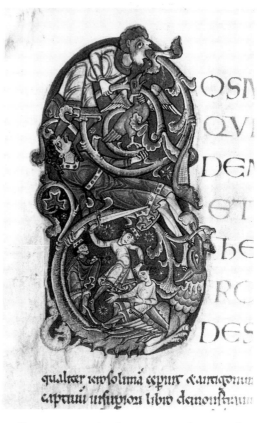

32 Initial 'S' with Cain and Abel and eater. Josephus' *Antiquities*, by the scribe Samuel. St John's College, Cambridge

qualiter iurofolimá cepiut &uriuqpuun
capruui iufiupiou libio denouftruun

cations. Spiritual writers were not adverse to using secular metaphors for sacred things in ways that made them more memorable and striking – the 'dissimilar similitudes' described by the Pseudo-Dionysius. Peter of Celle's treatise, *c.* 1145, on the monastic life compares the cloister to an athletic stadium, the cross, a treasury, a royal chamber and even a market in a series of extended allegories. His text is a good example of the way the monk was taught to think in terms of analogies, human and vegetable – analogies that help us see how they might 'read' what to us seems a strange jumble of images and creatures.

Peter actually treats 'reading' in a separate section and calls it 'a rich pasture where animals large and small . . . by interior rumination on the divine flowers of the Divine Word retain nothing else in their hearts and mouths'. The mouth is an ambivalent part of the body, being the site of both speech and mastication. The monk was meant to feed not on the flesh of animals but on the Word of God in a muscular mastication –

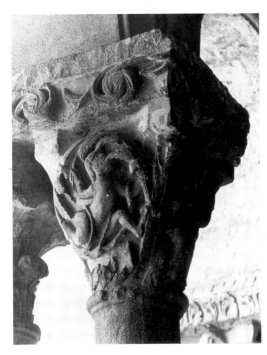

a *ruminatio*, so-called, that released the full flavour or meaning of the text.[81] The savour of the text, chewing on its succulent meanings, is a metaphor that can be traced from St Augustine onwards. The vocabulary of the digestive process makes especial sense in relation to the monastic links between eating and reading, especially in the refectory, where the two went together quite literally. It is striking in this respect how many twelfth-century initials (illus. 32) and cloister capitals (illus. 33) allude to the bite, the chew or the swallow. Dragons, humans, mermaids, fishes eat all kinds of things; vegetables and animals are not simply jumbled together but actually bite and digest one another, sometimes even themselves, in spiralling orgies of autophagia. Their oral gratification has, however, a spiritual aspect in that these were literally eaten in *meditatio*. This is an example of where forms that appear to us as merely 'deformed' for the sake of it, actually resonate with the spiritual experiences of the monastic audience. These images of *ruminatio* also contrast starkly with the more violent images of teeth tearing flesh carved on the exterior walls of Romanesque churches.

St Bernard's condemnation of cloister imagery actually suggests that as signs in the site of reading, such 'deformed

forms' could 'teach' as much as any narrative or saint's Life in stone. Victor Turner describes how Ndembu tribal initiates are taught the violation of taboo by rites in which monstrous masks are used to distinguish different levels of reality. Did deformity similarly define form for the monastic novice looking at these sculptures? An awareness of how such images sparked the imagination, or what twelfth-century authors called the *phantasmata*, or fantasy, can be observed in Peter of Celle's warning, invoking the commandment in Deuteronomy 5:8, against not only looking at images but even thinking of them:

> The painter's fingers must paint within the round circle of [the Law]. And first one should notice that the Law does not teach what or how you should paint, it only prohibits what you should not paint The historical sense of this commandment is to be observed to prevent our being preoccupied with those vanities or that tablet of the inward imagination, at the moment it should enter into contemplation, being found decorated with imaginary images from a likeness of shamelessness or any worldliness perceived in a sculpture of stone or wood or iron . . . the Law prohibited not just the reality of these things (the desires of the flesh) but even their likeness.[82]

In Romanesque, as in later Gothic, art (see Chapter 3) the realm of marginal monstrosity is irrevocably linked with the capacity of the human imagination to create and combine. What is most surprising is the obvious delight taken in the space of the imagination, in 'reading' the ridiculous in Romanesque art. Here the artist did not limit himself to making images 'within the round circle of the Law' but purposefully stepped outside it in order to define its limits.

AMBIVALENT ANIMALS AT AULNAY

> While he [Ysengrimus the wolf] was attending to these words, the crafty Becca [the sow] leaped upon him and tore off his left foot – 'I rejoice, and I want you to rejoice with me friends! Our friend isn't going anywhere today.' . . . Ysengrimus fell to the ground on his face, as if about to pray, and Salaura [the sow] came up asking meekly: 'I

beseech you to pray for me too my lord abbot . . . receive this token, so that by it, at least you'll remember me' – and she bored through his detested side and gouged out his ruptured liver.[83]

34 Carnival of animals, Elders of the Apocalypse and saints. Church of St Pierre, Aulnay-de-Saintonge

Of the four archivolt bands that curve over the small south door of St Pierre at Aulnay-de-Saintonge in the west of France, the outermost represents a mysterious procession of animals clawing and biting at each other as they parade east and west from the centre on various legs, paws, claws, talons, tiptoes and slimy undersides (illus. 34). Some of these figures, each carved into a single voussoir block, are recognizable even today, especially on the west side, where an ogling cyclops greets a griffin, a centaur shoots his arrow at a deer and the harp-playing ass struts on its hind legs. Towards the east – the direction of the sacred, and geographically the realm of monstrous Marvels – the creatures combine more confusedly. Indeed, they seem to have been carved in the process of becoming something else. A bearded man turns into a bird; one beast spews out another and is beaten by a

figure who is about to be eaten whole. A kind of mock-Jonah, this kind of sign does not belong to the Christian schema of bodily rebirth, however, but to an older strata of nightmare, where the difference between man and animal is indistinct. While ambiguous things cannot be defined in terms of any specific category, things that are ambivalent belong to more than one domain at a time, and it is ambivalence that I wish to explore on the outside and in the interstices of Aulnay.

Founded by the Cluniac abbey of St Cyprien of Poitiers, under whose jurisdiction it remained until 1119–22, the church of Aulnay-de-Saintonge was itself a marginal structure, later owned by the cathedral chapter of the same city. Arthur Kingsley Porter described it as a pilgrimage church and stated that 'More exquisite drollery than that of the outer voussoirs has rarely been attained. Grotesque art can go no further'.[84] At the limits of the building are the outer limits of form.

It is worth comparing these archivolt carvings with those of the central west door of the same building, where Virtues trample Vices and a strict vertical hierarchy of higher good over lower evil pertains. Here the centralizing axis places God in the middle and has the Virtues radiate from Him in the third archivolt. There is, by contrast, no centre in the south doorway, no Christ or Trinity, only a dragon-like creature that pulls itself into two, a convolution that sets up the two dissolute axes of movement. This bestial infestation swarming from the centre has no strict sequence, unlike the outermost archivolt of the west doorway, which is a sequence of the Months from left to right. As against calendrical Nature – that is, Nature we can read (from left to right), and controlled by God's cosmological pattern – the outer voussoirs here depict an untamed degenerate Nature, where putrid infestation gives birth to new forms, and violence, not order, prevails.

To look from all this difference and multiplicity down to the static, seated Elders of the Apocalypse below is to move from chaos to order. The repeated identical poses and attributes make the human conform to a hierarchy of rigidity and frontality, unlike the bestial transformation above. Below the Elders groups of Apostles communicate with one another more animatedly, but still stress the power of the *Logos* in

their talking gestures. These two bands seem to emerge from the shadowy darkness of the church's interior, whereas the uppermost band projects out into the world of action. The Divine is also upheld architectonically by a series of repeated Atlas figures, half-hidden in shadow beneath the Elders and Apostles but carved from the same block. Two very different processes of sculptural production are here articulated. In one the carver follows identical templates on the block, in the other he seems to experiment with splitting and undercutting the stone into its sharpest and most convoluted forms, and is able to transform it into fur, scales or hair. Compared to the routine, more coarse, carving of the Apostles and Elders, the monstrous rout seems to have been produced by a more expert sculptor, suggesting a scale of value that did not elevate the Divine archetype over the debased animal.

Jaws are everywhere, snapping, biting and pecking, not only at vegetation and other animals but even the self. Two facing figures seem to be copulating, or one is about to gorge on the other. Even the most famous group, which depicts a parodic liturgy enacted by a ram-Bishop (his horns punning on the *cornua*, or Bishop's mitre) with a sheepish sub-deacon holding the book, is an oral act (illus. 36). The sheep holds up his own flesh in the form of the book, his jagged teeth brush its edges, enacting another more metaphorical form of autophagia. Here one might think there is no 'text' for these marginal forms to play upon, but this is to forget the activated text of the Word made Flesh in the liturgy performed inside.

The question of what such animal antics were meant to signify perturbed some medieval churchmen as much as modern commentators. For the Spanish Bishop Luke of Tuy, 'animals, birds and serpents and other things' were pictured in the church 'for adornment and beauty only'.[85] Hugh of St Victor thought that only monks 'who dwell in cities' where 'crowds of people resort' should have recourse to images, and that 'those of us who are pleased with solitude prefer a real horse or an ox, useful in the fields rather than on the wall'. Similarly, the Cistercian Ailred of Rievaulx, writing not long after St Bernard's celebrated complaint, described how in 'the monastic cloister we see cranes and hares, deers, stags, magpies and crows', which he thinks do not accord with monastic spirituality but are more like 'the amusements of women'.[86] For another English Cistercian writing towards

the end of the twelfth century, depictions of animals and fables in churches were inappropriate, since it is the 'criminal presumption of painters that has gradually introduced these sports of fantasy'.[87] These clerical pronouncements suggest that such carvings were, as well as being 'effeminate' in their excess and superficiality, the sole inspiration of the sculptors working outside ecclesiastical controls. But surely there was supervision of itinerant craftsmen by the patrons of an expensive building project like Aulnay? Recently the mysterious corbel sculptures of the church there have been described as 'autonomous' elements created by secular masons in resistance to the Church and representing their own popular culture, which again suggests that the sculptors were working independently.[88]

The animals at Aulnay are neither meaningless decorations nor reflections of 'popular culture' outside the Church in which the clergy did not participate. Latin literates were part of a broader culture than we tend to think when we separate the religious from the secular. Moreover, monasteries housed many lay brothers from the local community who were illiterate and did most of the manual labour. The animals at Aulnay are the fox, ass, wolf and sow of popular fable, but also its monastic permutations. They do not illustrate a particular narrative or text, but their arrangement is reminiscent of parodic animal fables circulating in the oral tradition. Scenes of 'Ysengrim et sa fame' were painted on the walls of monks' cells, according to Gautier de Coincy.[89] In the mid-twelfth century a monk of Ghent wrote a Latin poem, *Ysengrimus*, which concerns the antics of a greedy wolf who is a bishop as well as the abbot of monasteries full of 'fat and gentle sheep'. This upside-down world of bloated bodies, gobbling and guzzling carnivores (the wolf ends up being eaten alive by the piglets of the sow-goddess Salaura) includes a marvellous mock-pilgrimage of animals:

Bertlina the roe, together with her companions, was eager to visit some places of pilgrimages, out of a desire to pray there. At first unaccompanied she later acquired seven companions . . . Rearidus the stag, the leader against a dangerous enemy, wore bristling armour on his many-branching head; Brefridus the goat, and Joseph, leader of rams, offered the same protection to the band with their

weapon-bearing foreheads. Carcophus the ass, fit for bear-
ing burdens, took his name from the nature of his duty;
Reynard had the leadership, gave orders and prohibitions;
Gerard the goose whose function was to keep watch . . .
Sprotinus the cock, time-keeper . . .[90]

35 Corbel
creatures. Church
of St Pierre,
Aulnay-de-Saintonge

This heavily armed bank of violent and greedy creatures is a
comment on the contemporary craze for pilgrimage and its
association with the Crusades. At Aulnay the monks might
indeed have associated the representions on the south door
with the vulgar rabble that came through on their way to
Spain – layfolk, in clerical eyes, being no better than beasts.
As the *Carmina Burana*, another collection of clerical ditties,
puts it: 'The illiterate man is like a brute / Since he to art is
deaf and mute.'[91] However, just as in the Latin poem, many
of the beasts satirize clerical rather than lay abuses. The
horned bishop's mock mass and the harp-playing ass were
critiques of ecclesiastical illiteracy and greed, to which many
of the pilgrims must have pointed with relish. For medieval
audiences different animals had different class associations;
they could refer both up as well as down the social scale and
to those both outside and inside the monastery.

The use of animals in Romanesque art is also significant in
terms of the way we think of animals' names as terms of
abuse, as ways of marking boundaries between clean and
unclean.[92] Animals, according to theologians, cannot exist
without their bodies, having no souls and not being included
in God's salvatory plan. In this respect they are flesh incar-
nate. Yet, at the same time, people related to them in ways
different from our anthropomorphized Disney fetishism of
today. For example, they could be tried, tortured and
executed as criminals, as was a pig by the monks of an abbey
at Fontenay-aux-Roses near Paris in 1266.[93] More pertinent
to the mingling of human and animal bodies in the Aulnay
example is the ubiquitous crime of bestiality, which, the Peni-
tentials of Confessors tell us, was a common practice in a
culture where people lived and slept alongside their beasts.
For such 'abominations', animal and human miscreants were
burned or hanged together as punishment. One of the most
powerful statements that the monstrosities of marginal art
make is that they violate the taboo that separates the human
from the animal. Christianity held it essential that man and

36 Mock Mass.
Church of St Pierre,
Aulnay-de-Saintonge

nature were 'discontinuous', but marginal art constantly mixes them up.

Unlike the cloister, the exterior of the Church was not part of the sacred space, it was the junction with the world. The exterior at Aulnay is a noxious cartiledge – infested, crawling with legions of slimy and furry vermin on its corbels, window splays and corners, and sprouting from shadowy corbels (illus. 35). This idea of placing grinning demons and other forms, mostly heads, along the upper walls as supports for other members, is deep-rooted in ancient history; in the North it is related to the Celtic custom of worshipping decapitated heads. The body was, after all, the first human building; the corpse literally became the dwelling-place from where the spirits of evil could be expelled. The human head, the most basic of all human images, is also the most dangerous, and its apotropaic use, along with the evil eye, was widespread in pre-modern culture. The Latin *Ysengrimus* even describes placing the disembodied head of an animal over a doorway for protection. This is not to be thought of as a 'popular' superstition however, but as part of a set of beliefs shared by the monks as well as by their lay audiences. For those whose bodies and souls had been promised to God, such protection was even more important.

Another Cistercian, Caesarius of Heisterbach, recounts how the enemy is always lurking in the shadows, ready to disrupt the monk's life and, especially, to try to invade the most sacred inner spaces around the altar. He relates how an anchoress saw demons in the form of monkeys and cats sitting on the backs of monks in choir mocking their gestures, how bears materialized in the presbytery crying with a human voice, and how grunting pigs scurried around a monk who fell asleep during mass.[94] Demons not only interrupted liturgical services, they also sought to terrify the monks and nuns when alone at their private *meditatio*. As the twelfth-century anchoress Christina of Markyate was reading her famous and still extant Psalter, 'toads invaded her cell to distract her attention by all kinds of ugliness from God's beauty'. According to her biographer:

Their sudden appearance, with their big and terrible eyes, was most frightening, for they squatted here and there, arrogating the middle of the psalter which lay open on her

lap at all hours of the day for her use. But when she refused to move and would not give up her singing of the psalms, they went away, which makes one think that they were devils.[95]

This story suggests a wholly new way of thinking about the slithering things coiling around the letters and framing the pages of twelfth-century manuscripts (illus. 32).

Such fears of infestation might be seen as psychological manifestions of the repressive rigours of the monastic regime, but they are also embodiments of alimentary codes and taboos. The repeated images of biting in stone and in paint surely served as admonitions against the flesh of both human and animal kind. Monks were meant to abstain from meat, which was thought to arouse animal desires. In his religious handbook, the *Jewel of the Church*, Gerald of Wales describes how a certain abbot had to write to the Bishop of Le Mans 'concerning a strange apparition and unheard of defilement'. Every time a young brother in the monastery tried to pray, an evil spirit 'places its hands on his genital organs and does not stop rubbing his body with his own until he is so agitated that he is polluted by an emission of semen'. The Bishop is informed that the young man is a virgin and has never eaten cooked meat. The remedy involves further fasting and pressing a crucifix on 'those members over which the enemy dares (beyond belief) to triumph'. Such a genital-oriented monster is carved at Aulnay next to the mock mass (illus. 36), and there are countless images of male and female genitalia in twelfth-century sculpture.[96] If we are tempted to think of the monastic life as a tranquil haven, the story of the nun at Watton told by Ailred of Rievaulx is a reminder of the violence that met monastic sexual offenders. The pregnant nun was forced to see her lover 'brought in as for a spectacle', to castrate him and then to have that 'part of which he had been relieved' thrust into her mouth 'befouled with blood'.[97] Before we rush to see 'sexuality' in the cloister we should be aware that for the medieval monk sexuality was, in Peter Brown's words, not a basic instinctual drive but secondary to

> colder drives that lured the human person into collusion with the demonic world. . . . They lay deeper in his iden-tity than did sexual desire. . . . Sexual dreams and sexual

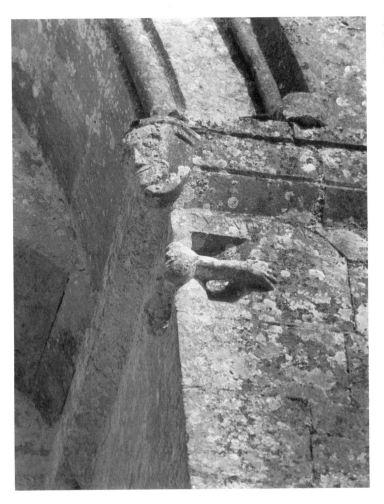

temptations betrayed the tread of far heavier beasts within the soul – anger, greed, avarice and vainglory.[98]

Gerald of Wales concludes his story of the masturbating novice with a description of monastic life as 'an arena in which the conflict is always imminent . . . a struggle which for us is against "principalities and powers, against the rulers of the world of darkness, against the spirits of wickedness in high places"'.[99] For monks and other enclosed religious groups, those in 'high places' could, of course, mean the secular powers of the world, but it also referred to the demons of the 'otherworld' portrayed on the outer walls of Romanesque structures. The exterior 'high places' of Aulnay are literally incrusted with evil forms, not only kissing couples, priapic

men and deformed monsters but plants, herbs and animals, that serve to visualize a realm of otherness at the edges of things. By contrast, the interior is a smooth space of austere columns and calm unfigured spaces. Only a group of historiated capitals with mostly religious subjects breaks an essentially abstract space, a vessel for contemplation from whence all evil has been expunged. In the rites of exorcism the Bishop would have expelled demonic spirits from the sacred space, literally cleansing it in a ceremony of consecration and alphabetic inscription in which he inscribed the Greek and Roman alphabets from one corner of the building to another. The external corners are articulated with mysterious and fragmentary signs of semi-human attention (illus. 37). At Aulnay the margin is not a two-dimensional band but a three-dimensional space enclosing the whole church like an undulating, ulcerous skin. The 'body' metaphor was commonly used for the Church and was especially resonant for the monks, for whom every belch and rumble in the stomach signalled an invasion of their bodies. Just as the mouth and other orifices, such as the eyes, had to be kept guarded against the onslaught of evil, the entrances, doorways and windows at Aulnay are those most entrusted with the protective gaze of deformed forms. They are a means of animating the building. Providing both a locus of protection and one of fascination (meaning to be bewitched by a demon or look), the Romanesque monster was a stable point of reference from which the monk could define where he stood in relation to those always imminent 'others'. For persons who sought to 'read in the marble', whether they came from the cloister or from the world outside, the image on the edge was just as important as, and in certain senses more easily understood than, the ineffable signs at the centre.

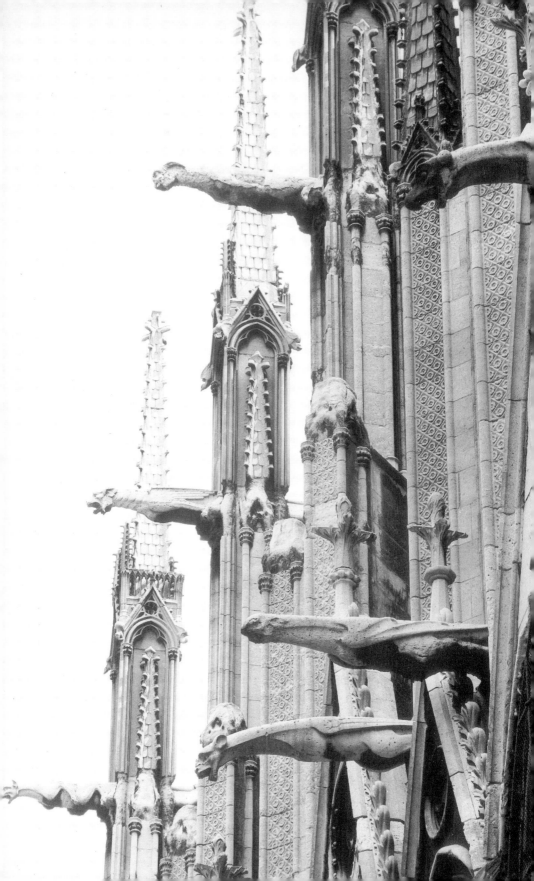

3 In the Margins of the Cathedral

Them that are outside, God judgeth (I Cor. 5:12)

Unlike the monastery, which was opposed to the world, the cathedral stood within clamorous streets, a powerful symbol of God's expanding business among the rising urban communities of the thirteenth century. Cities within cities, these vast structural complexes were ruled by a feudal magnate – the bishop – and were inhabited and maintained (except for some English monastic foundations, such as Canterbury and Norwich) by canons who, unlike monks, could own and bequeath property. Their margins were domains to be contested, like the *parvis*, or 'paradise', the narrow strip leading up to the west front, which at Amiens Cathedral was fought over by townspeople and clergy for two centuries.[100] It is the influence of a nineteenth-century nostalgic myth that leads one to think of these vast structures of stone, mortar and glass as expressing the social unity of the populace. More often than not, as at Amiens, Reims and Laon in France and Lincoln and Coventry in England, the economic strain of building a new cathedral aroused violent conflict between secular and religious powers, and the overtaxed populace frequently rose up against the clergy.[101] The French Capetian crown, one of the earliest centralized monarchies, was also an important impetus in the ideology of cathedral building that spread the Gothic style of the Ile de France throughout Europe. Although a number of great cathedrals were under way in the late twelfth century, the important event that to some extent ratified their power was the Fourth Lateran Council of 1215, in which the Church consolidated its hegemony over souls by excluding heretics, Jews and usurers from the sacred precincts and stipulated mass and confession at least once a year for every Christian. As the biggest edifices in existence, these vast mass-machines were not unlike the shimmering Postmodern towers of today's corporate headquarters; their advanced architectural and technical complexity was symbolic not only of the wealth within but also of the power to exclude those without.

38 Gargoyles. Cathedral of Notre-Dame, Paris

According to the *Oxford English Dictionary*, a gargoyle is 'a grotesque spout, representing some animal or human figure, projecting from the gutter of a building (especially in Gothic architecture), in order to carry the rainwater clear of the walls'. These carved devices were used on ecclesiastical buildings and also on townhouses. The late fourteenth-century English poet John Lydgate describes how 'every hous keuered was with lead / And many gargoyl and many hidous hed', although ecclesiastical control of urban space is evidenced in a document censuring a clerk of Arras for failing to obtain episcopal permission for placing 'gargouilles' on the façade of his house.[102] First recorded in a building document of 1295 – 'stones that are called *gargoules*' – the word derives from the roots *garge* (to gurgle) and *goule* (throat). Many of these functional monsters are indeed all mouth, spurting from gaping gullets both human and dragonish (illus. 38), but others invert the bodily topography of ejection and turn their bottoms out to the street. The gargoyle is all body and no soul – a pure projector of filth, the opposite of the angel whose body is weightless and orifice-less.

The use of animal heads as waterspouts was not an invention of the thirteenth century but can be traced back to Antiquity. Their elaboration in the Gothic period was a means of sustaining the monstrous margins of Romanesque buildings discussed in the previous chapter. Part of their fascination must have been their 'function' as pseudo-fountains, animated by the forces of nature. This is how they are explained in the *Roman d'Abladane*, a 'classical' Romance written by a canon of Amiens cathedral, which describes a 'marvel' of the old city being two 'gargoules' on the city gates that spew nice or nasty substances upon people entering the city, depending on whether their intentions were good or bad.[103]

The meaning of these emetic engines has long been controversial. In the nineteenth century, when historians sought to give exact meaning to every creature in the crevices of the cathedral, they were thought to illustrate specific texts, such as Psalm 21:12, 'Therefore shalt thou make them turn their back', or Psalm 22:13, 'They gaped upon me with their mouths, as a ravening and a roaring lion. I am poured out like water and all my bones are out of joint'. More outlandish

suggestions include their being the earliest depictions of dinosaurs dug up during the Middle Ages, planetary constellations and portraits of heretics. For one early iconographer, the abbé Auber, they represented devils conquered by the Church that were made to perform menial tasks.[104] In Joris-Karl Huysman's Symbolist novel of 1898, *La Cathédrale*, gargoyles are called 'hybrid monsters, signifying the vomiting forth of sin ejected from the sanctuary; reminding the passer-by, who sees them pouring forth water from the gutter, that when seen outside the church, they are the voidance of the spirit, the cloaca of the soul'.[105]

Emile Mâle, the most influential cryptographer of the cathedrals, disagreed. Anything that was not included in the text of Vincent of Beauvais' great encylopaedic *Speculum* was the meaningless product of pure fantasy:

> What do they signify – the prodigious heads that emerge from the façade of Notre Dame of Reims, and those funereal birds veiled by shrouds? . . . No symbolism can explain these monstrous creatures of the cathedrals. The bestiaries are silent. Such creatures came from the imaginations of the people. These gargoyles, resembling the vampires of cemeteries, and the dragons vanquished by ancient bishops, survived in the depths of people's consciousness; they came from ancient fireside tales.[106]

Mâle here, in fact, alludes to something that helps explain the popularity, at least, of the dragon form of gargoyle – the stories of the founding bishops of cathedrals who, like Marcellus at Paris and St Romain at Rouen, were famous for having rid their respective towns of such creatures.[107] In both cities these ecclesiastics were carved in triumph over the tamed monster on the portals of their cathedrals (illus. 43). At Rouen the serpent was known as the 'Gargouille', and its destruction by St Romain with the aid of a condemned prisoner was celebrated on his feast day every year, when a criminal would receive the 'privilege of St Romain' and be released. Then, too, the stone representations 'came to life' in an animated version of the beast that was paraded through the city in a re-enactment of the saint's power over slithering things.

By the thirteenth century the apotropaic power of the images of evil had been transformed into just such a civic show, replacing fear with fun. This loss of demonic associ-

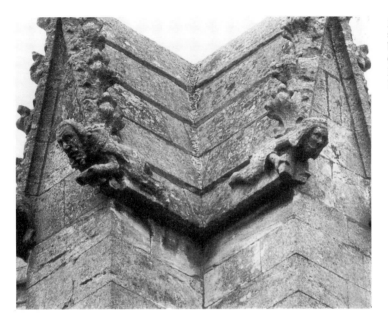

39 Man with
scroll, woman with
book. St Andrew's
Church,
Heckington,
Lincolnshire

ation can also be seen in the widening reference of gargoyle
sculptures to include the human as well as the monstrous.
They become butts of satire, depicting such despicable trades
as butchers, prostitutes and moneylenders, or universal sins,
such as gluttony. Among England's richest array of gargoyles
– on the fourteenth-century parish church at Heckington, Lin-
colnshire – is an elegantly dressed woman holding an open
book (illus. 39). Traditionally, women were not supposed to
take knowledge into their own hands, although this volume
may contain illicit lighter reading, perhaps a Romance. Other
social sins are twisted into gargoyle functions, suggesting that
the evils excluded from the Church are not only those of
lay society. According to a sermon of the English preacher
Bromyard, gargoyles are like the slothful clergy 'who com-
plain of the least task'. Just as the animals at Aulnay satirized
the clerical hierarchy of the day, the more diverse and
unstable religious orders of the fourteenth century were
mocked in the disorder of many a projecting sculpture. The
rise of marginal imagery has been related to the vernaculariz-
ation of religion in this period and the increasing role of
preaching. Bromyard uses sculptural references as *exempla* in
his sermons; for example, the old notion of images being
illusory and useless is used to describe those that likewise
pretend to be what they are not:

At times, on these great buildings we see a stone displaying a grinning open mouth, and from other indications, appearing as if it supported the whole edifice. But nevertheless a plain stone hid in a corner does far more of the work; for the other is rather for show than for support. Such may well be compared to those persons who, when they hear the cry of poor beggars for alms . . . with open mouths bewail . . . but do not offer a helping hand.[108]

Laughter and fear are closely related, and as Ernst Kris noted in his essay 'Ego Development and the Comic',

> the grinning gargoyles on Gothic cathedrals . . . intended to turn away evil . . . tend to become mere comic masks; by the fifteenth century the process is complete and, instead of threatening, they are intended to amuse.[109]

Like the French word *drôle*, or amusing, which has lost its original associations with the uncanny, the gargoyle's mouth becomes the clown's. Yet this process is also one of de-demonization and lays an increasing emphasis upon human perversity and monstrosity. This runs parallel to the intensifying psychological emphasis upon sin and self-reflection after the Fourth Lateran Council. No longer did the onlooker see the gargoyle as a hideous primordial beast that had been put to flight by the local bishop or as a dark succubus of the Devil, it became a reflection of the possible perversity in oneself.

This process of the humanization of the diabolic does not occur with other creatures – the so-called chimeras – perched on pinnacles and buttresses that, strictly speaking, do not have the gargoyle's function. The most famous beak-headed and melancholy example on the north tower of Notre-Dame in Paris, popularized in Charles Meryon's etching *Le Stryge* ('The Vampire') of 1853, was, in fact, one of the Romantic recreations of the architect Viollet-le-Duc, who had restored the Cathedral in 1843 (illus. 40). Gothic chimeras are Northern versions of the griffon, the fantastic beast-guardians found in Italian Romanesque portals and based on Classical sources. Extraneous to the architecture, they are carved to seem as though they had just alighted, like crows. It was these truly marginal additions of the cathedral that most intrigued observers of the last century in their quest for the 'spirit' of

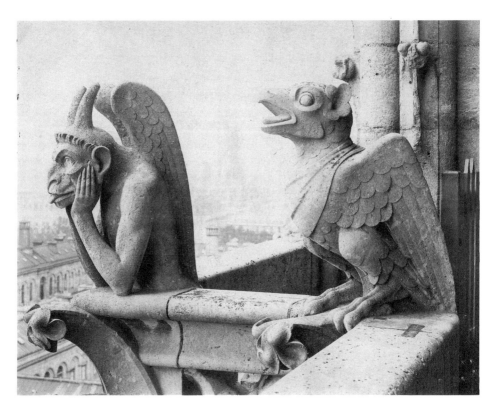

Gothic. It is likely they terrified medieval onlookers by their lack of human reference.

The third type of Gothic marginal sculpture consists of corbel-heads and capitals more clearly derived from Romanesque traditions. Sometimes the interior of the cathedral is invaded by their physiognomic mockery, as occurs in the nave and crossing of Wells Cathedral, *c.* 1220, where human heads of all types and social classes punctuate the rhythms of the stiff-leaf carving. In the south transept is a whole series of figured capitals: as well as Marcolf pulling a thorn from his foot and a complex scene of violent vineyard robbers is the famous so-called 'toothache sufferer' glowering down at the observer (illus. 41).[110] Although this is a variation on the face-pulling grimace, the attention paid to the mouth – the site of so many different kinds of sin – makes this sufferer an emblem of abject human pain. While the old idea that he is related to a nearby curative shrine has to be discounted, his placement in the laypeoples' area of the building is important. It is not surprising to find an eruption of 'low life' squabbling

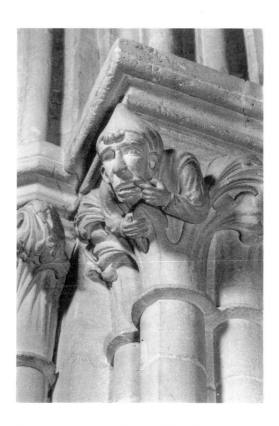

41 Mouth-puller. Capital, Wells Cathedral

and suffering in the very spaces where, Churchmen complained, a lot went on besides devotion.

At the cathedral of Semur-en-Auxerrois in Burgundy, the appearance of chattering corbel-heads in the choir itself, which was built in the 1230s, is even more startling. Here, the lower course of corbel-heads around the east end represent nobles and clergy, while higher up are more scurrilous fools and twisted figures.[111] Both Wells and Semur are smallish structures, and their marginal images can be seen from ground-level quite easily. The soaring scale of many cathedrals, however, often makes it impossible to see the marginal sculpture from below, either within or outside the sacred structure. The deformed and base are ejected by being made invisible. But this did not prevent the carvers lavishing care on the minute delineation of the unseen.

The difference between the inchoate, monstrous corbel types of 1120 we find at Aulnay (illus. 35) and those of only a century later that stud the shadowy and hidden interstices high up amid the gables and buttresses of Reims Cathedral

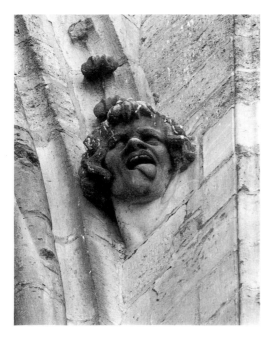

is astounding (illus. 42). These later heads are completely human and so powerful in their physiognomic exactness that art historians have described them as portraits of the artisans who made them or as case histories of certain mental illnesses.[112] Nowhere else in thirteenth-century sculpture does the carver get to display his skill at animating the human face, the slobbering mouth and the glinting eyes as he does here in these corner creations. Carved in the mason's yard, these hidden faces, when fitted into place, were not visible from far below, suggesting that they were, perhaps, sites of practice. Skill was important to the carver, for we know from later documents that the cost of spoiled stones was taken out of their wages. In this sense the freedom they exhibited in this one type of undictated, unseen and unauthorized sculpture emerges as rage, jeering and tongue-showing that mocks the edifice and its authorities. Disordered fragments of human personalities stuck onto the edges of the Heavenly Jersualem, they disrupt our notion of the cathedral as the 'Bible in stone', since they refer to no biblical personage or text. A side-show of abnormality and ugliness, unknown until photographers were able to scale the buildings on scaffolding a century ago, they are the most human, and the least divine, forms on the sacred edifice. Their liminal status widens the gap between

sacred and profane rather than smoothing it over. Being neither the angels that curve around the external choir buttresses at the 'head' of the edifice nor the beaked terrors that perch on the west front, they are squeezed somewhere in-between, somewhere within the world of humanity.

A RIOT OF THE IMAGINATION AT ROUEN

> Indecency and irony had no part in the artist's fun. The monstrous obscenities that have been pointed out in our cathedrals existed only in the minds of certain biased archaeologists. Thirteenth-century art is extremely chaste, astonishingly pure.[113]

Emile Mâle saw Gothic images as innocent and 'free of thought', and yet, in making the medieval artist conform to his Victorian vision, he overlooked how 'indecency and irony' had an important part to play in the rituals of the cathedral as well as in the workings of 'the mind' itself. One of Mâle's examples of monstrous images that 'mean nothing' are those carved on the Portail des Libraires at Rouen (illus. 43). This portal off the north transept was begun by Archbishop de Flavacourt in 1278 and faces a long, tunnel-like court hemmed in with later buildings – the Bishop's Prison and the Treasury. There are three niches either side of the door below an unfinished Last Judgement, and beneath these are square pedestals set diagonally. Their outer faces are carved with dozens of quatrefoil medallions. Their intricate structure is typical of the geometrical exactitude of Gothic architectural framing and can be seen on the south portal on the other side of the building, where the quatrefoils contain narrative biblical and hagiographic scenes. However, what is framed by all this elegant ecclesiastical order at the Portail des Libraires, is chaos.

Each quatrefoil contains a single babewyn, posing and strutting self-consciously (illus. 44). These creatures – women with birds' bodies, dwarfish grylli, exulting goats, pig-headed dancers and hooded old men with tails between their legs like hideously overgrown genitals – exhibit nearly every single convention of babewynerie that was current, including some rare and incredibly inventive images. There is a 'real' monster among them – a performing monkey and his jongleur trainer

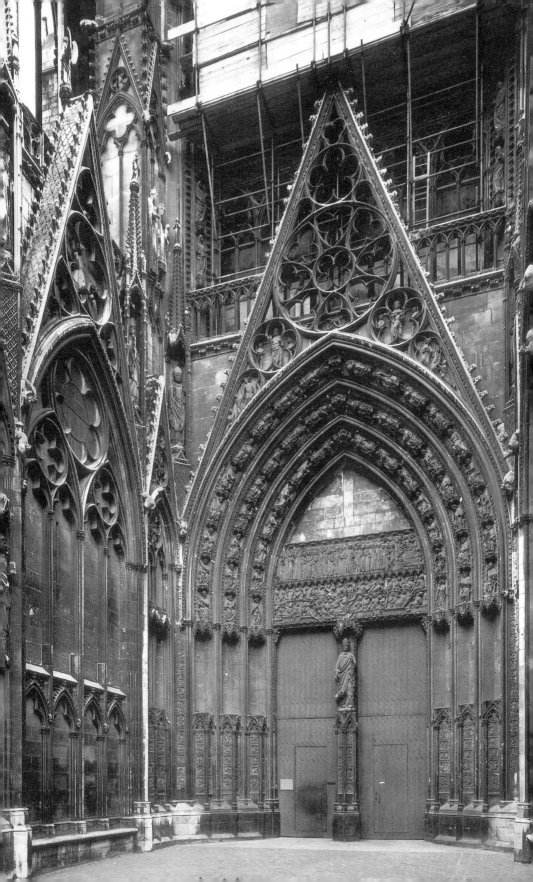

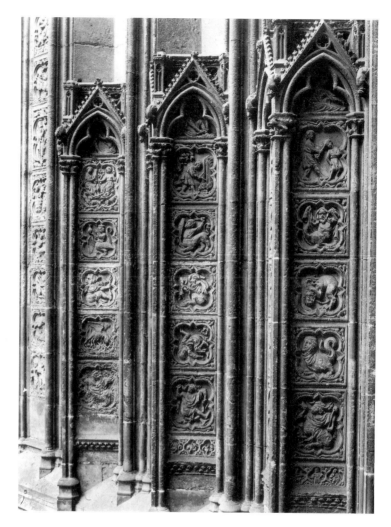

44 Genesis and a
feast of creatures.
Portail des
Libraires, Rouen
Cathedral

– perhaps an allegory of the soul trapped within the body (illus.
45). Each has its frame, as if each were a specimen or example
in a Bestiary manuscript. In fact, they represent a kind of anti-
Bestiary in the sense that these mingling of parts and pieces of
animal and human defy classification. They are like Asge-
mundus, the 'ruler of the arse-hole', a demon described at the
climax of the monastic Latin poem *Ysengrimus* as

> a devil whose beak is that of a hawk, whose mane is horse-
> like, with the tail of a cat, the horns of an ox, and the beard
> of a goat. Wool covers his loins and his back is feathered
> like a goose; he has the feet of a cock in front, and those of
> a dog at the rear.[114]

43 Portail des
Libraires, Rouen
Cathedral

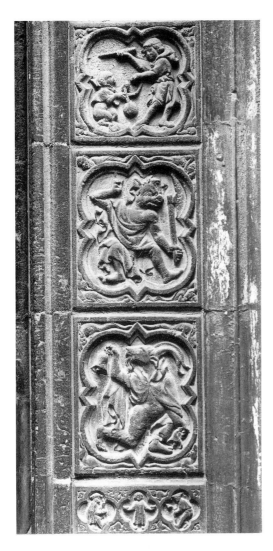

45 Jongleur and
monkey, two
monsters and a
lower marginal
scene of (?)charity.
Portail des
Libraires, Rouen
Cathedral

Juxtaposed above all this formlessness is the narrative of
the World's formation. On the left of the doorway, reading
from left to right, is Adam and Eve's life on earth – from their
expulsion from Paradise to the death of Abel. On the right
of the doorway, reading left to right, are the seven days of
Creation. Heavily draped figures brood in the lunettes above,
like the figures of Christ's ancestors so admired in that part
of Michelangelo's Sistine Chapel (illus. 46). Generation is, in
fact, crucial to the scheme – the generation of animals, mon-
sters and thoughts in the powerful medieval imagination.

According to Vincent of Beauvais – the thirteenth-century

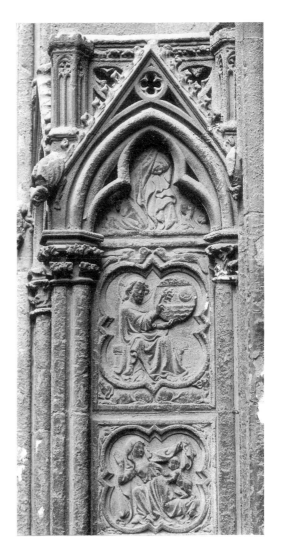

46 Shrouded
mourner, Creation
scene and parody
of the Virgin Birth.
Portail des
Libraires, Rouen
Cathedral

scholastic on whom Mâle depended so much when building
his *summa* in stone – the imagination acts as a repository of
images that go beyond those perceived by the five senses,
such as the chimera, a creature he describes as having the
head of a lion, the body of a goat and the tail of a serpent.
For Albert the Great, *phantasia*, lying between imagination
and memory, was the faculty that allowed one to imagine a
man with two heads, or a being with a human body, the
head of a lion and the tail of a horse.[115] In this respect, the
sculptures at Rouen represent the products of the imagination
as argued by Scholastic philosophers of the time.

Beneath God, dividing the light from the darkness, a woman opens her cloak like a modern magician to present a bestial dog-baby, perhaps a parodic Virgin and Child composition (illus. 46). In this period, deformed offspring were considered the result of sin, usually the breaking of a sexual taboo. But there was also a belief that women could bear the children of demons. William of Auvergne, the Bishop of Paris, wrote a treatise on the supernatural *succubi*, the demons that fertilized women through the intermediaries of animals, often bears.[116] In Padua in 1265, a woman confessed to a priest that she had slept with a horned goat. On the portal at Rouen, goats and humans mingle, becoming bird-women, dog-men and hermaphrodites, like exhibits in a medieval freak show.

Rather than being freaks in our sense, these images are conceived as products of the terrifyingly promiscuous medieval imagination. For imagination was not only understood to be a cognitive faculty lodged in the front of the brain, nearest the eyes and thus closely linked to vision, but a force that could actually create forms. As the thirteenth-century Polish scholar Witelo argued, imagination, being an intermediary between mind and matter, allowed demons to couple with human beings, since what was perceived in the *phantasia* was, in some cases, real. It was for this reason that pregnant women were urged not to look at monkeys (illus. 45) or even to think of monstrous things, lest their imaginations impregnate their offspring with hideous forms. Similarly, it was a medical commonplace that if an adulteress thought of her husband during the sexual act her child would resemble not her partner, but the absent husband.[117] Vision was both fecund and dangerous. The opposite of God's ordered creation, the Rouen carvings display its crazed corollary, the flawed, distorted products of purely human invention. Picturing the mind's profligate excess is a brilliant conceit, since this is exactly what these forms were in front of the designer's mind, the place of imagination in medieval faculty psychology.

Our modern notion of the separateness of sacred and profane experience has blinded us to seeing the worldliness of the medieval cathedral, although the tourist shops that fill many English cathedrals today capture some of its original mercantile ambience. According to the testimony of

thirteenth-century French clerics such as Humbert of Romans, churches were places not only for prayer but where people 'indulge in idle chatter, do business transactions and secular work . . . and some desecrate the church by doing physical violence there'. Humbert particularly attacks those who, on Feast days, 'go in for excessive eating and drinking, and other such things belonging to carnal pleasures', those who 'turn God's feast into a feast of the world'.[118] The babewyns at Rouen, including quack doctors and over-dressed women, are probably related to warnings against this profanation of the sacred space.

The idea of the external walls of an edifice being associated with sin can be found in contemporary writings, such as the *Roman de la Rose* and the *Roman de Fauvel*, in which emblems of Evil are described as carved or painted on the outside walls of a garden and palace. Rouen's north portal was notoriously tainted in this respect. Not only was Cain's murder of his brother carved there (illus. 44), an actual murder had occurred on the very spot; the sanctified ground of the cemetery beyond, desecrated by this shedding of blood, was moved.

The function of the courtyard also involved the 'sins of the world'. In the previous century the north doorway had been the site of a chapel of the Virgin which, along with some of the canons' houses, had to be demolished in 1280 so that the portal could be built. The doorway later came to be called the Portail des Libraires because in the fifteenth century there were twelve booksellers' stalls arranged in the courtyard outside, which were rented from the Chapter at a price of 60 livres each. Before this date there is evidence to suggest it was called the *Portail des Boursiers*, or Money-lenders, and that it was a major entrance to the building.[119] This association with mercantile activity and the venial sin of usury is especially interesting in the light of the Last Judgement in the lintel of the doorway, which depicts avaricious merchants being led to Hell. Did the cacophonous monstrosities in the quatrefoils similarly sound an ominous warning to the worldly activities that went on before them? Did the 'changing' money chime with the shape-changing and protean perversity of the creatures carved in stone? The whole doorway complex is, in fact, unfinished (illus. 43). The Last Judgement takes place on the lintel where the moneylender shrieks in fear as he is led

towards the mouth of Hell, but Christ is missing in the apex of the scheme. Was this court, with all its murderous and mercantile associations, too worldly for God to judge over? Or did the gap come to signify in its absence the soon-to-be-completed Doom that could happen any day?

It would be wrong to think of these images as addressing only those outside the sacred precincts. Like monastic monsters, they served just as much as reminders to the religious community within. Rouen had been notorious for its clerical abuses. At an enquiry of 1248 the chapter was found to 'wander about and talk with women during the celebration of the divine services', and individual priests were named as 'ill-famed' for 'incontinence, drunkenness, manslaughter, trading and usury'.[120]

The canons, when they did not pay others to stand for them, spent almost every waking hour of their lives singing the divine office, except at certain sanctioned disruptions that occurred on the Feast of Fools. Usually celebrated on Innocent's Day (28 December) or the Feast of the Circumcision (1st January), the Feast of Fools was essentially a rite of inversion, allowing the lower ranks of clergy, who served more menial tasks in the cathedral compared to the wealthier prebendary canons, to let off steam. The Church hierarchy continually tried to suppress the rites and revelries of what was called the *festum stultorum* or *asinaria festa* from as early as 1207, when Pope Innocent III condemned mask-wearing and other *theatrales ludi* performed by the deacons. The most lengthy attack on these riotous rites came later, from the pen of the Chancellor of the University of Paris, Jean Gerson:

> Priests and clerks may be seen wearing masks and monstrous visages at the Hours of Office. They dance in the choir dressed as women, panders or minstrels. They sing wanton songs. They eat black puddings at the altar while the celebrant is saying mass. They play dice there. They cense with stinking smoke from the soles of old shoes. They run and leap through the church, without a blush at their own shame. Finally they drive about the town and its theatres in shabby traps and carts; and arouse the laughter of their fellows and the bystanders in infamous performances with indecent gestures and verses scurrilous and unchaste.[121]

This describes exactly the breaking down of boundaries between the Church and the world and the inverted order of the canons' hierarchically structured lives that is typical of the liminal festival. But does this licensed disruption of clerical energy have anything to do with the ludic carvings on the Portail des Libraires? Certainly it suggests the capacity of the clergy to utilize the transformative power of ritual play and inversion, mock-riot and masking for themselves. Even in the more orthodox Prophet's Play performed at Rouen – again, probably by the lesser clergy – there is an *ordo* of Baalam, while the ass that is called for is played by what we would call a pantomime horse![122] Certainly such evidence of ludic ritual suggests the limitations of Mâle's 'chaste' view of Gothic sculpture, since the carvings addressed not only the sinful city outside but also encompassed the liturgical laughter that the canons and priests could themselves at times entertain. Gothic art has for too long been studied as 'rational' architectural order, while the irrational, magical impulses that also helped create its illusory transcendence have been ignored.

MISERICORDS AND POSTERIORS

For centuries the choir of even the smallest parish church had been the site of one of the most fertile of the marginal genres that Bakhtin has called 'the lower bodily stratum', carvings hidden from all but the eyes of the canons and choristers who sat or leaned upon them – the misericords (illus. 47). The name is thought to have derived from the idea of a 'mercy-seat' that provided some support for the older and infirm monks and canons during the long hours of services. When in the up position a misericord provided a ledge to lean back on, and when down, a proper seat. 'Hidden from the eye of mischief', in the words of Edward Prior, one of the earliest historians of English medieval sculpture, its art was on the underside in more ways than one. In the small field not visible when the seat is in use, the woodcarver had a chance to develop the marginal repertory found in manuscripts into three-dimensional woodcarvings.[123] But the compositions need not always have been derived from manuscripts. At Rouen Cathedral, for example, there is a marvellous set of misericords – ordered in 1467 by Cardinal Guillaume D'Estou-

teville – that was copied from the babewyns of the Portail des Libraires.[124] This suggests that nearly two hundred years after the monstrous carvings in stone had been made, they were still valued by artists and patrons as a repertory of imaginative and respectably riotous babewynerie.

The variety of subject-matter, the freshness and grainy earthiness of the carving and the intimate scale of misericords have attracted countless popular and scholarly treatments (we all have our favourites). But what is often not emphasized enough is the relative position of this art and its meaning, as regards the low subject-matter. A number of French examples have a distinctly 'popular' aspect, depicting riddles, pastimes and folk tales in a dynamic and often derogatory style. Here in the very centre of the sacred space, the marginal world erupts. Why this became a fashion, and why it was allowed, has to be related to the way in which these carvings were literally debased and made subservient to those 'above' them. The peasants labouring in the fields, the foolish merchant who carries his horse across a stream, the fox preaching to the geese – all are blotted out by the bottoms of the clergy. Sometimes this is actually reflected in the carver's design, as at Saumur, where a figure is pinned with his nose reaching up to the choir-stall seat – literally the posterior of the sitter (illus. 47).

The censorship of the 'low' realism of these scenes by the portly canons' behinds during the divine services was the

47 Sniffing the bottom. Misericord, Church of St Pierre, Saumur

obliteration of one social group by another. The ribald subject-matter was clearly visible only to the clerical élite, since laypeople, even in small churches, were not allowed to enter the sanctuary. This might explain the popularity, especially in England, of misericords showing scenes from popular romances, such as *Tristan and Isolde*, and other courtly subjects – not for the elevation of these themes, but literally to squash them. Although some misericords do display religious subjects, such as the Judgement of Solomon at Worcester and Noah's Ark at Ely, these are not the central Christological subjects, but scenes that allow, like the Mystery plays, anecdotal details and the depiction of social manners. Especially popular were the antics of Reynard the Fox and other animal fables, but also subjects of human labour that included scenes of self-reference showing carvers at work.[125] Three misericords from a single set now in London are especially interesting since they show the development of marginal images within this 'marginal genre' itself, using the 'ears' of the central bracket. Alongside scenes of the harvest and human labour are monstrous grylli and cloth-draped monsters with beak-heads picking the grain (illus. 48). These have been described as representations of the monstrous races of the East, when, in fact, they would have been visible in many fourteenth-century villages at harvest time. They are clearly depictions of men in the mumming and hobbyhorse costumes used in folk rituals.[126]

Just as the misericords, while representing a wide social panoply, put people in their place in the human hierarchy, the cathedrals, as image-complexes, positioned people in relation to God and the Judgement. This does not mean that we must view all the hilarious or disturbing inversions of misericords, gargoyles and other three-dimensional marginal forms I have briefly discussed here as the crude image of a predetermined 'official' ideology. The lay carvers who created these animated figures gave them eyes that glint with vivacity, and pert poses that are lacking in the simulacres of sanctity that stand rigid beside them. When an English Cistercian complains about the 'licence' given to artists by 'those who supervise such matters', it suggests that ecclesiastical patrons left the non-essential parts of programmes to the imaginations of their makers, as was the case with the illumination of religious manuscripts.[127]

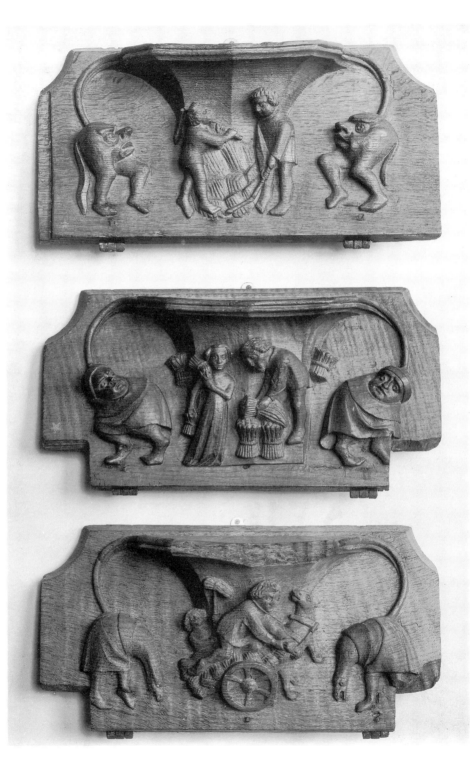

A century ago, Ruskin, who overstressed this 'freedom' of the medieval craftsman, described and greatly admired the carvings of the Portail des Libraires. As the culmination of French Gothic, they exemplified what the great English critic called 'thoughtfulness or fancy', in his *Seven Lamps of Architecture* (1849). Ruskin's obsessive gaze was focused on a carved detail that was not in the centre of a quatrefoil, one of the minute worm-men squeezed into the lower right margin of the frame, then less worn-away by pollution: 'the fellow is vexed and puzzled in his malice, and his hand is pressed hard on his cheek bone, and the flesh of the cheek is wrinkled under the eye by the pressure'.[128] Ruskin's nineteenth-century naturalist's eye could observe the minutest emotional inflexion of humanity, even in a Gothic monster. It is a pity that today we have parcelled these off into a category of the grotesque, and cannot admire their deformity with the same sensitivity. Ruskin was also acute in seeing these sculptures as the embodiment of 'thoughtfulness'. What he did not appreciate, however, was how far from the rational natural-ism of his own age were those ever-rampant and constantly creative representations of the medieval imagination.

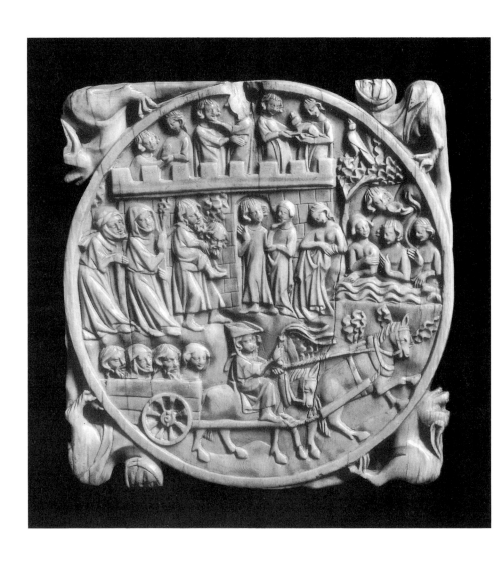

4 In the Margins of the Court

> 'In time I exist and in time I speak', said Augustine; and added, 'What time is I know not'. In a like spirit of perplexity I may say that in the court I exist and in the court I speak and what the court is, God knows, I know not. I do know however that the court is not time; but temporal it is, changeable and various, space-bound and wandering, never continuing in one state.[129]

This is how Walter Map, clerk in the glittering retinue of Henry II and Eleanor of Aquitaine, begins his satirical work, *Courtiers' Trifles*. The court was not a fixed site but a body of people focused around a ruler who was constantly on the move from one estate to another. This peripatetic life and the constant flux of new favourites and fashions made the court a very different kind of social space from the stable monastery and cathedral, although it was just as exclusive. Here too, however, monsters lurk. Gargoyle-like, they crouch on the edges of an ivory mirror-back (illus. 49), two of them like hooded *villeins* or peasants, banished from the battlements within. In this Castle of Love, the occupants fondle one other and small furry animals – signs of copulation to come. In the gardens below, lords and ladies splash in the Fountain of Youth; old folk are brought in carts and on piggyback to bathe in its rejuvenating waters, like cripples at a saint's shrine, before being allowed to enter the castle as 'beautiful people'. The medieval court, it has been argued, was the first 'youth culture'.[130] It was dominated by sexually active young males who, still seeking their fortunes, were not yet established in their own households. For them the Knight's Quest of the Romances embodied their own search for legitimacy through prowess and marriage.

49 Castle of Love and Fountain of Youth. Ivory mirror case, Walters Art Gallery, Baltimore

By the time this ivory was produced in the early fourteenth century, the French aristocracy, while enjoying luxury toiletries and lavish rituals, tournaments and feasts, had lost much of its real political power. From the late twelfth century, enhanced royal authority and rising mercantile interests

threatened the nobility from above and below. In the works of art made for knights, marginal forms appear that respond to their fears of the lower orders, and to their wish to retain the signs of rank, blood, gesture and manners, all of which subjected their courtly bodies to a pseudo-spiritual code of ethical chivalric behaviour and, in turn, subjugated all other bodies beneath them. It was already a dream of a lost order. While they placed others in the margins, they themselves were already halfway there.

THE SPECTACLE OF ROMANCE

Romance has been called the 'secular scripture' of the nobility, and just as the nobility commissioned artists to illustrate and decorate their Psalters and Hours, the same élite families owned illuminated manuscripts of these vernacular works. One of the most striking is now in the Beinecke Library at Yale University, which, in the margins of one folio, has the arms of its probable patron, Guillaume de Termonde (1278–1312), the son of Guy de Dampierre, Count of Flanders.[131] In some manuscripts made for the status-conscious aristocracy, blazons and heraldic shields fill up most of the margins, but here the reference appears only on the tiny trappings of a knight's horse. The fact that reference to the owner is made at the edges rather than in the miniatures of this book is significant, suggesting that the margins are partly a site of self-referentiality. The vast codex contains three Romances of the Arthurian cycle. Its large format, almost the size of liturgical choir-books, which had to be visible to a group of singers, was perhaps intended for similar groups of courtly readers and listeners who could peer at the hundreds of bright illuminations in framed miniatures, initials and margins as the codex was read to them by a cleric or servant. The idea of the image as spectacle evolved especially strongly in the courts where jousts and tournaments were held. There are internal spectators pictured in the margins of the Yale manuscript – a group of noblewomen watches Gaheriet and Gawain in combat in the miniature below (illus. 54).

Although 'Tales of Arthur' were condemned by the Church, some writers did not disapprove of them altogether, because they also contained lessons in courtesy.[132] The images of good versus evil knights, mysterious castles, heroes

50 Hector meets weeping damsels, in combat with Tercians and marginal archer. *Lancelot del Lac.* Beinecke Rare Book Library, Yale University, New Haven

51 *overleaf:* Elevation of the Host and scene from a Romance. Psalter. Bodleian Library, Oxford

52 *overleaf:* Praising the Lord through music. *Luttrell Psalter.* British Library, London

loise atendre. ains se toene suiano ⁊ le
vient atuignant par destiere ⁊ ot han
ciee lespee por ferir. Et qnt cil voit le
cop venir. si ot paour de mort. Si se lef
se cheoir a tre. Et cil qui son cop ne pot
retenir. fiert es arcons derlere. si tren
che tout outre le cheual mort de sus le
chr qui se fu lessie cheour. puis vient a
la damoisele qui fesoit trop gnt dueil.
laisse mes freres. Si le monte deuant
lui sor son cheual. Et sen retorne tout
le chemin kil estoit venus .

Et qut cele sen voit mener mal
gre sien. Si comence a crier sain
te marie aidies aidies. Et fert si
tres gnt dueil que nul la veist qui pitie
nen preist. Ainsi sen va li chirs ⁊ enmo
ne cele qui ne fine deplorer ⁊ de color fe
rir. Et qnt lyonel voit ke il sen part en
tel maniere. Si dit ke ore a il trop aten
du. quit il en voit la damoisele mener
il ne veut mie la damoisele lessier ⁊ ust
ne esueillier lancelot. car il a paour qil
ne le tenist a coart se il ne doutoit riens
autant come lancelot

Quant il sest armes au mieus qil
puet. si a mise la sele en sonche
ual. Si monte ⁊ prent son escu
⁊ sa lance. ⁊ lesse lancelot dormant ⁊ se
toene apres le chir qnke le cheual puet
aler. Si la conseut a laualer dun tre.
Et qnt il est pres si li crie que il mette
ius la damoisele. ou il le compera. Et
il se regarde ⁊ voit ke retoener le con
uient. Si met ius la damoisele ⁊ sache
lespee deuant soi. ⁊ guenchist le cheual
au chr ⁊ cil li vient acorant ⁊ le fiert si
q̄ par mi lestu ⁊ par mi le hauberc li
met le glaiue sans plus de nual fere.
⁊ cil latteint sor le heaume ⁊ done tel

coup de lespee qil abat qn kil en ataint
a destre partie. Si leult cus sans faille
qel lespee li toene en la main. Li cous
fu gns ⁊ de force ferus. Si fu lyonel si es
tordis kil chiet a la tre tous pasmes.

Et li chirs met sespee ou fuerr. Et
fer la damoisele monter ou cheual
lyonel. ou ele voelle. ou non. Si le
contredist ele asses. ayes toute uoies le con
uient fere. Et il se besse uers terre ⁊ prent
lyonel par les espaules tout ainsi armes
com il estoit. ⁊ le truise deuant lui. ⁊ len
porte en tel maniere entre lui ⁊ la damoi
sele. Si se teist ore li contes de lui ⁊ de lance
lot. ⁊ retorne a hestor des mares. car gnt
piece sen est teus .

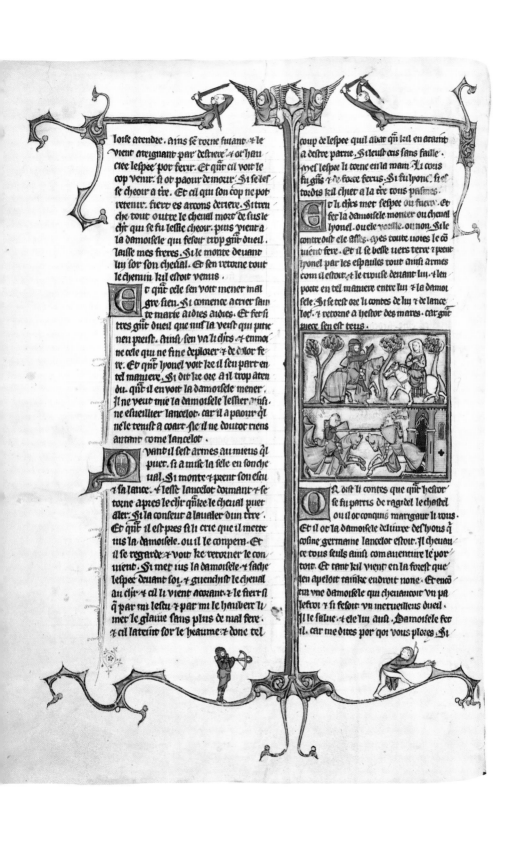

Or dist li contes que qnt hestor
se fu partis de ragidel le chastel
ou il ot conquis marigaut li tous.
Et il ot la damoisele deliure des lyons q̄
cosine germaine lancelor estoit. Il cheuau
ce tous seuls ainsi com auenture le por
toit. Et tant kil vient en la forest que
lien apeloit rainke endroit none. Et enco
tra une damoisele qui cheuauchoit un pa
lefroi ⁊ si fesoit un merueilleus dueil.
Il le salue ⁊ ele lui aussi. Damoisele fet
il. car me dites por qoi vous plores. Si

er letata est syon ·

Et exultauerūt filie iude: ppt iudicia tua dñe
nam tu dominus altissimus sup omnem ter
ram: nimis exaltatus es sup omnes deos

Qui diligitis dñm odite malū: custodit dñs
aīas sanctox suox de manu peccatoris liberabit eos ·

Lux orta est iusto: t rectis corde leticia

Letamini iusti in domino: t confitemini
memorie sanctificationis eius ·

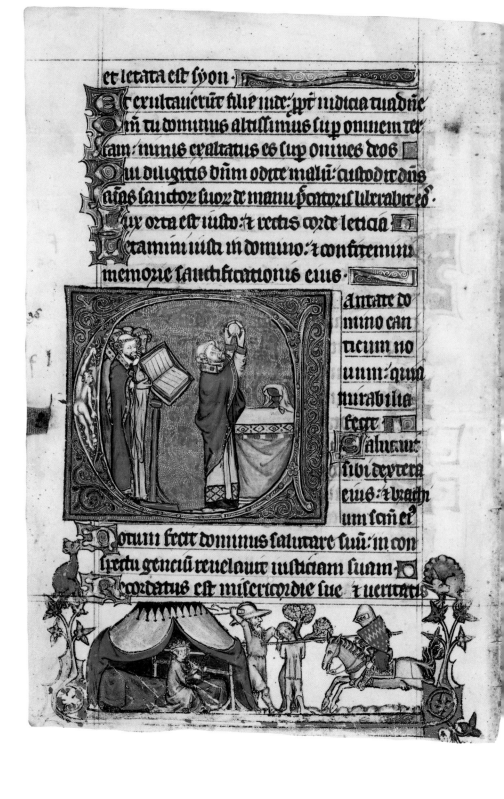

antate do
mino can
ticum no
uum: quia
mirabilia
fecit

Saluauit
sibi dextera
eius: t brachi
um sc̄m ei

Notum fecit dominus salutare suū: in con
spectu gentiū reuelauit iusticiam suam ·

Recordatus est misericordie sue t ueritatis

ciones eorum.

Exaltate dominum deum nostrū:
et adorate in monte sancto eius: quo
niam sanctus dominus deus noster.
Jubilate deo omnis terra: seruite do
mino in leticia

Introite in conspectu eius: in exulta
cione

Scitote quoniam dominus ipse
est deus: ipse fecit nos ⁊ non ipsi nos.
Populus eius ⁊ oues pascue eius
introite portas eius in confessione
atria eius in ympnis confitemini illi.
Laudate nomen eius quoniam

quidam habent; ad
reuerentiam nobis
loquor. Sed dicit ali
quis. Quomodo re
surgent mortui. Qua
li autem in corpore ue
nient? Insipiens tu
quod seminas non ui
uificatur: nisi prius
moriatur. Et quod se
minas non corpus?
quod futurum est semi
nas sed nudum granu

ut puta tritici: aut a
licuius ceteror. Deus
aute dat illi corpus
sicut uult: et unicui
que seminu propriu
corpus. e
tradas domine bestiis ani
mas confitentiu tibi et a
nimas pauperum tuor ne ob
obliuiscaris in finem.
Memorare que sit nostra
substantia domine et quia
non uane constituisti omnes

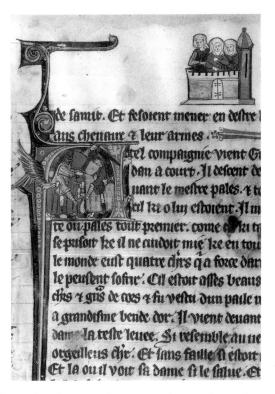

rescuing damsels and other stock conventions of secular manuscript illumination might thus have also served as models of deportment. If this is the case, what of the fox-chasing wives and backward-riding bishop in the margins of this book? Were they also part of the courtesy training of the youthful aristocrat?

Rather than deal with the whole gamut of imagery in this book, I want to focus on its marginal depiction of its own audience. It is easy to see the other excluded antics, the labours of Adam and Eve (folio 253r), the humiliation of the bishop (folio 104r), the one-legged cripple (folio 108r) or the famous friar- and nun-jousting (folio 100v), as representing those 'outside' the court and 'beneath' its aristocratic audience. It would be interesting to undertake a survey to see whether anti-clerical and anti-peasant images occur more often in the margins of Romances. But, in addition to these, the margins satirize the knightly class itself, and include the ubiquitous image of the knight fleeing the snail and mockeries of the pre-eminent aristocratic pastimes of jousting and hunting.

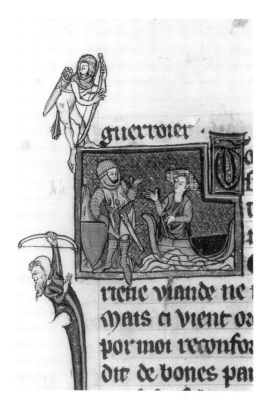

Once again, in this manuscript the marginal 'play' glosses and provides an ironic commentary on the central action of the text and its illustrations, which narrate the adventures of the Knights of the Round Table. For example, on the page where Hector is shown meeting a group of damsels and fighting with the Tercians in a two-tiered framed miniature, the *bas-de-page* has a knight firing his crossbow at the exposed behind of a crouching figure (illus. 50). Looking closely, we can see that in the underdrawing or sketch for the target figure, the arm was originally bent over to expose his buttocks, but the painter has changed this to make him point upwards to the miniature, as if drawing attention to the proper chivalrous activity of a knight depicted above.

The 'arrow in the hindquarters' motif is common in thirteenth-century manuscripts. In most cases the arrows might be seen as metaphors for God's punishment of sinners, where the victims are monsters or monkeys. The Psalmist tells us that God smites his enemies 'in the hindquarters' (Psalm 78: 66). But arrows are also signs of 'evildoers who

56 The Grail
Liturgy with
marginal angels.
*Queste de Saint
Graal.* Beinecke
Rare Book Library,
New Haven

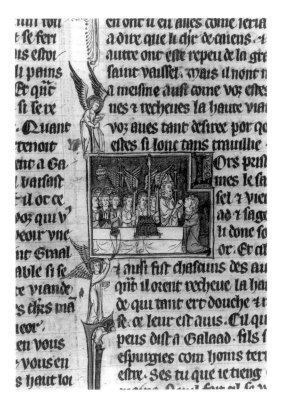

aim like arrows their bitter words, shooting . . . at the inno-
cent man' (Psalm 64: 3–5). Archers were condemned by the
Second Lateran Council and thought of as 'wild men living
on the fringes of society and engaged in inferior forms of
military activity .[133] The knight in this illustration is here
using a 'low' and unchivalrous weapon against an unarmed
man. But arrows in texts are also traditionally guides for the
eye, pointing out, like N.B. marks, significant sections. Here,
one's gaze is led across the *bas-de-page* and, by the pointing
figure, up to where Lancelot woos ladies and fights other
men on horseback, rather than creeping up on them from
behind.

The motif occurs again in the same manuscript, this time
with the knight on the receiving end, in the *Quest for the Holy
Graal*, where Perceval encounters the beautiful damsel in her
ship (illus. 55). Perched above on the frame, and thus draw-
ing attention to what goes on both inside and outside the
frame, is a half-nude knight – again with a bow – who gets
it in the end with an arrow fired from below by a bearded,

churlish figure. This arrow is an inverted metaphor of the look of love, the dart of the God of Love. Not the eye, but the 'lower bodily strata' are implicated here. Arrows also appear in the story itself. In a text miniature that comes later in the book Lancelot is depicted being struck by the huntsman's arrow (folio 294). On the previous folio is a marginal image of a stag being wounded by a similar projectile, suggesting that the margins can more directly parody the actions of the Arthurian knights at the centre.

The climax of the *Quest for the Holy Grail* story is the scene in which Galahad receives the host from the hands of Christ himself, who rises 'with pierced arms and feet' from the chalice. But this is not how the scene is illustrated in the Yale manuscript, where Joseph, the first Christian bishop, performs the mass, although everything else in the miniature – the covered chalice, the bleeding lance and the four angels – are exactly as described in the text (illus. 56). Was the illuminator worried about depicting such a sensuous, suffering Christ in a book celebrating the sensuousness of the adulterous courtly body? At this moment when the kneeling Galahad receives the host, the margins are filled, not with exposed buttocks and archer-knights, but with censing angels. Why is there no marginal parody of this liturgical scene, as commonly appears in liturgical manuscripts?[134] The appropriation of sacerdotal spirituality by the Romances was perhaps so strained that it was not possible to 'play' with this aspect so easily. In this sense, it is ironic that medieval secular manuscripts like this one often treat religious themes more seriously than liturgical books, where marginal undermining abounds!

In a richly illuminated English Psalter in the Bodleian Library, liturgy and Romance again coincide on a page that shows the priest elevating the host at mass for Psalm 92, while below, a knight on horseback, watched by a lady from her pavilion, spears a club-wielding giant through the heart (illus. 51). An earlier victim of the churl is tied to a tree directly below the sacrificial chalice above, though the exact interplay between sacerdotal scene and this particular Romance narrative eludes me. Many episodes in the Vulgate cycle, which was also popular in England, are comparable, but none fits the scene exactly. Even so, this combination reveals how much the devotional and literary tastes of the aristocracy

overlapped. The same thing occurs in the Taymouth Hours, where the *bas-de-page* tells the story of the Romance of Beves of Hampton and another story whose text has not come down to us, but which we know as the 'Phantom Tales of Female Ingratitude' because of this and another marginal sequence in the Smithfield Decretals.[135] The narrative in the Taymouth Hours even includes captions in French to guide the reader through the story of a damsel captured by a wildman of the woods (illus. 57). We are not dealing here with the allegorical use of secular themes, as occurs in a well-known page of the earlier Psalter of Christina of Markyate – the St Albans Psalter. Here, on the *Beatus Vir* page, a marginal scene of two fighting knights is interpreted in an adjacent gloss as a corporeal image of a spiritual battle within the soul.[136] There is a delight in the surface detail and action in these marginal Romance narratives that keeps them corporeal and implicates the courtly audience in the sacred framework of the whole. The 'fighting knights' that St Bernard criticized as distractions in the Romanesque cloister are no longer marginal; they are the focus of the new psychology of Romance.

Such interweavings of sacred and secular 'scriptures' through images are a means of self-legitimation for the nobility, akin to the pseudo-sacred orders of chivalry that were set up at this time. In the vernacular courtly culture of fashion, intrigue and adultery that is described in the vast Vulgate

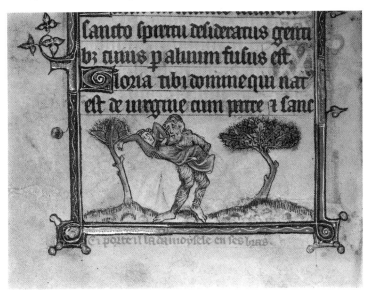

57 A wildman 'carries the damoysele in his arms'. *Taymouth Hours.* British Library, London

58 Tournament
and babewyns.
*Treatise of Walter de
Milemete.* Library of
Christ Church
College, Oxford

cycle it is easy to forget that at its centre, just as on the Psalter page, is the vessel that carried Christ's blood. The quest of the knights culminates in the miracle of transubstantiation.

The Bodleian Psalter, which on other pages has further *bas-de-page* scenes of dwarfs and knights battling against Evil, was probably made for Edward III of England, an ardent Arthurian enthusiast.[137] When only fourteen Edward had been presented with a learned Latin treatise on kingship written for him by the scholar Walter de Milemete. This medieval children's book survives, and in its brightly framed margins are the jousting knights and babewyns that helped form the tastes of the future king when he became bored with the ethics of rulership (illus. 58).

The tournament, which is really a kind of parody of war, was criticized by the Church and even prohibited in some quarters, though it remained popular both at the Edwardian court and in the margins of manuscripts made for courtiers.

'The Order of Knighthood in these days of ours is mere disorder', wrote Peter of Blois to his Archbishop, complaining that knights were now only interested in embroidering their saddles and emblazoning their shields 'with scenes of battle and tourney, delighting in a certain imagination of those wars which, in very deed, they dare not mingle in or behold'.[138] This is an important observation of the way the medieval aristocracy used art as a substitute for the political power they had lost. All the codes and signs that we now think of as quintessential to the Age of Chivalry were, in their own time, already nostalgic gestures, simulations. Only in the margins can we see the class code in crisis, as cowardly knights flee from snails and get it from behind, their nobility usurped, sodomized, by inferiors in the social order.

COURTLY CRAP

> They who were brought up dressed in purple have embraced dung (Lamentations 4:5).

Of all aspects of medieval culture it is perhaps the currency of scatology, the constant playing with faeces in text and image, that is hardest for us to understand today. The margins of manuscripts are literally full of it.[139] What are we to make of a crouching gentleman defecating turds that are then carried ceremoniously to a lady in the *bas-de-page* of an elegant French Book of Hours (illus. 59)? The first assumption we have to rid ourselves of is that 'earthy' medieval folk were, like children, innocent anal obsessives. But second, and even more important, we have to forget our modern, post-Freudian, notions of excrement linked with decay, infection and death. Medieval people did not problematize faecal matter as 'dirt', as Freud's 'matter out of place'.[140] Shit had its proper place in the scheme of things. Not yet a secret secretion, it ran down the middle of the streets, its odours omnipresent. As manure it was part of the cycle of life, death and rebirth, and as everyday matter it found its way onto the pages of prayer-books. Although clerical commentators such as Pope Innocent III saw in human sputum, urine and excrement the 'vile ignobility of human existence', it was the nobility who enjoyed a taste for it. In the usual way, what was considered low and dirty was inverted to become the high

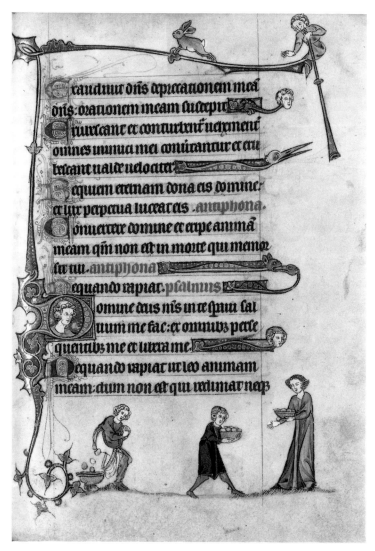

59 Shitting for one's lady. Book of Hours. Trinity College, Cambridge

60 Alexander battles a dragon, naked boys tilt at a barrel and a lady worships at the altar of the anus. *Romance of Alexander*. Bodleian Library, Oxford

and holy. Thus turds are the relics worshipped by a nun at the altar of the anus in the margins of the Bodleian Alexander Romance (illus. 60).

Rather than seeing all marginal imagery from within the discourse of Church exempla, which is how these scatalogical images have been explained previously, we must look to other genres – the epic *Audiger*, for example, and the courtly fabliaux – for analogies to these raunchy images. In one fabliau, called *Jouglet*, a young bridegroom has uncontrollable diarrhoea on his wedding night, which parodies the notion

Es crous z des montaignes
qui sont en che regne
Lor sourdent vnes bestes
de molt grant cruaute
Si grans ome culeures
qui lor sont deuiale
De .iij. chiefs ou .iiij. sont li plusor arme
Li .i. sont pers z inde z li autre dore
Li oil lor reflamboient qui sont enuenime
Par mi le fu se metent quil vient enbrase
Quant cil de lost les vient si ont grant cri leue
Li home alixand leur sont encontre ale
De ceus que li fus art sont li plusor tue
Cal de lost sen tornent si lont le roi conte
Qui sont de .xx. serians z de .xxx. seure
Qui tuit sont des serpens occis z deuore
Estour .uij. liues deuant lalbe aparant
Lor resourt vne beste quapelent dantirant
Rien or le front arme de .iij. cors qui sont grant
Quant ele vit le fu si ot grant maltalant
Les pauellions esgarde si vait entor corant
Li home alixand li sont venu deuant
Qui la fierent despecs z de dars en lanchant
Mes quanque il li font ne prise mie .i. gant
Vint z .vij. cheualiers lor a mort en boutant
z afoles i fuerent .l. z dui sergant
Dedens leue sest mise trestout lor rex wiant
Seignors dist alixand nen adrefes mes mie
Dune rien vous dirai nest hom qui men desdie
Seloins z maltalens fait toute rien hardie
Lessies bouure la beste tant quele soit emplie
Car puis quel ert saoule si sera resortie
z nous li ferons ia deuant vne establie
Quant ele nous verra toute ert acuardie
Iane se desdendra sen lassiut z escrie
Gardes que ele soit noblement asfaillie
Ie la requerrai a melpee. fordie
La gent qui ert en lost de sydome z dareste
Atendent la beste viengne q lor viande gueste
De lune part escrient si li ont paour fete
La beste fu pesant z de leue resete
Ele ert lede z hideuse molt ert de fiere geste
Les pauellions esgarde z si dresce la teste

Et se doubla en crois puis sentent z afete
A .i. cor quele a fait lor i fist tel moleste
Quatre vins cheualiers lor occit z tempeste
Quant ele ot ce tor fait en leue sest retrete

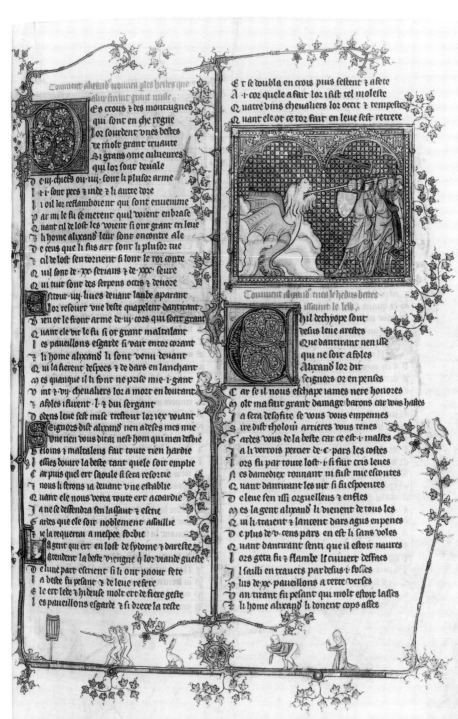

Chil dethyope sont
venus leue arestes
Que dantirant nen uist
qui ne soit afoles
Alixand lor dit
seignors or en penses
Car se il nous eschape iames nere honores
Molt ma fait grant damage barons car vous hastes
Sa sera desfite se vous vous empennes
Ire dist tholom arrieres vous tenes
Gardes vous de la beste car ce est .i. maltes
A li verrois percier de .c. pars les costes
Lors fu par toute lost .i. li faur cris leues
Ses damediex tonnant ni fust mie escoutes
Quant dantirant les uit si fu espoentes
De leue sen issi orguelleus z enfles
Mes la gent alixand li vienent de tous les
Qui li traient z lancent dars agus en penes
De plus de .v. cens pars en est li sans voles
Quant dantirant senti que il estoit naures
Lors geta fu z flambe li cuuert desfaes
Il sailli en trauers par desus .i. folies
Plus de .xx. pauellions a terre verses
Dan tirant fu pesant qui molt estoit lasses
z li home alixand li donent cops asses

of the lover giving his all to his mistress and which perhaps lies behind the straining young man in the Trinity Hours (illus. 59). There is also a fascinating fabliau called *De la Crote*, in which a wife's turd becomes the focus of a guessing-game that results in the husband being forced to eat his wife's excrement.[141]

It was at the courts that the notorious scatalogical French poem *Audiger* was enjoyed. This work was sung by jongleurs all over Europe, and its verses quoted in plays; it was even cited in a letter by King Edward III.[142] Its strophes and structure parodied the *chansons de gestes* of the twelfth century. Like them it told the story of a noble family and its most valiant son, who avenges the insults of enemies in combat and returns home to marry his bride. This noble family wallows in excrement, however, and the son, Audiger, takes on as one of his opponents an incontinent old woman, who forces him to eat three-and-a-half of her turds for breakfast, telling him 'and then you will kiss my cunt and the crack of my ass'. She eats, digests and recycles him repeatedly, analogous to the omniphagic orgies pictured in Gothic marginal art. Excremental products are also given as gifts, as they are in the margins of the Trinity Hours. Early in *Audiger* the hero's mother, Rainberge, brings Count Turgibus 'a fist full of shit, then takes some of her piss and showers him with it', while the couple's dowry consists of 'quinze estrons de chien'.[143]

Now, of course, all this is inversion of epic and courtly stereotypes. The enormous popularity of *Audiger* was due to its radical undermining of expectations. This was a traditional aspect of aesthetic theory according to Geoffrey of Vinsauf's treatise on poetry, the *Poetria Nova*:

> Art . . . plays about almost like a magician, and brings it about that the last becomes the first, the future the present . . . thus rustic matters become polished, old becomes new, public, private, black, white, and vile precious.[144]

The art of *Audiger* does exactly this – vile substances are transformed into precious dung-pearls for a courtly audience that savoured each morsel of filth while, at the same time of course, stood above and beyond it.

The question of why women are the recipients of faecal matter in the two marginal images is not so easily answered

by *Audiger*, in which the male tends to be on the receiving end of both Grinberge's foul faeces and the delectable turds of his wife, Troncecevrance. These laxative ladies have been seen as embodying 'the threatening power of female fecundity: the power to humiliate and to renew'.[145] That power, visible in both this text and in the fabliau tradition, has been usurped by the men in the margins (illus. 59). It is perhaps significant that there is not one example of a defecating woman among the thousands of marginal images and hundreds of *obscenae* catalogued by Lilian Randall. Perhaps it was visually too close to the taboo subject of birth. Defecating as a sign of power and fecundity is appropriated as a kind of pseudo-birth by men, as is the more common theme of men sitting on nests laying eggs.[146] While this egg theme has been seen as a particular jibe against 'tailed' Englishmen, it is an example of a rarely broken taboo – that of the male becoming female.

These two images must also be related to their context. The lover's shitty gift (illus. 59) occurs below Psalm 7, in which the Lord is asked to *libera me* (free his bowels?), and he is watched by a young male head from within the letter. Above the kneeling nun in the Alexander Romance (illus. 60) is a conventional framed image of Alexander the hero slaying a vast dragon whose jaws are open wide, making the lower margins parodic of the knight's thrusting attack; on the left naked boys tilt at a barrel, while on the right the 'other mouth' releases its contents. Another important association – made in modern psychoanalytic as well as in medieval literature – is that of excrement with money.[147] In these two images men are shown as manipulators of 'cash flow', producers of gold that is either collected or worshipped by women. On an even more general level we might think of faecal production as creative power. Just as scholars of the fabliau have begun to see excrement-making as a trope of fiction itself, the recirculation of dead matter, these latrines of faecal form swirling at the edges of the page can similarly evoke the artist's power to make forms from the 'clay' of the earth.[148] Because we have so cleanly separated faeces from everything else in our lives, its medieval status, interwoven with the sacred text, makes us uneasy. Instead of turds being just what they are – matter – they become mysterious signs that we are unable to read, savour and enjoy with the gusto of our ancestors.

> The 11th day of March. Item paid to James of St Albans the King's Painter who danced before the King upon a table and made him laugh heartily, being a gift of the King's own hands, in aid to him, his wife and children, 1s.[149]

Edward II splitting his sides at a member of his court, an artist in fact, making a fool of himself is quite typical of medieval humour. This same monarch also paid his cook twenty shillings 'because he rode before the King and fell oftentimes from his horse, whereat the King laughed heartilly'. Such cruel slapstick occurs everywhere in the images painted by court artists in the margins of manuscripts made for the same élite patrons. Large sums of money were spent on professional entertainers, and they too appear pictured in the margins, the space of social separation dividing élite spectators from their servants and performers.

Jugglers, dancers, jongleurs and musicians abound in late thirteenth-century English manuscripts painted in what is sometimes called the Court Style. Such a book is the Psalter made for Alfonso, son of Edward I, before his death in 1284, which has a marvellous plate-balancing monkey-act in one margin.[150] The fashion of professional music-making in the margins reaches its apogee in the lively Luttrell Psalter, made for a minor nobleman, where 'high' and 'low' instruments share the same page (illus. 52). The traditional view of marginal images as negative *exempla*, as signs that stand for worldly sins, cannot be upheld in these instances.[151] That entertainment was not conceived of in this Augustinian moralistic way at court is shown by the enormous expenses lavished on such entertainers by fourteenth-century fashion-setters and, especially, by the Crown itself. By 1290, for example, expenses for the marriage of an English princess to John de Brabant included payments made to the 426 minstrels who had performed during the festivities.[152] Matilda Makejoy *saltatrix*, an acrobatic dancer, was paid a large sum in 1296 for performing in front of the two Crown Princes when they were still children. Female acrobats like Matilda are painted in the margins of the Smithfield Decretals, a law-book written in Italy but illuminated in London, *c*. 1330.[153] The tumbler, denigrated in the margins of the twelfth-century Church, was here a valued and well-paid servant, part of a hierarchy of

61 Ladies watching knights in the initial, servants scurry below. *Tristram.* Bibliothèque Nationale, Paris

minstrels ranging from trumpeters to personal harpists to the Queen.

Once again, the audience for these images of entertainments is important in assessing the latter's meaning. For the young Prince Alfonso, whose Psalter is full of monkeys and drummers, the framework of court ritual and performance legitimated these brightly clothed bodies as proper for his perusal. In a contrary example, a Book of Hours made for a devout couple in Liège connected to the Béguine Order, the same gestures and female flexibility that made Matilda Makejoy a celebrity at court was a sign of the debasement of the *proprium corpus* described in the text above (illus. 53).

Another major category of marginal figures includes the ordinary household servants that carry dishes and fetch food for the feasts, as shown in the margins of a thirteenth-century French Romance (illus. 61). Sweating servants and the mundane bustle of the castle are not, of course, mentioned in the shimmering world described in the texts of Romances. This reality only intrudes at the edges of their manuscript matrix. In the margins of the Luttrell Psalter, which was made for Sir

Geoffrey Luttrell of Irnham, Lincolnshire, in the 1320s, his household servants are depicted preparing a lavish feast that is brought to the table some pages later. I have written elsewhere about the ways in which the margins of this Psalter depict not only the *famuli*, or household servants, of Sir Geoffrey, but also the customary labours performed in the fields by his free and unfree tenants.[154] The unanswered question is whether the artists of his Psalter were also under his jurisdiction? Or did they have the freedom to portray his workers as they wished, as ill-fed, depressed-looking slaves, as some have interpreted their features? The evidence of the Luttrell Psalter suggests not, since the book's marginal imagery so clearly represents the world from the Lord of the Manor's point of view. This prized possession becomes a kind of record of the richness of his estates, its watermills, windmills and livestock. When Sir Geoffrey read phrases such as 'Lord of all the earth' and 'Let the fields exult' in his Psalter, he could look in the margins and be reminded of the profits being made in his own fields (illus. 62).

62 Carting away the harvest and a yoked peasant. *The Luttrell Psalter.* British Library, London

Such a social reading might also explain the prevalence of more common marginal motifs in Gothic books, such as the hound chasing the hare, which even in non-illustrated texts often frames the opening page. This must surely have signalled and elevated the art of venery, the hunting that was not only a privileged pastime for the aristocracy but also a political issue at a time when many lords were expanding their forest preserves at their tenants' expense. Rabbits, so ubiquitous in medieval marginal art, are economic as well as sexual signifiers, for their meat and fur was much sought after. Warrens were regulated by Lords of the Manor only for their own profit.[155] In 1285, in a period of an expanding manorial economy, the Statute of Westminster extended the Lord's right to enclose common lands. Even in the following century, one of reversals, overpopulation, famine and plague, the animal signs of the healthy manorial economy – hounds, hares, stags and rabbits – continue the chase across the abundant landscape of the margins of aristocratic manuscripts.

There are a few cases of actual manorial documents recording laws and jurisdictions being illustrated in the margins, as in the case of the Free Warren Charter, dated 10 June 1291, in which the King grants Roger de Pilkington various rights 'so that no-one should enter the lands for hunting therein or

domini: a facie domini omnis terra.
Annunciauerunt celi iusticiam eius:
t uiderunt omnes populi gloriam
eius.
Confundantur omnes qui ado
rant sculptilia: t qui gloriantur in
simulacris suis.
Adorate eum omnes angeli eius:
audiunt et letata est syon.
Et exultauerunt filie iude: propter
iudicia tua domine.
Quoniam tu dominus altissimus
super omnem terram: nimis exalta
tus es super omnes deos.

taking anything pertaining to the warren without the licence of Roger' (illus. 63).[156] The thirty-two figures of various beasts and birds in the upper margins and quadrupeds in the lower ones are possessions protected by the document and its seal. The gamekeeper with his dogs appears in the bottom left. Like a pictorial ledger, the margins become the place for recording property rights, both here and – less literally – in the Luttrell Psalter.

Yet, although the Luttrell Psalter and other English Gothic manuscripts can be seen as representing in the margins the superiority and wealth of their patrons over their servants, the culture enjoyed by Sir Geoffrey and that enjoyed by his peasants were not in opposition. The fact that he could not only share in their folk culture but even appropriate it for his own ends is clear from the famous marginal monsters, the babewyns, in the book. These relate to folk-plays and hobby-horse festivals – harvest rituals that were performed by the villagers themselves and, increasingly, for the Lord of the Manor on important feast-days and at other festivities. On the page where the harvest is dragged up the left margin (illus. 62), a half-human horse, or ox-headed babewyn, evokes not only the hard lot of the peasant 'harnessed like oxen to the yoke' but also the mumming in which a villager dressed himself in animal masks and performed for his Lord.

Those who seek to find in marginal images the pure world of 'folklore' and 'popular culture' should remember that these works of art were not made from or for peasant perceptions. The few glimpses they give us of folk life, as in the Luttrell Psalter or the margins of the Alexander Romance, are screened through the lens of aristocratic perception. The village mumming in the margins of the latter, in which the men wear animal masks, is a rare and valuable representation of such festivities of the 'folk', but it is only present as an anti-model of the more courtly dance of the Lords and Ladies in the framed miniature above (illus. 67).

The artists who painted these images were sometimes servants in the retinue of the nobility, but even those who were professionals were lower on the social scale than those for whom they worked. Was the servant able to poke fun at his master in the margins in the same way that the Latin fabulist Phaedrus, who was widely read during the Middle Ages, thought he could?

63 Prohibited prey. *Free Warren Charter*, 1291. Fitzwilliam Museum, Cambridge

64 *overleaf*: Young man led to the 'Gates of Hell'. Book of Hours. Bodleian Library, Oxford

65 *overleaf*: Detail of verso page of illus. 64

go dixi in dimidi
o dierum meorum
uadam ad por-
tas inferi

Quesium residuum anno-
meorum: dixi non uidebo do-
minum deum in terra
uiuenaum.

Non aspiciam hominem et
habitatorem quietis.

Generatio mea ablata
est: et conuoluta est a me

quasi tabernaculum pas-
torum.

Precisa est uelut a texen-
te uita mea: dum ad huc
ordirer succidit me: de ma-
ne usque ad uesperam fini-
es me.

Sperabam usque ad ma-
ne: quasi leo sic contriuit
omnia ossa mea.

De mane usque ad uespe-
rum finies me: sicut pul-
lus hyrundinis sic cla-

161

go dixi in diuidi
o dieium meor
nada in ad ire

tas infeti

Quieciun refichuin ino
meor dpi non indelo do
minuin delin in terra ui
nencium.

Non apiciam homine
uhin: erhabitator em g
eis.

Generatio mea ablata
er: er connoluta er a me

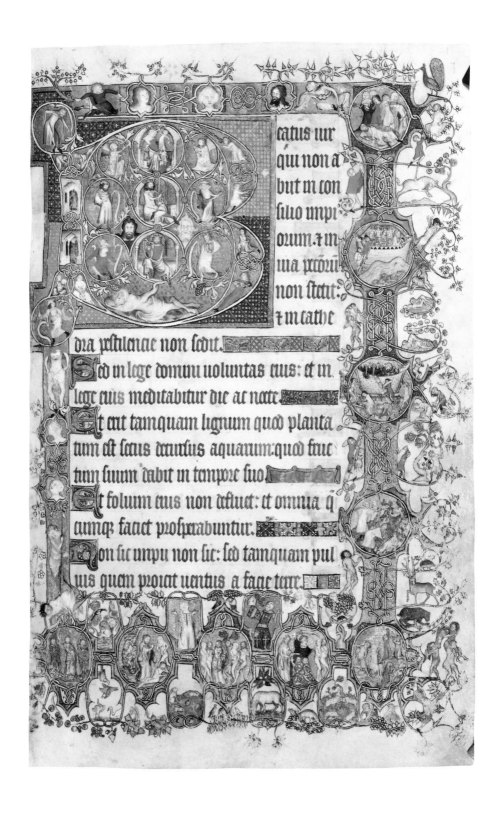

eatus uir
qui non a
buit in con
silio impi
orum. 7 in
uia pctoum
non stetit:
7 in cathe
dra pstilencie non sedit. Sed in lege domini uoluntas eius: et in.
lege eius meditabitur die ac nocte. Et erit tamquam lignum quod planta
tum est secus decursus aquarum:quod fruc
tum suum dabit in tempore suo. Et folium eius non defluet: et omnia q cumque facict prosperabuntur. Non sic impii non sic: sed tamquam pul uis quem proicit uentus a facie terre.

Now I will briefly explain why the type of thing called fable was invented. The slave, being liable to punishment for any offence, since he dared not say outright what he wished to say, projected his personal sentiments into fables and eluded censure under the guise of jesting and made-up stories.[157]

The role England played in the development of the fable is well-known. The model of courtly culture encoded in the Arthurian legends had its roots in twelfth-century England and the Court of Henry II, where Marie de France wrote her 'Fables' that put into polite French the tales told by the illiterate. While the old idea that Gothic marginal illustration was an English invention cannot be substantiated, the role of Anglo-Norman court culture in the creation of new discursive strategies is indisputable. If we wanted to trace a 'great tradition' of English marginal imagery leading up to the fourteenth-century Ormesby and Luttrell Psalters, we must begin with the margins of the most splendid of all secular narratives from the Middle Ages, one which unravels like an epic in its sweeping cloth *laissés* – the Bayeux Tapestry. Here, a commentary on historical events is provided by animal narratives, some of which were later used by Marie de France, which David Bernstein has cogently argued are subversive commentaries on the historical action unfolding above and below.[158] There are a few quite audacious margins, as in the scene where the treacherous Harold is captured and led to William, Duke of Normandy (illus. 68). Below the figure of Harold on horseback, who is shown with a hawk on his wrist while holding his reins in his right hand, is a man with an enormous erection opening his arms to a woman who hides her genitals in shame. Does this stark-naked and uncourtly couple draw attention to the shameful treachery about to be perpetrated by Harold? Or is an analogy being made between the woman's body and the trap he is about to enter? The embroideresses who stitched this twitching couple's members together were probably following male designs rather than inventing designs for the edges of so important a record.

This raises the important issue of gender. The margins, as we have often seen, represent things excluded from official discourse. The 'official' images of the court, in miniatures, ivories, tapestries and sculptures, elevate women onto ped-

preceding pages:

66 The Beatus bursts its bounds. *Hours of St Omer.* British Library, London

67 Dance of courtiers, dance of peasant mummers. *Romance of Alexander.* Bodleian Library, Oxford

68 Guy brings Harold to Duke William of Normandy; couple about to copulate on the edge. *The Bayeux Tapestry*. Musée de la Tapisserie, Bayeux

estals as the longed-for ladies of courtly love. How they are pictured in the margins might at first seem to free them from this passive specular role of doll or icon. But this, too, is an illusion. The inversion and release of liminality works only for those in power, those who maintain the status quo and have something at stake in resisting change. Caroline Bynum, who takes issue with Victor Turner's notion of 'liminality', argues that ritual reversals are mostly impossible for women, and that 'women are fully liminal only to men'.[159] The margins are not the site of liberation for medieval women, as has been suggested by Philippe Verdier.[160] These are images made, for the most part, by and for men. Binding ladies in the lists as spectators of unending games of male prowess, pitting them against men in marital jousts, giving them the upper hand in the popular marginal image of Phyllis riding Aristotle, or making them the luxurious sirens that drop their distaffs to cavort with any man who comes along – women are clearly the victims of a deep misogyny in medieval marginal art, which seals them into oppressive simulations of their social position. While this is not unexpected in Bibles, Psalters and Books of Hours, since the bodies of women were perverse in Catholic teaching, they are also denigrated in the margins of Romance, where women, we tend to think, play a different, more positive, role. Once again we are forced to see overlaps and continuities in the cultural practices and spaces that we tend to separate, and to see how revealing are the edges of discourse, which always return us to the rules of the centre – where women, like peasants, servants and other subjected groups are, in the end, the ones who have to eat shit.

Vrbis affatim pater exemplisq̃ docebat
Saluans paulatim quos a phanis retrahebat
Et gens efferuis dum ult huc trade pernit
Nonnulli credut. alij terrore recedunt
Ac eadem fregit manus ydola que pius egit

5 In the Margins of the City

[Gawain] looks at the entire town peopled by many fine people, at the changers of gold and silver and moneys, all under cover; he sees the open places, the streets completely filled with good workmen who are practicing their different trades. This man is making helmets, this one mailed coats; another makes saddles and another shields . . . Some prick the fabrics and others clip them, and these here are melting gold and silver. They make rich and lovely pieces: cups, drinking vessels and eating bowls and jewels worked in with enamels; also rings, belts and pins. One could certainly believe that in that town there was a fair every day it was so full of wealth.[161]

When the knight in Chrétien de Troyes' Grail poem enters the city he becomes part of a world that contrasts as much with the ecclesiastical as with the courtly model of space – one of horizontal multiplicity rather than vertical hierarchy, a mingling of rich, poor, free, unfree, peasants, knights and clergy as well as the rising bourgeoisie, all rubbing shoulders within the same walls. The distinction between high and low was, however, still retained in *representations* of urban space. This is especially evident in the lavish illustrations in a manuscript of the *Life of St Denis*, first Bishop of Paris, which was begun for Phillip IV but presented to his successor, Phillip V, in 1317 (illus. 69). Here the larger hagiographical narrative squeezes the contemporary bustle of the city to the bottom of the page. But the activities painted in the lower margins of the framed sacred narrative of the saint's life were in reality central, especially for its patron, the King. The busy bridges over the Seine, the merchants' boats bearing barrels of wine, a variety of shops, surgeons and street-pavers form a continuous strip throughout the manuscript, as if the *bas-de-page* had broken through the walls of the picture frame to enter the city.[162] These lively scenes seem at odds with the saints and their Latin speech-scrolls above; indeed, they represent a new vernacular world of 'things' – commodities. New things

69 Beggars on the bridges of medieval Paris. *Life of St Denis*. Bibliothèque Nationale, Paris

demand new words and concepts. In *De Laudibus Parisibus* of 1323 the Parisian scholar John of Jandun describes how such strange and exotic merchandise (*delicatis et extraneis*) was sold at Les Halles, and how he is unable to give their names in Latin, *propria nomina latina*.[163] Like the famous cries of the street-vendors, the discourse of the city was the vernacular babble after Babel.

Polysemous and multicoded, the city was the site of exchange, of money, goods and people, creating a shifting nexus rather than a stable hierarchy. Each social group possessed 'its own concept of urban space just as the different interests of the city compete with each other for control of the social surplus'.[164] Art was a crucial outlet for that surplus, with Paris becoming the first art centre in Western Europe. The increasing demand for tapestries, fabrics, ivories, jewelry, plate, pictures and prayer-books came from the rising bourgeoisie, who sought to possess symbols of status and aristocratic luxury. Paris developed a booktrade serving the university and lay patrons as early as the twelfth century; other cities – Ghent, Bruges and London – soon followed. It has been noted that 'the region where marginal illumination was most fully developed in the decades preceding and following the turn of the fourteenth century coincides with one of the most active trading areas in Northern Europe at this time'.[165] What was the relationship between nascent capitalism and images in the margins? Certainly the variety of stuffs, the rich fabrics and the very pigments and colours of the Parisian markets made their way into the margins of manuscripts. Bringing together the exotic and the familiar, fairs promoted the conjunction of discourses and the particular confrontation of jongleurs, dancing bears, bath-house attendents, knife-grinders and tradesmen visible in marginal masterpieces such as the Hours of Jeanne d'Evreux, made in Paris, and the Bodleian Alexander Romance, made in the Flemish city of Bruges. They suggest a cacophony only possible in an urban context. But rather than examine this mercantile context of interaction in the multiplicity of the margins, I want to find representations of urban marginals themselves. Can we find in pictures the same kinds of relations between social centres and margins that are explored in Bronislaw Geremek's important study, *The Margins of Society in Late Medieval Paris*, which deals with those men and women exist-

ing on the fringes of society – prostitutes, pimps, petty criminals, the unemployed and, most visibly, beggars?[166]

PANHANDLERS AND PROSTITUTES
IN MEDIEVAL PARIS

> I have pawned the little I had so that poverty lords it over
> me and then I had to pawn my very clothes; frequenting
> taverns has disrobed me. I don't know what will become
> of me or where to go. The streets cluttered with poor people
> [*ces genz menus*] and at every step one hears, 'Beggar! God
> who calls me? Come here, this bowl is empty'.[167]

In the Paris portrayed along the bottom edge of the scenes of
the *Life of St Denis*, beggars and their bowls are depicted as
much a part of the social fabric as the moneychanger and
shoemaker; indeed, it is a female cutler who leans out of her
storefront on the Petit Pont to give alms to a beggar with a
child on 'its' back (illus. 69). The medieval acceptance of pov-
erty as part of God's scheme of things, indeed as a necessity,
lies behind the inclusion of these unfortunates in a series of
images 'promoting' the wealth and industry of the city. To
have so many parasites was, in fact, a sign of wealth, since
they depended upon the alms of the rich, who by giving
charity helped wipe clean their slates of sin.

These illuminations cannot, however, be taken as evidence
of a direct sort about the reality of social experience. While
they bear some relation to the spaces they depict, it is not a
topographical but an ideological space that places the poor in
particular places. Each full-page scene in the *Life of St Denis*
manuscript depicts the commercial activity of the two bridges
across the Seine, which linked the Ile de la Cité with the Right
and Left Banks, mapping the currents of power in the city.
The three depictions of beggars in the book – the beggar and
child shown here, the barefoot pilgrim on the very first page
and a pair of cripples on folio 2v – all occur on the Petit Pont
leading to the Left Bank rather than on the commercial Grand
Pont leading to the wealthier Right Bank. This smaller bridge
was also closer to the Hôtel Dieu, the overcrowded haven for
sick paupers with over four hundred beds that was situated
between Notre-Dame and the Seine.

The *Life of St Denis* focuses on entrances, bridges and gates

at places of mendicancy, which fits with what we know of the topography of poverty in Paris of this period. The concentric distribution of wealth meant that the poor huddled nearer the walls, a natural attraction for the vagrant and those just arriving from the countryside. It is important to remember that city walls were a major physical and symbolic barrier for medieval people, defining jurisdiction and control as well as excluding undesirables, such as lepers, who were quarantined in one or other of the nearly fifty leprosariums that existed in Paris in the fourteenth century, most located near or outside the gates. Many of the poor lived along the city walls near the Porte St Martin on the right bank. St Martin was the Roman rider who gave half his cloak to a beggar he encountered – significantly, at the gates of the city of Amiens – and he was the most common public icon of charity given by the wealthy – those on horseback – to those who went on their bare feet. A few poorer parishes existed on the Ile de la Cité itself and, as Geremek points out, 'wealth lived side by side with the greatest deprivation'.[168] Like today's beggars in London or New York, medieval alms-seekers roamed everywhere, in the streets, on the bridges, in the shadows of the cathedral searching for coins, crumbs and shelter. Their appearance in the social survey of the very heart of medieval Paris in the *Life of St Denis* suggests their ubiquity. But the early fourteenth century was a time when the traditional view of poverty came under pressure, as famines and wars swelled the ranks of those 'without'. Churchmen, caught up in the debate over the 'voluntary poverty' of the Franciscans, pushed more of a work ethic and judged that 'he who will not work, neither shall he eat'. The beggar became associated with the vagabond and criminal and, like Jews and lepers, became the object of hysterical accusations, including those of having poisoned wells and having kidnapped and mutilated children for the purpose of attracting more alms. The *Life of St Denis* was painted in the midst of the worst years of the century for famine, inflation and unrest, a period that preceded the Black Death but came close to it in terms of mass starvation and misery; however, this aspect is not visible in its backward-looking ideal vision of the deserving, brightly dressed beggar living within and yet on the edge of the urban social order.

Beggars also appear in large numbers in the margins of Books of Hours made in Paris and other major cities where

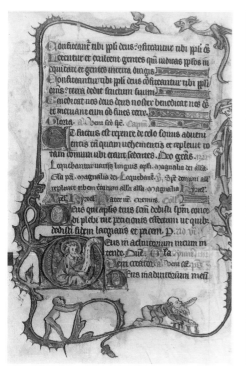

mendicancy was becoming more of a social problem (illus. 70–73). In a Book of Hours from the thriving commercial city of Ghent, a well-dressed burgher is pictured in the side margin about to proffer a coin to a cripple holding his begging-bowl between his teeth (illus. 70). In the same Book a beggar dressed in a fool's cap carries a monkey instead of a child on his back, suggesting people's unease with the 'staging' or simulation of poverty.[169] In many cases these unfortunates are depicted as variants of the deformed forms of babewyns and other heteroclite bodies, but rather than having extra body parts, these unfortunates lack them, the most common type being the legless figure who pulls himself, often acrobatically, forward on his stumps with small wooden contraptions for crutches (illus. 71). One has to remember that in this period, disease was considered a punishment for sin or possession by the Devil. Lepers, for example, were thought to bear their uncleanness from having been conceived on Sundays or during menstruation.[170] That these more realistic depictions of human suffering be placed alongside monsters

and monkeys in the margins is not surprising, considering the harsh attitude to the indigent in this period, with the poor thought of as 'more bestial than beasts', monstrous deformities of nature and 'made of the Devil's excrement'.[171]

In his popular book, *Ways of Seeing*, John Berger described his outrage at certain juxtapositions he saw in a copy of *The Sunday Times* colour supplement – in which a glossy advertisement for furs appeared on the same page as a photograph of starving Biafran babies.[172] Such confrontations not only failed to appal medieval audiences, they were sought out by them. There is no better example of this than the page of the *Petits Heures* of Jean, Duc de Berry, the richest man in France, an early art collector whose famous *Très Riches Heures* includes views of Paris as depicted from his palace on the Seine's Left Bank. In the more intimately scaled *Petits Heures*, one page juxtaposes a portrait of the Duke kneeling to the Virgin and Child in the centre with the marginal image of a beggar, accompanied by a barefoot boy, carrying a child (illus. 72).

The bearded old beggar in this image has the hindquarters of an animal. He is less than human. This group stands exposed on the spiky emptiness of vellum as opposed to the Duke framed in his lush blue and gold interior. On a velvet cushion is the Duke's little lapdog, a hint at the vast amounts he spent on his pets – far more, according to chroniclers, than he gave to the poor. Yet what function did the marginal image serve here? Did it remind the Duke of his Christian duty of charity, or did it not rather serve to distinguish the haves from the have nots, inverting the usual priorities of access to Divinity? The Beggar and Child image here is a pauperized parody of the Holy Mother and Child within; the Duke and the beggar are even dressed in the same rose colour! Is there any critique of the Duke's excess here? I doubt it, considering this patron's involvement with book production and the fact that by the end of the fourteenth century – when the Duke was living in high style – money could buy one a place in Heaven quite easily, though most of the Duke's went into art and entertainment and not into the bellies of the starving, to judge by contemporary accounts. Although traditionally the Church had taught that the deserving poor would gain their just rewards in the hereafter, according to the Parisian poet Rutebuf, the poor man's soul was allowed neither into Hell nor Heaven, because it emanated not from his mouth (the

72 The Duke, the Virgin and the destitute. The *Petits Heures of Jean, Duc de Berry*. Bibliothèque Nationale, Paris

134

73 St Louis washes
the feet of beggars.
*Hours of Jeanne
d'Evreux.*
Metropolitan
Museum of Art,
New York

traditional iconography) but from his anus as a foul-smelling
fart that even the devils could not withstand.[173]

In other lavish manuscripts produced in Paris the same
juxtaposition is made between wealth and poverty. In the
minute Hours of Jeanne d'Evreux the shimmering *grisaille*
surfaces painted by Jean Pucelle delineate putrid, sore-
infested beggars as well as the Queen, who owned the book.
On some folios beggars play the role of Atlantes – holding up
the tiny aedicules of Gothic architecture (illus. 73). They are
inspired by the subjugated 'marmousets', a rabble of empty
bellied and open-mouthed folk carved at Gothic cathedrals
like Amiens, which seem to make the 'stones cry out' (illus.
74), cowering beneath the feet of victorious saints and Church
Fathers. The cathedral was also an important locus for the
giving of alms, and beggars were often simulated in stone
alongside their real referents, protruding on the socles below
the jamb figures. These simulacres of the living half-dead that
huddled at the west portals of major churches were noted by
Ruskin a hundred years ago and were still there at Amiens
on my last visit.

Pucelle plays on these images of abjection, miniaturizing –
and thus neutralizing – their cries. Their elastic marginal
bodies contrast with the more static draperies of the divine

personages at the centre. *Mobilitas* itself had associations of vice, as the thirteenth-century Parisian preacher Humbert of Romans argued:

> There are others who move about, unable to remain in one place: they appear now here, now there, running to and fro without ceasing. These are like the people of whom it is said in Jeremiah 14, 'They love to move about and never rest and the Lord is not pleased with them.' Blessed Benedict calls them *gyrovagi*.[174]

Literally gyrating, inverting and jumping from letter to letter and line-ending to *bas-de-page*, the animated folk who people the margins of Jean Pucelle's minute cities are, in their very unfixity, damnable. It was their lack of place (like dirt) that made beggars so disturbing, their wanderings out of their subservient roles as caryatids or Atlantes in the Hours of Jeanne d'Evreux. Here the wandering poor also appear alongside the narrative of her sainted grandfather, Louis IX, who

74 Crouching open-mouthed *marmouset* beneath Habbakuk. Amiens Cathedral

not only gave much to the poor but was supposed to have washed their feet and kissed the sores of lepers (illus. 73). Prominent in the framed miniature is the King's biographer Joinville, who crosses his arms and refuses to demean himself like the haloed King. The hand of another courtier reaches across to give money, suggestive of the King's patronage of the Hôtel Dieu and other charitable establishments in Paris. This giving gesture contrasts with the pleading arm of the beggar outside the frame who hobbles forwards, bowl in hand. Pucelle plays upon contrasts between soft *grisaille* surface and frenetic violence, between minute elegance and its frayed edges. Lilian Randall has shown how, in the same book, the artist links the Arrest of Christ and Judas' kiss in the framed miniature with the violent, courtly party game of Hot Cockles painted in the opposite *bas-de-page*.[175]

Here the contrast is between the humility of beggar and King and the pride of the corrupt clergy. In the top-right corner a hooded babewyn looks in the mirror of Vanity, while in the letter a fat priest plays the bellows of Pride from a book held out by an even more diminutive monk. Meanwhile, the monarch, fount and head of the realm, simulates his divine marginality at the centre.

Another aspect of the depiction of the poor and crippled that it is hard for us to understand today is their being made the object of fun. Laughing at ugliness and deformity was institutionalized in court dwarfs and buffoons, but in the cities it became a more ribald public spectacle. In Arras the plays of Jean Bodel (who died a leper) and Adam de la Halle satirized the corruption of the clergy but also the half-humanness of the *vilain*, or peasant, who is always monstrously ugly. The farce *Garçon et Aveugle* involved playing tricks on a blind old man and was pictured in the margins of the Taymouth Hours and the Bodleian Alexander Romance. Thus, we cannot rule out that alongside the evocation of Christian pity, the marginal depictions of twisted and deformed beggars might have been amusing, especially the popular subject of beggars fighting each other with their stumps and crutches. Such cosmetic, perfumed and laughter-inducing images of bodies that in reality must have looked and smelled truly repulsive remind us of the power of representations, not simply to articulate reality, but, literally, to construct it.

75 Portal of St Stephen, Cathedral of Notre-Dame, Paris

The south transept portal of Notre-Dame in Paris (illus. 75) led to the Bishop's Palace and, although not easily seen by the public, its sculptural programme is very much a propaganda piece. As well as having an image of St Martin and the Beggar in the left pinnacle it includes another marginal type in the panoply of the thirteenth-century city – the prostitute. She appears in the reliefs at the lowest register at the extreme right end, nearest the public square. Facing the Left Bank, these reliefs aptly narrate scenes in the life of students.[176] At bottom left, a young student is shown becoming embroiled in legal wranglings with a woman of ill-repute who, in the top-right scene, is tied to a ladder, where she is being pelted with muck and rotten eggs by the crowd below as a punishment for swearing falsely in the Bishop's Court (illus. 76). It is not the detailed narratives of these complex and controversial scenes that interest me here; it is their surrounding marginal imagery. At bottom left we see men reaching deep into their pockets and exchanging money, suggestive of 'buying' the flesh of the fallen women at the centre. In the margins of the

139

scene of punishment are dogs being beaten and spectators watching from their windows. Rather than elegant ladies observing the courtly joust from the lists that we have seen in many manuscript margins (illus. 61), here ladies are enjoying the urban spectacle of public punishment and ritual humiliation.

The prostitute in these reliefs is not being punished for her trade – which was precariously authorized throughout the Middle Ages. Nevertheless, Louis IX, as well undertaking

76 Four reliefs, portal of St Stephen. Cathedral of Notre-Dame, Paris

charitable work among the poor, in 1254 limited prostitution in Paris to eight particular streets in which prostitutes might ply their trade, and excluded them 'from the centre of cities', especially from 'churches and churchyards'. The prostitutes of Amiens were forced to spend night and day in a street called the Rue des Filles, but this became so overcrowded that their workplace had to be enlarged.

The appearance of prostitutes in monumental sculpture at Notre-Dame in Paris, and on the west front of Amiens, where two quatrefoils on the 'bas-de-page' of the façade show the prophet Hosea buying a whore for fifteen pieces of silver (Hosea 3:2), were part of the Church's effort to control and convert these literally loose women. They were deemed dangerous in that they were not tied to a husband and family, but instead wandered the streets selling their bodies. Innocent III had declared that a man who married a prostitute performed a 'work of charity' that would count towards the remission of his sins. More interesting in terms of the appearance of this urban vice on the façades of cathedrals is the fact that, as the cleric Thomas Chobham relates, the whores of Paris habitually offered candles and gifts at Notre-Dame on Saturdays, although they were not allowed to make contributions during mass 'lest they mingle the stench of the stews with the odours of sacrifice'.[177] A group of them had their offer to donate a window to the same cathedral refused by the Bishop.

Prostitutes appear less frequently in the margins of manuscripts, although female attendants at their bath-houses (ostensibly brothels) appear with some regularity. In the margins of a tiny Book of Hours, Douce MS 6 in the Bodleian Library, a young man is led to his pleasure by what would seem to be an urban 'madam' (illus. 64). The whole opening of the Holy Word reeks with the stench of the stews. A rabbit perched on the E of 'Ego' sniffs at the lady within the letter, while across the page the line-endings erupt into a man 'supping' and a phallic unicorn. The bas-de-page scene, with its stress on the architecture of the doorway towards which the youth is being led, is a none-too-subtle response to the words of the Psalm at the top of the page: 'I said in the midst of my days I shall go to the gates of Hell' (Ad portas inferni), referring, of course, to the vaginal gates of no return. The association between Hell and bought sex was not invented by the artist.

In a fabliau of the period, a priest enters the town of Nesle and sees beautiful girls displaying themselves on balconies; that night he dreams of a 'cunt market'. He is sold a repugnant pudendum that smells 'like the gates of Hell'.[178]

Produced in Ghent *c.* 1320–30, Douce 6 is a miniscule *summa* of urban mercantile misappropriations, and it is full of the kind of hybrid multiple discourses to be found in the comic drama of French Flanders. Adam de la Halle's *Jeu de la feuillée*, performed in late-thirteenth-century Arras, has an urban cast that consists of a merchant, doctor, vagrant madman, renegade priest, fairy prostitute and mad son who attempts to bugger his father, thinking him a cow. Relics, women's bodies and coins are crucial signs that, in this play, become 'objects of fetishistic desire'.[179] These figures, their wordplay and constant subversion of sacred stereotypes are similar to what we see in the margins of manuscripts produced in this region. At Psalm 109 in Douce 6, for example, across from the dead rising from their graves at the Last

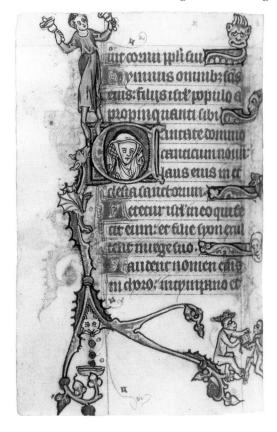

77 Bells, simian seals and vomited coins. Psalter. Bodleian Library, Oxford

Judgement is a lady who grabs her lover's rising member, 'the rod of thy strength' in the words of the Psalm alongside.[180] On another page, the key to all these transactions is vomited out of the mouth of a gargoyle-like monster – money, actual blobs of gold-leaf stamped with a cross in the centre (illus. 77). These were the signs that carried the economy of the new Sodoms and Gomorrahs, chastised by the Churchmen of the time. Money, like shit, is everywhere in the margins, being passed to beggars, between lovers, between buyer and merchant, between client and prostitute. Jangling in the beggar's cup like the bells that are rung on this page, coin was the 'new song' – the *canticum novum* to which everyone had to dance, even the patron of this book who bought these very images and paid the urban artist, just as he paid the prostitute, with these sullied signs of the city.

CARNIVAL, CHARIVARI AND THE SCANDAL OF THE CENTRE

> The public square and the streets adjoining it are the proper place for carnival. The public square brings what is marginal or borderline in ordinary life to the very centre of the community.[181]

The order of the city, its policing of desire and control of capital, was questioned and contested only at the significant social rupture of carnival. This predominantly urban ritual developed out of the pre-Lenten feast of putting away flesh (*carne-vale*), with a wide variety of local differences.[182] In the most influential study of carnival culture, the Russian scholar Bakhtin stressed its counter-cultural resistance to the official order by the 'folk', but this has recently been questioned as Utopian nostalgia.[183] Often licensed by the civic authorities, all the inversion, cross-dressing, riotous drinking and parodic performance at carnival time was a carefully controlled valve for letting off steam. In this sense, carnival seems similar to what we have seen going on in the manuscript margins, since in both carnival and marginal art what looks at first like unfettered freedom of expression often served to legitimate the status quo, chastising the weaker groups in the social order, such as women and ethnic and social minorities. We have to face up to carnival's complicity with the official order, played out in the supposed subversion of it.

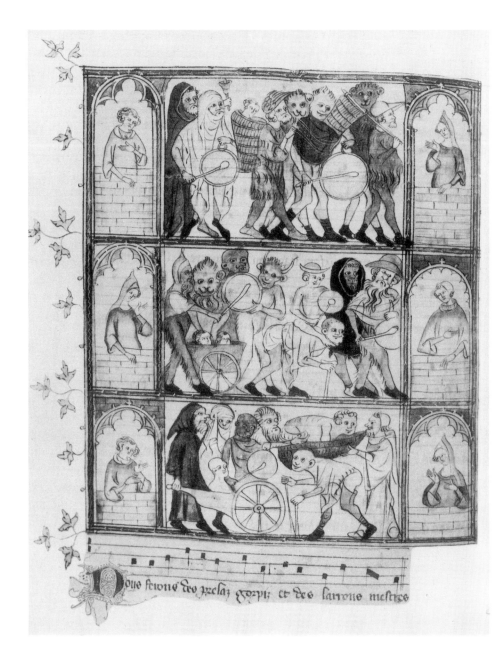

Doue ftions dvo pælag gcozpi; et deo farrono meftreo

It would not really be accurate to term images in the margins as *carnivalesque*, despite their radical refusal of order and systematic inversion of body-parts. In reality, carnival festivities occurred in the centres and public squares of towns and villages, not at their edges, their public nature embodying the civic authorization of misrule. An early image showing this centrality as well as the marvellous trappings and masks used on such occasions occurs in a manuscript of the *Roman de Fauvel* made in Paris in 1316 (illus. 78). It actually depicts a quite specialized form of ludic disruption, the *charivari*, which was a deep-rooted rite of social control and complaint.[184] This is the only occasion in French manuscript illumination when scatalogical antics, monstrous masks and ludic spectacle occur not in the margins but in the centre of the page, being observed by urban spectators from the sides.

There is no better example than the *charivari* of how premodern societies used ritualized disruption to reinstate social norms rather than resist them. Known in England as 'Rough-Music', the *charivari* was a procession of loud instruments – the pots and pans and utensils of everyday life – calculated to rattle the nerves of social miscreants, adulterers, wife-beaters or unmarried couples, but most often to complain at second marriages. The procession described in the *Roman de Fauvel* and illustrated in the manuscripts includes men dressed as monks, in 'gros sacs', and showing their arses to the spectators ('l'un montrait son cul au vent') or throwing shit at them.[185] This scurrilous and scatalogical rout is headed by Hellequin, a fabled figure who leads the undead and carries the souls of illegitimate infants on his back. The artist has been careful to show the figures as men wearing masks, as humans simulating otherworldly creatures.

Jean Pucelle reinvents the public parade of *charivari* in the miniscule private spaces of the Hours of Jeanne d'Evreux (illus. 79). The sequence of Christ's conception, culminating in the Visitation, where the Virgin's pregnancy is pointed out by Elizabeth, is juxtaposed with manic pot-banging in the margins below. One figure even follows the exact directions of the *Roman de Fauvel*, having 'a basin which he bangs underneath'. Is this a *charivari* against the scandal of the Virgin birth? The questionable legitimacy of Christ and foolish Joseph parodied as a cuckold occurs in plays and art of the later Middle Ages, but it is pushed to its extreme here. The testicular bagpipes

drooping below are a literal absent signifier, since they were not needed in the creation of God's son.

These, what seem to us, radical misreadings of the sacred, playing upon conception and the scandal of birth, are even more telling when one considers the life of Queen Jeanne for whom this book was made, probably for her wedding in 1325. She may have used this little book to pray for her own immaculate conception. This was because Charles IV had married her in order that she produce a male heir, which his previous two queens had failed to do. As noted above, the *charivari* was most often aimed at too-hasty remarriages. When Charles IV died of tuberculosis in 1328, Jeanne was left carrying this child, whose sex was crucial to the continuity of the Capetian line. If it was a male, she would be the mother of the future King of France, but if it were a girl Sallic law meant she could expect nothing. On 1 April 1328 Jeanne gave birth to a daughter. The subsequent wranglings of the claimants – Philippe de Valois and Edward III of England – concerned legitimacy and birth. In this respect, and unbeknown to Jean Pucelle when he painted them, the clanking pots and noisy *charivari* in Jeanne's tiny prayer-book herald not only the disastrous Capetian effort at procreation but sound out the scandal that began the Hundred Years' War.

A great multitude of poor people were assembled at the gate of the Friars Preachers seeking alms, Robert Fynel, Simon, Robert and William his sons and 22 other male persons, names unknown, Matilda, daughter of Robert the carpenter, Beatriz Cole, Johanna, 'le Peyntures' . . . and 22 women names unknown, whilst entering the gate, were fatally crushed owing to the numbers.[186]

The death of Johanna, this unknown woman artist, trampled with other poor people begging alms from a Dominican priory, serves to remind us of the socially marginal position of many medieval artists. In the list of 'illicit trades' reviled in the Medieval West as studied by Le Goff, we read not only of butchers, innkeepers, jongleurs and, of course, prostitutes, but also of painters.[187] Most of them had small family businesses, which were nothing like our ideal notion of the 'workshop'. Richart and Jeanne de Montbaston were just such a husband and wife team of illuminators who worked under the jurisdiction of the University of Paris. They portrayed themselves at work in the margins of a *Roman de la Rose* manuscript (illus. 80), where their division of labour is made clear. At the right Richart writes the text, hanging up the gatherings on a rack to dry, while on the other side his wife Jeanne paints the images. There are numerous other documents attesting to the involvement of women in the Paris book-trade, both as

80 Richart and Jeanne de Montbaston, illuminators. *Roman de la Rose*. Bibliothèque Nationale, Paris

81 Nun picking
penises from
phallus-tree.
Roman de la Rose.
Bibliothèque
Nationale, Paris

illuminators and as the *libraires* who organized the work of
others and ran shops. From a manuscript documented as
having been illuminated by Richart in 1348 we can trace the
many products of this couple, and learn how Jeanne con-
tinued her husband's business after his death, swearing her
oath as *libraire*, or bookseller, before the University in 1353.[188]
The copulations, prominent erections and a tree flowering
with phalluses pictured in the *bas-des-pages* of this manuscript
may very well have been the work of this lady, perhaps the
first example we have of a woman artist subverting sexual
roles in the depiction of male desire and domination over her

sex. Her little men are dominated by their vast erections. Jumping on animals, nuns and anything else that passes by (illus. 81), these men are as much the butt of the joke as the traditionally errant cloistered females who share their space.

Self-representations by medieval artists in all media are more common than one might suppose. Scribes and artists had been depicting themselves in the *bas-des-pages* and margins of manuscripts since the twelfth century.[189] In the thirteenth century, the St Albans monk and artist Matthew Paris painted himself in the lower margin of his Chronica Majora below his depiction of the Virgin and Child. Like the scribe who is only the passive channel and transmitter of the Word, and whose self can only emerge at the end of the labour of writing – 'so and so wrote this book' – the artist, too, was always at the limits, the edges of works. In the tiny pages of Douce 6 a sculptor is reduced to a line-ending.[190]

The position of the maker in his lowly status before the masterworks he made was a matter of religious humility, one that always pointed beyond himself. As the artist-monk Theophilus warned, 'you can do nothing of yourself'. In stained glass the lower edge of the window was often the site for the donor images, as in the trade windows at Chartres, but it also allowed the artist occasionally to depict himself, sometimes giving his name. In sculpture there are famous examples of self-inscriptions within Romanesque tympana, and even sometimes marginal depictions of the artist at work, but these are always tiny in relation to a much larger centre or to the corbels and gargoyles of the 'excluded' exterior. It is surprising, however, that there are a large number of images, especially from the twelfth century, showing artists at work, which should make us question the cliché of medieval anonymity. It was not that the artist was a nobody, it was more a matter of his situation relative to the body, the Word of God that was his subject. Even if his art was not religious and he worked for a secular lord designing tapestries and armorial pageants, his position was still subservient and secondary to the 'Lord'.

With the increased division of labour and professionalization in the thirteenth and fourteenth centuries, there is, in fact, less authorial self-inscription than in the previous century. The artist, while in some senses gaining in prestige (especially the goldsmith and the architect), lost the unity of

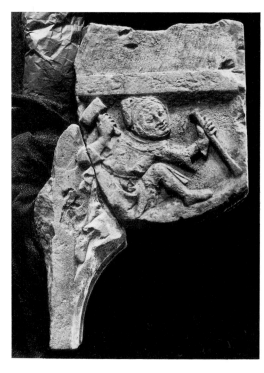

82 Mason with
mallet and chisel in
spandrel of St
William of York's
tomb. Yorkshire
Museum, York

conception and personalization of production. Depictions of
the producers do appear, as in the tomb of St William of York
that stood in the east end of the nave at York Minster, in a
cusped spandrel, which sports the tiny figure of a gloved
stonemason clutching his mallet and chisel (illus. 82). The
modern notion of self-expression, which allows the creator to
impose his or her self as the object and centre of attention,
was unknown. It is, indeed, crucial to the ideas developed in
this book that the margins were not only the site for rep-
resenting 'the other' – peasants, servants, beggars, cripples,
fools and women – but also the place of self-inscription for
the medieval artist.

The most lively of marginal masterpieces is the Smithfield
Decretals, illuminated in London *c*. 1330. Among its 600 mar-
ginal illustrations, all placed literally 'under the Law' in the
bas-de-page, are a number of scenes of artists at work. One
shows St Dunstan, the famous monastic artist, in his cell
drawing a picture of a butterfly (illus. 83). A strange appar-
ition appears before him, perhaps an allusion to the legend
of how the Devil mocked the saint at his work. William of
Malmesbury described Dunstan as an artist skilled in emulat-

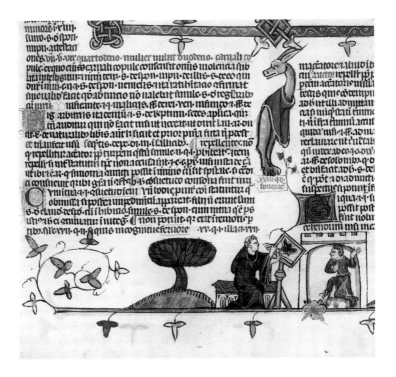

83 St Dunstan draws a butterfly. *Smithfield Decretals.* British Library, London

ing nature and translating into images anything he observed in the world. The butterfly is a sign of the fleeting and illusory, evoking a new aspect of the artist's role – to capture something living, to go beyond conventions. In this representation of a venerable English monastic saint-artist, the new image of the urban professional of the fourteenth century is also evident.

For the husband and wife team in Paris and the illuminators of London who painted the Smithfield Decretals, the city was the art centre, where patrons, even royal ones, came increasingly to buy and commission work. By the fourteenth century an art market begins to develop. This commodification is in many ways crucial to the development of marginal illumination in its expansive period, c. 1300–50. The rising urban bourgeois especially wanted to ape the styles and show of the aristocratic courts and buy into their symbols of heraldry and chivalry. In manuscripts produced at the major mercantile centres of Paris, London, Peterborough, Ghent, Arras, Bruges and Bologna, we see the most developed taste for marginal art. Although the patrons are various, being royal, monastic, clerical and bourgeois, the manuscripts have a

strong urban feel, like the Smithfield Decretals, which sensationalizes the capital's low life as much as any current tabloid. Its bear-baiters, dancers and other urban aboriginals are not unlike those described by a late twelfth-century monk of Winchester:

> The number of parasites is infinite. Actors, jesters, smooth-skinned lads, Moors, flatterers, pretty boys, effeminates, pederasts, singing and dancing girls, quacks, belly-dancers, sorceresses, extortioners, night-wanderers, magicians, mimes, beggars, buffoons . . . if you do not want to dwell with evildoers, do not live in London.[191]

On another level, the wealth and public life of cities promoted the beginnings of what we would call 'fashion', and the excess of marginal art provides exactly the superfluity the *nouveaux-riches* were seeking in the early fourteenth century. An Italian lawyer Odofredus complained that his son went to Paris to study but had ended up squandering all his money having his books 'bemonkeyed' (*fecit libros suos babuinare*) and written in gold letters.[192] The very forms that, two centuries before, had inflamed St Bernard as unfitting for the attention of men of God were now signs of prestige and luxury, the latest Paris 'fashion' that the artist now served instead of God.

6 The End of the Edge

> It appears that certain aphasiacs, when shown various differently coloured skeins of wool on a table top, are consistently unable to arrange them into any coherent pattern Within this simple space in which things are normally arranged and given names, the aphasiac will create a multiplicity of tiny fragmented regions in which nameless resemblances agglutinate things into unconnected islets.[193]

One page of a Psalter made for a Norfolk family *c.* 1330 will have to stand for the summation, and yet, at the same time, the beginning of the demise of the tradition of Gothic marginal representation that I have been celebrating (illus. 66). The opening of the first Psalm, *Beatus Vir*, is illustrated with the usual Tree of Jesse, an image of divinely ordained lineage. But this generation dissolves into prolific promiscuity in a myriad of minute figures and spaces. Nine marginal roundels narrate the story of the Creation and Fall from bottom left to top right, culminating in the shame and drunkenness of Noah, whose exposed penis and position echoes the sleeping Jesse within the letter B. But there are a thousand other correspondences in the coils that make up this teeming trelliswork. In the left margin wildmen fight, men chop down trees and Adam and Eve, now fallen, can copulate. Bust-like portrait heads produce another 'genealogical' aspect, as do the two noble donors, William de St Omer and Elizabeth of Mulbarton. At the very bottom are various minutely rendered animals, horses, rabbits and birds. A dark-robed figure at top left tugs on the tendrils as if struggling to hold the whole thing together. Here on one page are all the various types and elements of the marginal repertory in an obsessively microscopic scale. There is an anxiety about unravelling these skeins that is not unlike that of Foucault's aphasiac – a sense of the fragility of the whole system that loads so much into such a small space. Similar traits visible in later fourteenth-century English illumination are due not only to Continental

influence, but embody the conflicts and crises over space and power in the decades following the Black Death.

Already in the *Beatus* page a major change has taken place. The marginal scenes are no longer painted upon the bare vellum, hovering between the text and the field, but are given their own circular pockets of space. This is the beginning of an increasing three-dimensionality in marginal image-making, which will totally transform this area in the late fourteenth century and early fifteenth, and make the 'play' we have explored, defunct. The margins either become a shimmering illusion or an architectural frame, a hole through which one looks towards the centre.

ILLUSION AND COMMODIFICATION

The margins had always been the site of illusion. From the eighth-century Utrecht Psalter, where an idol topples in the bottom margin as an illustration of 'profane illusion' mentioned in the Psalm text, to the simulations of Gothic grylli, babewyns and other *singes*, this is where the artist played games with representation that, I have argued, were deeply self-conscious.[194] By the fifteenth century these games had become more literal illusions.

In the Hours of Catherine of Cleves, one of the most magnificent of all fifteenth-century Netherlandish manuscripts, we can see the two systems of marginal representation, the old and the new, colliding. On some pages there are the traditional monkeys and little men doing their thing in the *bas-de-page*. On others it is as if the book has literally been invaded by objects: actual things have been plonked onto the page – a rosary, mussel shells, and, most audaciously, pretzels and biscuits (illus. 84). On this page tiny men try to hold the edges together, but on other pages they have been superseded by flowers, pea-pods and other life-size things casting their shadows and dripping dew.[195]

This taste for *trompe-l'oeil* effects, pictorial tricks that include flies landing on petals, reaches its apogee in Flemish manuscripts of the later fifteenth century. The pages become Eyckian mirrors in which the personal paraphernalia of the owner is reflected. The opening up of space visible in the main scenes is not carried through to the margins, which remain cupboard-like shallow spaces lodged in front of the deep

anctissime bartholomee
dei apostole. qui per des
truchonem ydolorū et
multam operationem miracu
lorum populum nō modicā
ad fidem domini nostri thesu
xpisti conuertisti amore. auē
omnes huius seculi uanitates

85 The margins
frame St Matthew
and the angel.
Spinola Hours. J.
Paul Getty
Museum, Malibu

space of the miniature within, as if to create an illusionistic
frame. In the Spinola Hours it is this frame and its shadows
that are the most 'real' part of the page, outshining the Holy
writer within and the monkey-business petering-out without
(illus. 85). This immediately sets up a relativity not visible in
Gothic book design, where the script shares an equality with
image and margin. Once the thin vine scrolls and bar-borders
become self-sustaining illusions, the fictions that once danced
among them are deemed inappropriate and not 'real' enough.
It is the eye as a reflecting surface, a vacuous mirror, not
a beacon of the imagination, that is being played upon in
fifteenth-century manuscripts.

The range of things focused upon by the illuminator with
a gaze like a spotlight is similarly narrowed down. It is the
things of nature that can be pressed and dried, kept like
butterfly specimens in this glassy case of illusion. The 'dead
life' of *nature-morte*, or still-life, has one of its origins here.
As well as flowers, pilgrims' badges and pieces of jewelry

belonging to the patron are often placed in the margins, making the possibility for perverse play imprurient.[196] It is not noted often enough how the spatial revolution in Renaissance art coincided with the origins of a system of oppositions between high and low art, between the vulgar and the refined, the unique and the commonplace, that have remained with us to the present. Patrons no longer wanted everyday things – pots and pans, popular riddles and fabliaux – pictured in their margins as did Marguerite in her Hours (illus. 14). Her Ghent grandchildren wanted rare and valuable objects scrutinized with a veracity that puts a price on them. All this might be called commodification, since the 'things' placed in the margins are now material objects, either valuable in their own right or prestigious in the art or fashion market. It is significant that this change occurred in the Flemish and northern French centres of commerce and trade – Bruges and Ghent – where 'the aesthetics of decontextualization [was] at the heart of the display'. As an anthropologist of commodities puts it:

> The enhancement of values through the diversion of commodities from their customary circuits underlines the plunder of enemy valuables in warfare, the purchase and display of 'primitive' utilitarian objects, the framing of 'found' objects, the making of collections of any sort.[197]

Often forgotten in accounts of illusionism that describe the new autonomy and freedom of the artist's manipulation of the picture space, is how illusion is used as a means of power and control over others. To 'trick' the eyes with a picture that looks real but is not introduces a capturing of the gaze; the viewer is 'taken in' by the image, like the birds tricked by the Classical painter Zeuxis. The Renaissance 'windows on the world', through which larger segments of it could be possessed, treated the page as if it were a painting. But what Otto Pächt saw in Flemish illumination as profound and playful illusion, I would see as less liberating.[198] These are a different kind of joke than those told in the margins of Gothic books. Once you have got it, the visual pun is defunct and you stare forever.

In Italy, the margins became pseudo-classical triumphal arches, monumental frames for viewing new humanist texts;[199] another revolution involved not picture-space but

mechanical reproduction. The demise of the marginal tradition might be attributed to the printing press, which used repeatable blocks to frame pages of Books of Hours and limited the newly discovered Grotesque decorations to another 'modern' invention, the title page. As Samuel Kinser notes, compared to the manuscript book the printed book 'has small margins just wide enough for a word or two, an emendation, an exclamation'.[200] The urge to have clean edges often resulted in medieval manuscripts being cruelly cropped down, a practice typical of the increasing disrespect for everything but the text in subsequent centuries. The great religious upheaval of the Reformation also had its effect on the eradication of the medieval image-world. A great rift opens up between words and images. Language is now in a separate realm, written in discrete boxes or in fields hanging in the picture space.

86 The end of the end. *Voeux du Paon.* Pierpont Morgan Library, New York

Focusing all representation in the middle, the centre where man stood resplendent, Renaissance thinkers pretended that they no longer required this space of 'otherness', unless it be the new edges of the World being discovered by Columbus. As Hal Forster puts it, in the modern social order, which 'knows no outside (and which must contrive its own transgression in order to define its limits), difference is often fabricated'.[201] This is why 'marginality' is so fashionable today as a Postmodernist pose. Yet the process began centuries ago, as things previously kept to the margins were placed centre-stage and appropriated by bourgeois taste: peasants in Breughel's paintings, drunks in seventeenth-century genre paintings and 'low life' in Hogarth's social satires. If during the Middle Ages patrons had shared the margins with the monkeys, jongleurs and peasants they in reality lorded over, in later centuries the forms of representation split to demarcate distinct class positions. The 'grotesque' became a category in which to place everything barbaric and 'medieval' until such things came to titillate the Romantic sensibility in the nineteenth century. There would be no place for carnival, now banished to the 'popular' end of the market and only of interest to the curious antiquarian of folklore. Unlike the medieval patron or donor, the connoisseur positioned himself (he was usually male) above the tastes of the 'vulgar', and wanted images untainted by any whiff of the lower bodily stratum of the body politic.

La gent machidone au riche empereour
Caulz t ariste t le preu florid our
En maine callam̃ iusq̃ la maistre tour
e la cambre verr̃ issent li ameour
Betys en va deuãt li anne p amour
Esconas en prist ij ki mlt sauoit donour
Cone t pdicas appella p dulchour
Doucement les salue t lour dit sens uour
De nos diex t des vr̃es aиes ws hui bon iour
Ydr̃ laissa trestos son ameour
Caulz t ariste a fait mlt grãt honour
a la belle edea maine ioie grignour
Floridas a sailli t si a dit seruour
Esdin ur̃e cousin floridas lamnachour
Demades li nouelle ke sont ur̃e anchessour
uer che dit ydr̃ tous nos diex en aour
Dr̃ sisent gr̃t ioie q̃ muenemẽt entour
Pour les tapis de soie tetes a la verdour
Lor bone nouelle si eta le mellour
Pour les tapis de soie t sour lerbe menue
Sasist la gente de gresse ki mlt ert bñ venue
La pole damours i est bñ despondue
Engie a son droit qit elle su cheue
Atta pst edea p la blance main nue
Et loc elle li dist ke ne sort espdue
Telle dist callam̃ aues urel̃ daiethe
ne dist la pucelle ki ne su mie mue
Escoc bone amour fine su mlt bñ p珊eue
p ur̃e q sel moi su bien mantenue

All this may sound as if I am privileging, perhaps even idealizing, a 'free' and open medieval gaze over a more tyrannical modern visual system. Yet, if this book has shown anything, it is, I hope, that the art of the Middle Ages was not a sombre expression of social unity and transcendent order. Rather, it was rooted in the conflicted life of the body with all its somatic as well as spiritual possibilities. Representation has to be policed more thoroughly in the modern world, I would argue, precisely because the truths being articulated are no longer so fixed and stable as they once appeared to be. Today's senators and Conservative watchdogs have made the body an ideological battleground undreamt of by the medieval Inquisition. For them, 'Art' is something purer than a monstricule gulping down a monkey's turds at one end and farting loudly at the other (illus. 86). And yet, the freedom of this fourteenth-century illuminator was not like that of the Modern painter creating forms in a Cartesian void, nor like the Postmodern artist who toys with advertising and Pop icons, neither of whom are free of the anxiety, one might even say the tyranny, of originality. Gothic marginal art flourished from the late twelfth to the late fourteenth century by virtue of the absolute hegemony of the system it sought to subvert. Once that system was seriously questioned, art collapsed inwards, to create a more literal and myopic dead-centre, taking with it edges and all.

References

1 Bakhtin 1968, p. 96.
2 For the later history of the Grotesque see Kayser 1963.
3 Verdier 1972, n. 14.
4 Evans 1949, p. 38, and Janson 1952.
5 Leupin 1990, p. 148.
6 Porter 1960, xxviii and trans. in Gravdal 1989, p. 61.
7 Documents discussed by Evans 1949, pp. 38–44; for stained glass see Crewe 1987.
8 Camporesi 1989, p. 79.
9 Friedman 1981, pp. 43–51.
10 Duby 1962, p. 161.
11 Geremek 1990.
12 Speake 1980, p. 91.
13 Lewis 1980.
14 Camille 'Seeing and Reading' 1985.
15 Goddard 1987. The riddle is in Stith Thompson 1955–8, F.665.
16 Parkes 1976.
17 Hugh of St Victor 1961, p. 119.
18 Langland 1975, p. 370.
19 De Hamel 1984.
20 See Camille 'Illustrations in Harley 3487', 1985.
21 *Dialogue of Solomon and Marcolf* as cited in Corti 1979.
22 Corti 1979; Kunzle 1978.
23 See edition by Duff 1892, p. 22.
24 Babcock-Abrahams 1975, Koepping 1985.
25 The Douai Psalter, folio 124*v*; see Sandler 1986, fig. 273. Marcolf also appears in Marguerite's Hours (my illus. 25).
26 Gifford 1974.
27 Sandler 1986, cat. 43.
28 Robertson 1966.
29 Harrison and Wibberly 1982, pl. 87.
30 Pächt 1943.
31 Babcock-Abrahams 1975, p. 164.
32 Kolve 1966.
33 For this MS see Randall 1966 and 1989.
34 Thompson 1898, p. 309. Davenport 1971 summarizes previous approaches to marginal images on pp. 91–3.
35 For a history of bowdlerizing babewyns see Randall 1966, p. 10, and Sandler 1975.
36 Baltustraitis 1960 and 1981.
37 Bastard 1850, p. 172.
38 Champfleury 1898 p. 40.
39 Maeterlinck 1907, p. 55.
40 Randall 1962.
41 Pinon 1980.
42 *New Paleographical Society* 1912, pl. 198.
43 For proverbs see Jones 1989 and Smith 1978, p. 69.
44 This drawing is reproduced in Brandenburg 1986, pl. 3.
45 Freud 1905, pp. 41–5.
46 Schapiro 1977 and 1979, and Kendrick 1988, p. 114.
47 This is Foucault 1965, p. 20 describing the gryllus. For hybrids in general see Sandler 1975, and on their psychological impact, Nash 1980.
48 Sandler 1986, no. 31.
49 Bloch 1986, pp. 77–8.
50 Roy 1976, p. 57.
51 Mellinkoff 1973.
52 Foucault 1978, Brown 1988 and Halperin 1989.
53 Sandler 1985.
54 Nordenfalk 1967.
55 Turner 1979.
56 For the *Belleville Breviary* see Avril 1978, pl. 12; for the *Tickhill Psalter*, Egbert 1940, and for Matthew Paris, Lewis 1988.
57 For instructions to illuminators see Camille 'Book of Signs' 1985, Sandler 1989 and Alexander 1990.
58 Freud 1905, p. 45.
59 Douglas 1975.

60 Bloch 1986, p. 125.
61 Richard de Fournival cited in Randall 1966, p. 5.
62 Yapp 1981.
63 Pächt 1954.
64 Pierpont Morgan Library 1974, no. 29. Called 'the Hours of Marguerite Beaujeu' by Belin 1925 and Harthan 1977, p. 52.
65 Arnheim 1982.
66 Two pregnant women and a giantess are 'opened up' in the margins of a Paris MS of Albert the Great's *De Animalibus* (my illus. 23); see Imbault Huart 1983, pp. 122–3.
67 For the *Roman de Fauvel* depiction of Hellequin see my illus. 78.
68 Miles 1989, p. 153.
69 Bakhtin 1968, p. 317.
70 Bruyne 1946, p. 271.
71 Leach 1976, p. 35.
72 Peter of Celle 1987, p. 79.
73 Ladner 1967; Turner 1979.
74 Kristeva 1982, p. 125.
75 Seidel 1988.
76 Cassagrande and Vecchio 1979.
77 Cited in Leclercq 1973.
78 Peter of Celle, p. 103.
79 St Bernard's letter is cited from Davies-Weyer 1971, p. 70.
80 Morson 1956 and Clark 1982.
81 For eating see Marin 1987, p. 37, and Leclercq 1978.
82 Peter of Celle, p. 160–1.
83 Mann, *Ysengrimus* 1987, p. 533.
84 Porter 1923. For a recent study of Aulnay see Werner 1979.
85 Gilbert 1985, p. 137.
86 For Hugh see Swartout 1932, pp. 16–7, and for Aelred, Walker and Webb 1962, p. 74.
87 James 1951, p. 141.
88 Kedar 1986.
89 Randall 1966, p. 10.
90 Mann, *Ysengrimus* 1987, p. 365.
91 Murray 1970, p. 241.
92 Leach 1964 and 1976, and Klingender 1971.
93 Evans 1906.
94 Caesarius of Heisterbach 1929, pp. 232, 382.
95 Talbot 1959, p. 99.
96 For erotic themes in twelfth-century sculpture see Sheridan and Ross 1975, Anderson 1977, and Weir and Jerman 1986.
97 Constable 1978, p. 208.
98 Brown 1988, p. 422.
99 Gerald of Wales 1979, p. 178. For magic see Lowenthal 1978.
100 Brandenburg 1989.
101 Abou-El-Haj 1988.
102 Cited in Randall 1966, p. 5. For gargoyles see Bridham 1930.
103 Flutre 1971 and Camille 1989, p. 251.
104 Bridham, p. xiv.
105 Huysmans 1898; English trans. 1922.
106 Mâle 1984, p. 59.
107 Le Goff 1980.
108 Owst 1961, p. 238.
109 Kris 1952, p. 213.
110 Gardner 1975.
111 Gaignebet and Lajoux 1985, pp. 271–5.
112 Richer 1918, p. 168; Weigert 1934.
113 Mâle 1984, p. 59.
114 Mann 1987, p. 535.
115 Minnis 1971, p. 73.
116 Jacquart and Thomasset 1988, p. 165.
117 Ibid., p. 288.
118 Murray 1974, p. 304.
119 Krohm 1971, p. 54, and Lanfry 1960, p. 31.
120 Coulton 1910, p. 311.
121 Chambers 1903, p. 294, and Morrison 1989.
122 Young 1933, II, pp. 154–65.
123 Prior 1912, p. 533; Grossinger 1975.
124 Adeline 1873, p. 65.
125 See Bond 1910 and Remnant 1969. For English examples and for French misericords, Kraus 1975 and Gaignebet and Lajoux 1985.
126 Tracy 1988 describes them as Marvels of the East. Compare peasant labour and play as juxtaposed in the Luttrell Psalter (illus. 63).
127 This is the Cistercian 'Pictor in Carmine', James 1951.
128 Ruskin 1903, p. 217, and for his drawing pl. xiv. Marcel Proust later went on a pilgrimage to locate this minute

creature, as he recounts in the Preface to his 1904 French translation of Ruskin's *Bible of Amiens.*

129 Walter Map 1983, p. 3
130 Duby 1977, pp. 179–85.
131 Stones 1976.
132 Jaeger 1985, p. 266.
133 Le Goff 1988, p. 113.
134 For liturgical parodies see Randall 1966, figs 569–72. For sacred and profane models see Stones 1977.
135 Brownrigg 1989.
136 Helsinger 1971.
137 Alexander 1983.
138 Coulton 1918, p. 281. Vale 1982 is excellent on tournaments.
139 Wentersdorf 1984.
140 Douglas 1966.
141 Bloch 1986, pp. 52–3.
142 An English translation appears in Brians 1972, but see also Sinclair 1978 and Gravdal 1989, pp. 65–77.
143 Translated from Gravdal, ibid.
144 Translated from Leupin 1989, p. 17.
145 Gravdal p. 79.
146 Randall 1960.
147 Little 1971.
148 Bloch 1986.
149 Cited in Grose and Astle 1808.
150 Randall 1966, fig. 324; Constantinowa 1937.
151 This is the approach taken by Robertson 1963, and to some extent by Randall 1957 and 1966.
152 Bullock-Davies 1978, p. 12.
153 London, British Library, Royal MS 10.E.IV folio 58.
154 Camille 1987; Backhouse 1989.
155 Bailey 1988.
156 Clay 1931. For a French manorial MS with marginal images see Verriest 1950.
157 Cited in Bernstein 1986, p. 135.
158 Bernstein pp. 124–33.
159 Bynum 1984.
160 Verdier 1975; see also Sekules 1987.
161 Chrétien de Troyes, *Conte de Graal,* trans. Holmes 1952, p. 133.

162 Egbert 1974 and Lacaze 1972–3.
163 Jandun 1867, p. 51.
164 Gottdiener 1986.
165 Randall 1966, p. 9.
166 Geremek 1988.
167 Guillaume de Villeneuve, cited in Egbert 1974, p. 32.
168 Geremek p. 77.
169 Randall 1966, fig. 82.
170 Jacquart and Thomasset 1988, pp. 181–93.
171 Mollat 1988, p. 178.
172 Berger 1972, p. 152.
173 Rutebuf 1989, p. 61.
174 Brett 1984, p. 127.
175 Randall 1972.
176 Kraus 1967, pp. 3–16.
177 Brundage 1987, p. 393.
178 Leupin 1989, p. 87.
179 Vance 1987, p. 219.
180 See Robertson 1966, fig. 23.
181 La Capra 1983, p. 301.
182 Heers 1983, p. 299.
183 Bakhtin 1968, Stallybrass and White 1986. For an excellent visual study of Carnival see Gaignebet and Lajoux 1985.
184 Le Goff and Schmitt 1981.
185 Laangfors 1914, p. 165.
186 Calender of Coroner's Rolls of the City of London 1322, Sharpe 1913, p. 61.
187 Le Goff 1980, p. 59.
188 Bibliothèque Nationale 1972, p. 138.
189 Egbert 1967 has many examples.
190 Egbert, p. 55.
191 Cited in Rossiand 1990, p. 139.
192 Rouse and Rouse 1988, p. 259.
193 Foucault 1966, p. XVIII.
194 For the 'illusion' in the Utrecht Psalter see Camille 1989, fig. 23.
195 Facsimile by Plummer 1966.
196 Kren 1983.
197 Appaduri 1986, p. 28.
198 Pächt 1986, who calls it a spatial 'resolution'. The best analysis of still-life is now Bryson 1990.
199 Pächt 1947.
200 Kinser 1990, p. 25.
201 Forster 1985, p. 166.

Bibliography

Abou El-Haj, Barbara, 'The Urban Setting for Late Medieval Church
 Building: Reims and its Cathedral between 1210 and 1240', *Art History*, XI
 (1988), pp. 17–41.
Adeline, Jules, *Les sculptures grotesques et symboliques*, Rouen, 1879.
Alexander, J. J. G., 'Painting and Manuscript Illumination for Royal
 Patrons in the Later Middle Ages', *English Court Culture in the Later
 Middle Ages*, ed. V. J. Scattergood and J. W. Sherborne, New York, 1983.
———, 'Preliminary Marginal Drawings in Medieval Manuscripts',
 Artistes, artisans et production artistique au moyen âge, III, ed. X. Barral
 I. Altet, Paris, 1990, pp. 307–21.
Anderson, J., *The Witch on the Wall*, London, 1977.
Appaduri, Arjun, *The Social Life of Things*, Cambridge, 1986.
Arnheim, Rudolf, *The Power of the Center: A Study of Composition in the
 Visual Arts*, Berkeley, 1982.
Avril, François, *Manuscript Painting at the Court of France: The Fourteenth
 Century*, New York, 1978.
Babcock-Abrahams, Barbara, '"A Tolerated Margin of Mess": The
 Trickster and his Tales Reconsidered', *Journal of the Folklore Institute*,
 XI (1975), pp. 147–86.
Backhouse, Janet, *The Luttrell Psalter*, London, 1989.
Bailey, Mark, 'The Rabbit and the Medieval East Anglian Economy', *The
 Agricultural History Review*, XXXVI (1988), pp. 1–20.
Bakhtin, M. M., *Rabelais and His World*, trans. H. Iswolsky, Bloomington, 1965.
Baltrusaitis, Jurgis, *Le Moyen Age fantastique*, Collection Henri Focillon, III,
 Paris, 1955.
———, *Réveils et prodigies: Le Gothique fantastique*, Paris, 1960.
Bastard, Alexander, Comte de, *Bulletin des comités historiques*, II (1850), p.
 172.
Belin, Mme, *Les Heures de Marguerite de Beaujeu*, Paris, 1925.
Berger, John, *Ways of Seeing*, London, 1972.
Bernstein, David, *The Mystery of the Bayeux Tapestry*, Chicago, 1987.
Bibliothèque Nationale, *Le Livre*, Paris, 1972.
Bloch, R. Howard, *The Scandal of the Fabliaux*, Chicago, 1986.
Bond, F., *Woodcarvings in English Churches: Misericords*, London, 1910.
Brandenburg, A. E., et. al., *Carnet de Villard de Honnecourt*, Paris, 1986.
———, *La Cathédrale*, Paris, 1989.
Brett, Edward Tracy, *Humbert of Romans: His Life and Views of Thirteenth
 Century Society*, Toronto, 1984.
Brians, Paul, trans. and ed., *Bawdy Tales from the Courts of Medieval France*,
 New York, 1972.
Bridham, Lester Burbank, *Gargoyles, Chimeras and the Grotesque in French
 Gothic Sculpture*, New York, 1930.
Brown, Peter, *The Body and Society: Men, Women and Sexual Renunciation in
 Early Christianity*, New York, 1988.
Brownrigg, Linda, 'The Taymouth Hours and the Romance of "Beves of
 Hampton"', in *English Manuscript Studies, 1100–1700*, ed. P. Beal and
 J. Griffiths, Oxford, 1989, pp. 222–41.
Brundage, James A., *Law, Sex and Christian Society in Medieval Europe*,
 Chicago, 1987.
Bruyne, Edgar de, *Etudes d'esthétique médiévale*, I, Bruges, 1946.

Bryson, Norman, *Looking at the Overlooked: Four Essays on Still Life Painting*, London, 1990.

Bullock-Davies, Constance, *Menestreuorum Multitudo: Minstrels at a Royal Feast*, Cardiff, 1978.

Bynum, Caroline Walker, 'Women's Stories, Women's Symbols: A Critique of Victor Turner's Theory of Liminality', *Anthropology and the Study of Religions*, ed. R. L. Moore and F. E. Reynolds, Chicago, 1984.

Caesarius of Heisterbach, *The Dialogue on Miracles*, trans. H. Von, E. Scott and C. C. Swinton Bland, London, 1929.

Camille, Michael, 'Seeing and Reading: Some Visual Implications of Medieval Literacy and Illiteracy', *Art History*, VIII (1985), pp. 26–49.

———, 'The Book of Signs: Writing and Visual Difference in Gothic Manuscript Illumination', *Word and Image*, I (1985), pp. 133–48

———, 'Illustrations in Harley MS 3487 and the Perception of Aristotle's "Libri naturales" in 13th-Century England', *England in the 13th Century*, Proceedings of the 1984 Harlaxton Symposium, ed. W. M. Ormrod, Harlaxton, 1985.

———, 'Labouring for the Lord: The Ploughman and the Social Order in the Luttrell Psalter', *Art History*, X (1987), pp. 423–54.

———, 'The Language of Images in England 1200–1400', *The Age of Chivalry: The Art of Plantagenet England*, ed. J. J. G. Alexander and P. Binski, London, 1987.

———, *The Gothic Idol: Ideology and Image-Making in the Middle Ages*, Cambridge, 1989.

———, 'Sounds of the Flesh-Images of the Word', *Public*, IV/5, 'Sound' (1990), pp. 161–9.

Camporesi, Piero, *Bread of Dreams: Food and Fantasy in Early Modern Europe*, trans. D. Gentilcore, Chicago, 1989.

Casagrande, Carla, and Vecchio, Silvana, 'Clercs et jongleurs dans la société médiévale (XIIe et XIIIe siècles)', *Annales: économies, sociétés, civilisations*, XXIV/5 (1979), pp. 913–28.

Chambers, E. K., *The Medieval Stage*, Oxford, 1903.

Champfleury [Jules Husson], *Histoire de la caricature du moyen âge et sous la renaissance*, Paris, 1898.

Clay, Charles, 'An Illuminated Charter of Free Warren, dated 1291', *The Antiquaries Journal*, XI (1931), pp. 129–34.

Constable, Giles, 'Aelred of Rievaulx and the Nuns of Watton: An Episode in the Early History of the Gilbertine Order', *Medieval Women*, ed. G. D. Baker, Oxford, 1978, pp. 205–26.

Constantinowa, Alexandra, '"Li Trésors" of Bruno Latini', *Art Bulletin*, XIX (1937), pp. 203–18.

Corti, Maria, 'Models and Anti-Models in Medieval Culture', *New Literary History*, X/2 (1979), pp. 343–60.

Coulton, G. G., *Social Life in Britain from the Conquest to the Reformation*, Cambridge, 1918.

Crewe, Sarah, *Stained Glass in England, ca. 1180–1540*, London, 1987, pp. 52–55.

Davenport, S. K., 'Illustrations Direct and Oblique in the Margins of an Alexander Romance at Oxford', *Journal of the Warburg and Courtauld Institutes*, XXXIV (1971), pp. 83–95.

Davies-Weyer, Caecilia, ed., *Early Medieval Art, 300–1150: Sources and Documents*, Englewood Cliffs, NJ, 1971, pp. 168–70.

Douglas, Mary, *Purity and Danger*, New York, 1966.

———, 'Jokes', *Implicit Meanings: Essays in Anthropology*, London, 1975, pp. 90–114.

Duby, George, *Rural Economy and the Country Life in the Medieval West*, London, 1962.

————, 'Youth in Aristocratic Society', *The Chivalrous Society*, trans. C. Postan, London, 1968.

Duff, Gordon, ed., *The Dialogue of Solomon and Marcolf*, London, 1892.

Egbert, Virginia Wylie, *The Medieval Artist at Work*, Princeton, 1967.

————, *On the Bridges of Medieval Paris: A Record of Early 14th-Century Life*, Princeton, 1974.

Evans, E. P., *The Criminal Prosecution and Punishment of Animals*, London, 1906.

Evans, J., *English Art, 1307–1461*, Oxford History of English Art, Oxford, 1949.

Flutre, L.F., 'Le Roman d'Abladare', *Romania*, xcii (1971), 469–97.

Forster, H., *Postmodern Culture*, London, 1985.

Foucault, Michel, *Madness and Civilization: A History of Insanity in the Age of Reason*, trans. R. Howard, New York, 1965.

————, *The Order of Things: An Archaeology of the Human Sciences*, trans. A. Sheridan-Smith, London, 1970.

————, *The History of Sexuality, I: An Introduction*, trans. R. Hurley, New York, 1978.

Freud, Sigmund, *Jokes and Their Relation to the Unconscious* (1905), *The Standard Edition of the Complete Psychological Works of Sigmund Freud*, viii, trans. and ed. by J. Strachey, London, 1953–74.

————, 'Character and Anal Eroticism' (1908), *The Standard Edition*, ix, trans. and ed. by J. Strachey, London, 1953–74.

Friedman, John Block, *The Monstrous Races in Medieval Art and Thought*, Cambridge, Mass., 1981.

Gaignebet, Claude, and Lajoux, Jean-Dominique, *Art profane et religion populaire au moyen âge*, Paris, 1985.

Gardner, Arthur, *Wells Capitals*, 5th edn. Wells, 1978.

Gerald of Wales, *The Jewel of the Church: A Translation of the "Gemma Ecclesiastica" of Giraldus Cambrensis*, ed. J. T. Hagen, Davies Medieval Texts and Studies, 1979.

Geremek, Bronislaw, *The Margins of Society in Late Medieval Paris*, trans. J. Birrell, Cambridge, 1988.

————, 'The Marginal Man', *Medieval Callings*, ed. J. Le Goff, Chicago, 1990, pp. 347–71.

Gifford, D. J., 'Iconographic Notes Towards a Definition of the Medieval Fool', *Journal of the Warburg and Courtauld Institutes*, xxxvii (1974), pp. 336–42.

Gilbert, Creighton, 'A Statement of the Aesthetic Attitude around 1230', *Hebrew University Studies in Literature and the Arts*, xiii/2 (1985), pp. 125–54.

Goddard, R. N. B., 'Marcabru, "Li proverbe au vilain" and the Tradition of Rustic Proverbs', *Neuephilologische Mittelungen* (1988), pp. 55–67.

Gottdiener, M., 'Culture, Ideology and the Signs of the City', *The City and the Sign: An Introduction of Urban Semiotics*, ed. M. Gottdiener and A. Ph. Lagopoulos, New York, 1986.

Gravdal, Kathryn, *Vilain and Courtois: Transgressive Poetry in French Literature of the Twelfth and Thirteenth Centuries*, Lincoln, 1989.

Grose, F., and Astle, T., 'On the Rude Sports of People of High Rank in Former Times', *The Antiquarian Repertory*, ii (1808).

Grossinger, Christa, 'English Misericords of the Fourteenth and Fifteenth Centuries and their Reference to Manuscript Illuminations', *Journal of the Warburg and Courtauld Institutes*, xxxviii (1975), pp. 97–108.

Halperin, David M., 'Is There a History of Sexuality?', *History and Theory*, xxviii (1989), pp. 259–74.

Hamel, Christopher de, *Glossed Books of the Bible and the Origins of the Paris Book Trade*, Woodbridge, Suffolk, 1984.

Harrison, Frank, and Wibberly, Roger, *Manuscripts of 14th-Century English Polyphony Facsimiles*, London, 1981.

Harthan, John, *The Book of Hours*, London, 1977.

Heers, Jacques, *Fêtes des fous et carnavals*, Paris, 1983.

Helsinger, Howard, 'Images on the Beatus Page of Some Medieval Psalters', *Art Bulletin*, LIII (1971), pp. 161–76.

Hernstein-Smith, Barbara, *On the Margins of Discourse: The Relations of Literature to Language*, Chicago, 1978.

Holmes, Urban Tigner, ed., *Daily Living in the 12th Century: Based on the Observations of Alexander Neckham in London and Paris*, Madison, 1952.

Hugh of St Victor, *The Didascalion of Hugh of St Victor: A Medieval Guide to the Arts*, trans. J. Taylor, London, 1961.

Huysmans, J.-K., *La Cathédrale*, English trans., London, 1922.

Imbault-Huart, Marie Jose, *La Médecine au moyen âge à travers les manuscrits de la Bibliothèque Nationale*, Paris, 1963.

Jacquart, Danielle, and Thomasset, Claude, *Sexuality and Medicine in the Middle Ages*, trans. M. Adamson, Princeton, 1988.

Jaeger, C. Stephen, *The Origins of Courtliness: Civilizing Trends and the Formation of Courtly Ideals, 939–1210*, Philadelphia, 1985.

James, M. R., 'Pictor in Carmine', *Archaeologia*, XCIV (1951), pp. 141–66.

Jandun, Jean de, 'Tractatus de Laudibus Parisius', *Paris et ses historiens*, ed. Le Roux de Lincy and L. Tisserand, Paris, 1867.

Janson, H. W., *Apes and Ape Lore in the Middle Ages*, London, 1952.

Jones, Malcolm, 'Folklore Motifs in Late Medieval Art, I: Proverbial Follies and Impossibilities', *Folklore*, c/2 (1989), pp. 201–17.

Kayser, Wolfgang, *The Grotesque in Art and Literature*, trans. U. Weisstein, Bloomington, 1963.

Keller, Hans-Erich and Stones, Alison, *La Vie de Sainte-Marguerite*, Tübingen, 1990.

Kenaan-Kedar, Nurith, 'Les Modillons de Saintonge et du Poitou comme manifestation de la culture laïque', *Cahiers de Civilisation Médiévale* XXIX/4 (1986), pp. 311–30.

Kendrick, Laura, *The Game of Love: Troubadour Wordplay*, Berkeley, 1988.

Kinser, Samuel, *Rabelais' Carnival: Text, Context, Metatext*, Berkeley, 1990.

Klingender, Francis, *Animals in Art and Thought to the End of the Middle Ages*, Cambridge, Mass., 1971.

Koepping, Klaus-Peter, 'Absurdity and Hidden Truth: Cunning Intelligence and Grotesque Body Image as Manifestations of the Trickster', *History of Religions* (1985).

Kolve, V. A., *The Play Called Corpus Christi*, Stanford, 1966.

Kraus, Henry, *The Living Theatre of Medieval Art*, Philadelphia, 1967.

——— and Kraus, Dorothy, *The Hidden World of Misericords*, New York, 1975.

Kren, Thomas, ed., *Renaissance Painting in Manuscripts*, J. Paul Getty Museum and British Library, London, 1983.

Kris, Ernst, 'Ego Development and the Comic', in *Psychoanalytic Explorations in Art*, New York, 1974, pp. 204–16.

Kristeva, Julia, *Powers of Horror: An Essay on Abjection*, trans. L. S. Roudiez, New York, 1982.

Krohm, Hartmut, 'Die Skulptur der Querhausfassaden an der Kathedrale von Rouen', *Aachener Kunstblaetter*, XL (1971), pp. 40–153.

Kunzle, David, 'World Upside Down: the Iconography of a European Broadsheet type', *The Reversible World: Essays in Symbolic Inversion*, ed. B. Babcock, Cornell, 1978.

Laangfors, A., *Le Roman de Fauvel par Gervais de Bus*, Paris, 1914–9.

LaCapra, Dominick, 'Bakhtin, Marxism and the Carnivalesque', *Rethinking Intellectual History*, Ithaca, NY, 1983, pp. 291–324.

Lacaze, Charlotte, 'Parisius–Paradisus, An Aspect of the Vie de St Denis Manuscript of 1317', *Marsyas*, XVI (1972–3), pp. 60–66.

Ladner, Gerhart B., 'Homo Viator: Mediaeval Ideas on Alienation and Order', *Speculum*, XLII/2 (1967), pp. 233–59.

Lanfry, G., *La Cathédrale après la Conquête de la Normandie et jusqu'a l'occupation Anglaise*, Les Cahiers de Notre Dame de Rouen, Rouen, 1960.

Langland, William, *Piers Plowman: The 'B' Version*, ed. G. Kane and E. Tabbot Donaldson, London, 1975.

Leach, Edmund, 'Anthropological Aspects of Language: Animal Categories and Verbal Abuse', *New Directions in the Study of Language*, ed. E. H. Lennenberg, Cambridge, Mass., 1964, pp. 23–63.

———, *Culture and Communication: The Logic by which Symbols are Connected*, Cambridge, 1976.

Leclercq, Jean, '"Joculator et saltator": St Bernard et l'image du jongleur dans les manuscrits', *Translatio Studii: Manuscript and Library Studies honoring Oliver L. Kapsner*, ed. J. G. Plante, Collegeville, Minn., 1973.

———, *The Love of Learning and the Desire for God: A Study of Monastic Culture*, trans. C. Misrahi, London, 1978.

Le Goff, Jacques, 'Ecclesiastical Culture and Folklore in the Middle Ages: St Marcellus of Paris and the Dragon', *Time, Work and Culture in the Middle Ages*, trans. A. Goldhammer, Chicago, 1980.

———, *The Medieval Imagination*, trans. A. Goldhammer, Chicago, 1980.

——— and Schmitt, Jean-Claude, eds, *Le Charivari*, Actes de la table ronde à organisée à Paris (25–27 April 1977) par l'Ecole des Hautes Etudes en Sciences Sociales et le Centre National de la Recherche Scientifique, Paris: The Hague and New York, 1981.

———, *Medieval Civilization: 400–1500*, trans. J. Barrow, Oxford, 1988.

Leupin, Alexandre, *Barbarolexis: Medieval Writing and Sexuality*, trans. K. M. Cooper, Cambridge, Mass., 1989.

Lewis, Suzanne, 'Sacred Calligraphy: the Chi Rho page in the Book of Kells', *Traditio*, XXXVI (1980), pp. 139–59.

———, *The Art of Matthew Paris in the Chronica Majora*, Berkeley, 1988.

Little, Lester K., 'Pride Goes Before Avarice: Social Change and the Vices in Latin Christendom', *American Historical Review*, LXXVI (1971), pp. 16–49.

———, *Religious Poverty and the Profit Economy in Medieval Europe*, London, 1978.

Lowenthal, L. J. A., 'Amulets in Medieval Sculpture', *Folklore*, LXXXIX (1978), pp. 3–9.

Maeterlinck, L., *Le Genre satirique dans la peinture flamande*, Brussels, 1907.

Mâle, Emile, *Religious Art in France of the Thirteenth Century: A Study of Medieval Iconography and its Sources*, trans. H. Bober, Princeton, 1984.

Mann, Jill, trans., *Ysengrimus*, Leiden, 1987.

Map, Walter, *De Nugis Curialium (Courtier's Trifles)*, ed. and trans. M. R. James; revd C. N. L. Brooke and R. A. B. Mynon, Oxford, 1983.

Marin, Louis, *Food for Thought*, trans. M. Hjort, Baltimore, 1989.

Mellinkoff, R., 'Riding Backwards: The Theme of Humiliation and Symbol of Evil', *Viator*, IV (1973), pp. 153–76.

Merback, Mitchell B., 'Scatology in the Margins: A Cultural Analysis of the "figura scatologicae" in Gothic Marginalia', MA thesis, University of Chicago, 1988.

Miles, Margaret, *Carnal Knowing: Female Nakedness and Religious Meaning in the Christian West*, Boston and New York, 1989.

Millar, Eric, ed., *The Rutland Psalter*, Oxford, 1937.

Miner, Dorothy, *Anastasie and her Sisters: Women Artists of the Middle Ages*, Baltimore, 1974.

Minnis, Alastair J., 'Langland's Ymaginatif and Late-Medieval Theories of Imagination,' *Comparative Criticism: A Yearbook* (1981), pp. 71–103.

Mollat, Michael, *The Poor in the Middle Ages: An Essay in Social History*, trans. A. Goldhammer, New Haven, 1986.

Morgan, Nigel, *Early Gothic Manuscripts, (1) 1190–1250 and (11) 1250–1280*, A Survey of Manuscripts illuminated in the British Isles, vols 4 and 5, London, 1982 and 1988.

———, 'The Artists of the Rutland Psalter', *The British Library Journal*, xiii (1987), pp. 159–86.

Morrison, Karl F., 'The Church as Play: Gerhoch of Reichersberg's Call for Reform', *Popes, Teachers, and Canon Law in the Middle Ages*, ed. J. R. Sweeney and S. Chodorow, Ithaca, NY, 1989.

Murray, Alexander, *Reason and Society in the Middle Ages*, Oxford, 1970.

———, 'Religion among the Poor in Thirteenth-Century France: The Testimony of Humbert of Romans', *Traditio*, xxx (1974), pp. 285–324.

Nash, Harvey, 'Human/Animal Body Imagery: Judgment of Mythological Hybrid (Part Human, Part Animal) Figures', *The Journal of General Psychology* (1980), pp. 49–108.

The New Paleographical Society Facsimiles of Ancient Manuscripts etc., 1st series, II, London, 1903–12.

Nordenfalk, Carl, 'Drolleries', *Burlington Magazine*, cix (1967), pp. 418–21.

Owst, R. G., *Literature and the Pulpit in Medieval England*, Oxford, 1966.

Pächt, Otto, 'A Giottoesque Episode in English Medieval Art', *Journal of the Warburg and Courtauld Institutes*, vi (1943), pp. 51–70.

———, *The Master of Mary of Burgundy*, London, 1947.

———,'Early Italian Nature Studies and the Early Calendar Landscape', *Journal of the Warburg and Courtauld Institutes*, xiii (1950), pp. 13–47.

———, Dodwell, C. R., and Wormald, F., eds, *The St Albans Psalter (Albani Psalter)*, London, 1960

———, *Book Illumination in the Middle Ages: An Introduction*, Oxford, 1986.

Page, Christopher, *The Owl and the Nightingale: Musical Life and Ideas in France, 1100–1300*, Oxford, 1989.

Parkes, M. B., 'The Influence of the Concept of Ordinatio and Compilatio on the Development of the Book', *Medieval Learning and Literature: Essays Presented to Richard William Hunt*, Oxford, 1976, pp. 115–41.

Peter of Celle, *Selected Works*, Kalamazoo, 1987.

Pierpont Morgan Library, *Medieval and Renaissance Manuscripts: Major Acquisitions, 1924–1974*, New York, 1974.

Pinon, R., 'From Illumination to Folksong: The Armed Snail, a Motif of Topsy-Turvey Land', *Folklore Studies of the Twentieth Century: Proceedings from the Centenary Conference of the Folklore Society*, ed. V. Newall, Woodbridge, Suffolk, 1980.

Plummer, John, *The Hours of Catherine of Cleves*, New York, 1966.

Porter, Arthur Kingsley, *The Romanesque Sculpture of the Pilgrimage Roads*, 1923; repr. Boston, 1969.

Porter, Lambert C., *La Fatrasie et le fatras: Essai sur la poésie irrationale en France au moyen âge*, Paris and Geneva, 1960.

Pouchelle, Marie-Christine, *The Body and Surgery in the Middle Ages*, London, 1990.

Prior, Edward S., and Gardner, Arthur, *An Account of Medieval Figure-Sculpture in England*, Cambridge, 1912.

Randall, Lilian M. C., 'Exempla as a Source of Gothic Marginal Illustration', *Art Bulletin*, xxxix (1957), pp. 97–107.

———, 'A Medieval Slander', *Art Bulletin*, xlii (1960), pp. 25–38.

———, 'The Snail in Gothic Marginal Warfare', *Speculum*, xxvii (1962), p. 358.

————, *Images in the Margins of Gothic Manuscripts*, Berkeley, 1966.

————, 'Humour and Fantasy in the Margins of an English Book of Hours', *Apollo*, LXXXIV (1966), pp. 482–88.

————, 'Games and Passion in Pucelle's Hours of Jean d'Evreux', *Speculum*, XLII (1972), pp. 246–57.

————, 'An Elephant in the Litany: Further Thoughts on an English Book of Hours in the Walters Art Gallery', *Beasts and Birds of the Middle Ages: The Bestiary and its Legacy*, ed. W. B. Clark and M. T. McMunn, Philadelphia, 1989.

Remnant, G. L., *A Catalogue of Misericords in Great Britain*, Oxford, 1969.

Richer, Paul, *L'Art et l'médecine*, Paris, 1918.

Robertson, D. W., *A Preface to Chaucer: Studies in Medieval Perspectives*, Princeton, 1963.

Rossiand, Jacques, 'The City-Dweller and Life in Cities and Towns', *Medieval Callings*, ed. J. Le Goff, Chicago, 1990, pp. 139–79.

Rouse, Richard H., and Rouse, Mary A., 'St Antonius of Florence on Manuscript Production', *Litterae Medii Aevi*, ed. M. Borgolte and H. Spilling, Sigmaringen, 1988.

Roy, Bruno, 'L'Humour érotique au XVe siècle', *L'Erotisme au moyen âge*, ed. B. Roy, Montreal and Paris, 1976.

Ruskin, John, *The Seven Lamps of Architecture* (1849), *Works*, VIII, ed. E. T. Cook and A. Wedderburn, London, 1903–12.

Rutebuf, *Oeuvres Complètes*, I, ed. M. Zink, Paris, 1989.

Sandler, Lucy Freeman, 'A Series of Marginal Illustrations in the Rutland Psalter', *Marsyas*, VIII (1959), pp. 70–4.

————, 'Reflections on the Construction of Hybrids in English Gothic Marginal Illustration', *Art the Ape of Nature: Studies in Honor of H. W. Janson*, New York, 1975.

————, 'A Bawdy Betrothal in the Ormesby Psalter', *Tribute to Lotte Brand Philip: Art Historian and Detective*, ed. W. W. Clark, C. Eisler, W. S. Heckscher and B. G. Lane, New York, 1985.

————, *Gothic Manuscripts 1285–1385*, V of *A Survey of Manuscripts Illuminated in the British Isles*, Oxford, 1986.

————, 'Notes for the Illuminator: The Case of the Omni Bonum', *Art Bulletin*, LXXI (1989), pp. 551–64.

Schmitt, Jean-Claude, 'L'Histoire des marginaux', *La Nouvelle Histoire*, ed. Jacques Le Goff, Paris, 1978, pp. 277–305.

Seidel, Linda, 'Medieval Cloister Carving and Monastic "Mentalité"', *The Medieval Monastery*, ed. A. MacLeish, Minnesota, 1988.

Sekules, V., 'Women in the English Art of the Fourteenth and Fifteenth Centuries', *The Age of Chivalry: The Art of Plantagenet England*, ed. J. J. G. Alexander and P. Binski, London, 1987.

Shaner, Mary E., 'The Fall of Nature in a Group of "Kentish Poppyhead"', *Medievalia*, 1/2 (1975), pp. 17–34.

Shapiro, Meyer, 'On the Aesthetic Attitude in Romanesque Art', *Romanesque Art*, New York, 1977, pp. 1–25.

————, 'Marginal Images and Drôlerie', *Late Antique, Early Christian and Medieval Art*, New York, 1979, pp. 196–98.

Sharpe, R. R., *Calendar of Coroners' Rolls of the City of London, 1300–1378*, London, 1913.

Sheridan, R. and Ross A., *Gargoyles and Grotesques: Paganism in the Medieval Church*, London, 1975.

Sinclair, K. V., 'Comic Audigier in England', *Romania* (1978), pp. 257–59.

Smith, Sarah Stanbury, '"Game in Myn Hood": The Traditions of a Comic Proverb', *Studies in Iconography*, IX (1983), pp. 1–11.

Speake, George, *Anglo-Saxon Animal Art and Its Germanic Background*, 1980.

Stallybrass, Peter and White, Allan, *The Politics and Poetics of Transgression*, Ithaca, NY, 1986.

Stones, Alison M., 'Secular Manuscript Illumination in France', *Medieval Manuscripts and Textual Criticism*, University of North Carolina Department of Romance Languages Symposia No. 4, ed. C. Kleinhenz, 1976, pp. 82–102.

———, 'Sacred and Profane Art: Secular and Liturgical Book Illumination in the Thirteenth Century', *The Epic in Medieval Society: Aesthetic and Moral Values*, ed. H. Scholler, Tübingen, 1977, pp. 100–13.

Strutt, Joseph, *The Sports and Pastimes of the People of England*, London, 1833.

Swartout, R. E., *The Monastic Craftsman*, Cambridge, 1932.

Talbot, C. H., *The Life of Christina of Markyate*, Oxford, 1959.

Thompson, Sir E. Maunde, *The Grotesque and the Humorous in the Illuminations of the Middle Ages*, London, 1896.

Thompson, Stith, *Motif Index of Folk Literature*, 2nd edn., Bloomington, 1955–8.

Tracey, Charles, *English Medieval Furniture and Woodwork*, London, 1988.

Turner, Victor, *Process, Performance and Pilgrimage: A Study in Comparative Symbology*, New Delhi, 1979.

Vale, Juliet, *Edward III and Chivalry: Chivalric Society and its Context, 1270–1350*, Woodbridge, Suffolk, 1982.

Vance, Eugene, *Mervelous Signals: Poetics and Sign Theory in the Middle Ages*, Lincoln, 1986.

Van Gennep, Arnold, *Rites of Passage*, 1908, repr. London, 1960.

Varty, Kenneth, *Reynard the Fox: A Study of the Fox in English Medieval Art*, Leicester, 1967.

Verdier, Philippe, 'Women in the Marginalia of Manuscripts and Related Works', *The Role of Women in the Middle Ages*, Papers of the 6th Annual Conference of the Center for Medieval and Early Renaissance Studies at the State University of New York, Binghampton, 1972, ed. R. T. Morewedge, Binghampton, 1975.

Verriest, L., *Le Vieil Rentier d'Audenarde*, Brussels, 1950.

Walker, A. and Webb, G., eds, *The Mirror of Charity of Aelred of Rievaulx*, London, 1962.

Weigert, H., 'Die Masken der Kathedrale zu Reims', *Pantheon*, XIV (1934), pp. 246–50.

Weir, Anthony and Jerman, James, *Images of Lust: Sexual Carvings on Medieval Churches*, London, 1986.

Wentersdorf, Karl P., 'The Symbolic Significance of the "Figura Scatologicae" in Gothic Manuscripts', *Word, Picture and Spectacle*, ed. C. Davidson, Kalamazoo, 1984, pp. 1–20.

Werner, F., *Aulnay de Saintonge und die Romanische Skulptur Westfrankreich*, Wörms, 1979.

Yapp, W. Brundson, *Birds in Medieval Manuscripts*, New York, 1981.

Young, Karl, *The Drama of the Medieval Church*, II, Oxford, 1933.

List of Illustrations

All measurements are in millimetres, height before width.

1 Detail of illus. 69.

2 World map. Psalter. British Library, London. Add MS 28681 fol. 9r. 170 × 124.

3 'Chi-Rho' monogram. *The Book of Kells*. Trinity College, Dublin. MS A.I.6 fol. 34r. 330 × 250.

4 Rustic enigmas at the edge of the Logos. *The Bury Bible*. Corpus Christi College, Cambridge. MS 2 fol. 1v. 514 × 355.

5 St Augustine disagrees. Peter Lombard's gloss on the Psalms. Trinity College, Cambridge. MS B.V.5 fol. 33v (detail).

6 Text versus Image. *The Rutland Psalter*. British Library, London. Add. MS 62925 fol. 14r. 298 × 203.

7 Folly crosses the philosophical text. Aristotle's *Physics*, book IV, British Library, London. Harley MS 3487 fol. 22v. 277 × 245.

8 Man pulling into place the missing fourth verse of Psalm 127. Psalter and Book of Hours. Walters Art Gallery, Baltimore. MS 102 fol. 33v (detail).

9 Monkeys mock writing. Missal illuminated by Petrus de Raimbeaucourt, 1323. Koninklijke Bibliotheek, The Hague. MS D.40 fol. 124r. 356 × 229.

10 Signs of the Passion. Book of Hours. Pierpont Morgan Library, New York. MS 754 fol. 105r. 152 × 111.

11 Bird-headed Christ. Book of Hours. Walters Art Gallery, Baltimore. MS 102 fol. 56v. 267 × 284.

12 Nun suckling a monkey. *Lancelot Romance*. John Rylands Library, Manchester. MS fr. 2 fol. 212r (detail).

13 Knight and snail, woman and ram. Psalter. Kongelige Bibliotek, Copenhagen. MS G.K.S. 3384 fols 160v–161r. 95 × 70.

14 Marguerite's monkey-business. Book of Hours. British Library, London. Add. MS 36684 fols 46v–47r. 152 × 111.

15 Christ-fool. *The Ormesby Psalter*. Bodleian Library, Oxford. Douce MS 366 fol. 72r. 381 × 248.

16 Knight flees snail in upper margin. Chartres Cathedral. Fragment of destroyed jube. Photo: James Austin.

17 The Crucifixion and 'dirty looks'. *Grey-Fitzpayn Hours*. Fitzwilliam Museum, Cambridge. MS 242 fol. 55v. 241 × 152.

18 The 1st Psalm and 'dirty looks'. *Bardolf-Vaux Psalter*. Lambeth Palace, London. MS 233 fol. 15r. 327 × 119.

19 A bawdy betrothal and a 'dirty look'. *The Ormesby Psalter.* Bodleian Library, Oxford. Douce MS 366 fol. 131r (detail).

20 A flourisher's doodle. Book of Hours. Walters Art Gallery, Baltimore. MS 102 fol. 51r (detail).

21,22 An anal opening. *The Rutland Psalter.* British Library, London, MS 62925 fols 66v–67r. 289 × 203.

23 Coitus of creatures. Albert the Great's *De Animalibus.* Bibliothèque Nationale, Paris. lat. 16169 fol. 84v. 330 × 245.

24 Sex on the verge of the text. Book of Hours. Pierpont Morgan Library, New York. MS M. 754 fol. 65v. 152 × 111.

25 Bum in the oven. Book of Hours. Pierpont Morgan Library, New York. MS M. 754 fol. 16v. 152 × 111.

26 Flagellation of Christ and egg/turd-bowling. Book of Hours. Pierpont Morgan Library, New York. MS M. 754 fol. 3v. 152 × 111.

27 Creatures and cannibals. Treatise on the Vices. British Library, London. Add. MS 28841 fol. 3r. 165 × 102.

28 Marginal mayhem. Book of hours. Pierpont Morgan Library, New York. MS M 754 fols 91v–92r. 155 × 220.

29 Stone capital with Transfiguration on face and games on the impost. No. 472. 360 × 520. Musée des Augustins, Toulouse. Photo: James Austin.

30 The fourth face of the same capital. Incredulity of St Thomas on face, men with books on impost. No. 472. 360 × 520. Musée des Augustins, Toulouse. Photo: James Austin.

31 Spectators, jongleur and acrobat. Stone voussoir. Church of St Nicholas, Civray. Photo: Guidol.

32 Initial 'S' with Cain and Abel and eater. Josephus' *Antiquities,* by the scribe Samuel. St John's College, Cambridge. MS A.8 fol. 1r (detail).

33 Man eating vine. Cloister capital, Montmajour Abbey. Photo: James Austin.

34 Carnival of animals, Elders of the Apocalypse, saints. South transept portal. Church of St Pierre, Aulnay-de-Saintonge. Photo: James Austin.

35 Corbel creatures. Exterior, east end. Church of St Pierre, Aulnay-de-Saintonge. Photo: James Austin.

36 Mock Mass. South transept portal. Church of St Pierre, Aulnay-de-Saintonge. Photo: James Austin.

37 Thing on the corner. Exterior, west façade. Church of St Pierre, Aulnay-de-Saintonge. Photo: James Austin.

38 Gargoyles. Exterior, north side. Cathedral of Notre-Dame, Paris. Photo: James Austin.

39 Man with scroll, woman with book. Gargoyles, exterior. St Andrew's Church, Heckington, Lincolnshire. Photo: Veronica Sekules.

40 Chimeras, restored by Viollet-le-Duc in 1843. Cathedral of Notre-Dame, Paris. Photo: Stone.

41 Mouth-puller. Capital, south-east transept, Wells Cathedral. Photo: author.

42 Face-pulling head. North-east corner, east tower, south transept. Reims Cathedral. Photo: James Austin.

43 Portail des Libraires. North transept façade. Rouen Cathedral. Photo: James Austin.

44 Genesis and a feast of creatures. Inside left jamb. Portail des Libraires, Rouen Cathedral. Photo: James Austin.

45 Jongleur and monkey, two monsters and a lower marginal scene of (?)charity. Inside right jamb. Portail des Libraires, Rouen Cathedral. Photo: James Austin.

46 Shrouded mourner, Creation and parody of the Virgin Birth. Inside right jamb. Portail des Libraires, Rouen Cathedral. Photo: James Austin.

47 Sniffing the bottom. Misericord. Church of St Pierre, Saumur.

48 Work and play: harvesters and babewyns. Misericords from a church in King's Lynn, Norfolk, now in the Victoria & Albert Museum, London.

49 Castle of Love and Fountain of Youth. Ivory mirror case. Walters Art Gallery, Baltimore. 130 × 125.

50 Hector meets weeping damsels, in combat with Tercians and marginal archer. *Lancelot del Lac.* Beinecke Rare Book Library, Yale University, New Haven. MS 229 fol. 39v. 476 × 343.

51 Elevation of the Host and scene from a Romance. Psalter. Bodleian Library, Oxford. Douce MS 131 fol. 81v. 235 × 136.

52 Praising the Lord through music. *The Luttrell Psalter.* British Library, London. Add. MS 42130 fol. 176r. 356 × 244.

53 Serving the body through music. *Book of Hours.* British Library, London. Stowe MS 17 fol. 233v–234r. 95 × 64.

54 Gaheriet and Gawain in combat watched by three ladies. *Lancelot del Lac.* Beinecke Rare Book Library, New Haven. MS 229 fol. 18r (detail).

55 Perceval and the beautiful damsel on her ship; knight in margin gets it in the behind. *Queste de Saint Graal.* Beinecke Rare Book Library, New Haven. MS 229 fol. 220r (detail). 476 × 343.

56 The Grail Liturgy with marginal angels. *Queste de Saint Graal.* Beinecke Rare Book Library, New Haven. MS 229 fol. 269v (detail).

57 A wildman 'carries the damoysele in his arms'. *Taymouth Hours.* British Library, London. Yates Thompson MS 13 fol. 62v (detail).

58 Tournament and babewyns. *Treatise of Walter de Milemete.* Library of Christ Church College, Oxford. MS 92 fol. 68r. 248 × 159.

59 Shitting for one's lady. Psalter. Trinity College, Cambridge. MS B.11.22 fol. 73r. 168 × 130.

60 Alexander battles a dragon, naked boys tilt at a barrel and a lady worships at the altar of the anus. *Romance of Alexander.* Bodleian Library, Oxford. MS Bodl. 264 fol. 56r. 435 × 318.

61 Ladies watching knights in the initial, servants scurry below. *Tristram*. Bibliothèque Nationale, Paris. MS fr. 776 fol. 67r. 312 × 216.

62 Carting away the harvest and a yoked peasant. *The Luttrell Psalter*. British Library, London. Add. MS 42130 fol. 143v. 356 × 244.

63 Prohibited prey. *Free Warren Charter*, 1291. Fitzwilliam Museum, Cambridge. MS 46–1980. 190 × 280.

64 Young man led to the 'Gates of Hell'. Psalter. Bodleian Library, Oxford. Douce MS 6 fol. 160v–161r. 95 × 70.

65 detail of verso page of illus. 64.

66 The Beatus bursts its bounds. *Psalter and Hours of St Omer*. British Library, London. Yates Thompson MS 14 fol. 7r. 337 × 225.

67 Dance of courtiers, dance of peasant mummers. *Romance of Alexander*. Bodleian Library, Oxford. MS Bodl. 264 fol. 112v. 438 × 318.

68 Guy brings Harold to Duke William of Normandy, couple about to copulate on the edge. *The Bayeux Tapestry*. Musée de la Tapisserie, Bayeux.

69 Beggars on the bridges of medieval Paris. Bibliothèque Nationale, Paris. MS fr. 2091 fol. 111r. 240 × 160.

70 Legless beggar and bourgeois with coin. Book of Hours. Walters Art Gallery, Baltimore. MS 82 fol. 193v. 162 × 105.

71 Beggar-acrobat. Book of Hours. Walters Art Gallery, Baltimore. MS 88 fol. 52v. 111 × 83.

72 The Duke, the Virgin and the destitute. The *Petits Heures of Jean, Duc de Berry*. Bibliothèque Nationale, Paris. MS lat. 18104 fol. 97v. 215 × 145.

73 St Louis washes the feet of beggars. *Hours of Jeanne d'Evereux*. Metropolitan Museum of Art, New York. Cloisters Collection, MS 54.1.2 fols 148v–149r. 94 × 64.

74 Crouching open-mouthed *marmouset* beneath Habbakuk. West front, Amiens Cathedral. Photo: James Austin.

75 Portal of St Stephen, Cathedral of Notre-Dame, Paris. Photo: James Austin.

76 Four reliefs, west side of portal of St Stephen, Cathedral of Notre-Dame, Paris. Photo: James Austin.

77 Bells, simian seals and vomited coins. Psalter. Bodleian Library, Oxford. Douce MS 6 fol. 157v. 95 × 70.

78 The charivari. *Roman de Fauvel*. Bibliothèque Nationale, Paris. MS fr. 146 fol. 36v.

79 Christ before Pilate and Visitation; charivari in the margins. *Hours of Jeanne d'Evreux*. Metropolitan Museum, New York. Cloisters Collection, MS 54.1.2 fols. 34v–35r. 94 × 64.

80 Richart and Jeanne de Montbaston, illuminators. *Roman de la Rose*. Bibliothèque Nationale, Paris. MS fr. 25526 fol. 77v (detail).

81 Nun picking penises from phallus-tree. *Roman de la Rose*. Bibliothèque Nationale, Paris. MS fr. 25526 fol. 196r.

82 Mason with mallet and chisel in spandrel of St William of York's tomb. Yorkshire Museum, York.

83 St Dunstan draws a butterfly, *Smithfield Decretals*. British Library, London. Royal MS 10 E. IV fol. 248r.

84 St Bartholomew and pretzels. *Book of Hours of Catherine of Cleves*. Pierpont Morgan Library, New York. MS M. 917 p. 228. 192 × 130.

85 The margins frame St Matthew and the angel. *Spinola Hours*. The J. Paul Getty Museum, Malibu. MS fol. 87v 232 × 166.

86 The end of the end. *Voeux du Paon*. Pierpont Morgan Library, New York. MS Glazier 24 fol. 24v. 248 × 170.